THE
RED LEATHER
DIARY

THE
RED LEATHER
DIARY

*Reclaiming a Life Through
the Pages of a Lost Journal*

Lily Koppel

HARPER
An Imprint of HarperCollinsPublishers
www.harpercollins.com

HarperCollins books may be purchased for educational, business, or sales promotional use. For information, please write: Special Markets Department, HarperCollins Publishers, 10 East 53rd Street, New York, NY 10022.

FIRST EDITION

Designed by Leah Carlson-Stanisic

Library of Congress Cataloging-in-Publication Data is available upon request.

ISBN: 978-0-06-125677-6

08 09 10 11 12 ID/RRD 10 9 8 7 6 5 4 3

For Florence

CONTENTS

Foreword *ix*

CHAPTER I
THE DISCOVERY 1

CHAPTER 2
THE DIARY 23

CHAPTER 3
MODERN MERCURY 41

CHAPTER 4
A PORTRAIT OF THE ARTIST AS A YOUNG WOMAN 57

CHAPTER 5
THE LAVENDER REMINGTON 73

CHAPTER 6
THE AMERICAN DREAM 85

CHAPTER 7
THE SNAKESKIN COAT 95

CHAPTER 8
EVA LE GALLIENNE 109

CHAPTER 9
MY FIRST LOVE AFFAIR 129

CHAPTER 10
SPRING LAKE 151

CHAPTER 11
PEARL 165

CHAPTER 12
M 185

CHAPTER 13
EVELYN 203

CHAPTER 14
THE CIRCUS 221

CHAPTER 15
THE SALON OF FLORENCE WOLFSON 233

CHAPTER 16
THE ITALIAN COUNT 249

CHAPTER 17
PRIVATE EYE 277

CHAPTER 18
SPEAK, MEMORY 295

Acknowledgments *321*

*As a teenager, Florence Wolfson kept the diary from 1929 to 1934.
Rescued in 2003, the battered volume was reunited with its author
in 2006. Ninety-year-old Florence had forgotten about the diary
until Lily Koppel called with the news of its discovery. "Am quite
a busy young lady," Florence read from an entry written when she
was fifteen.* (Photo: Angel Franco/ *New York Times*.)

FOREWORD

At ninety, having survived a car crash and *E. coli*, I was living what can only be called a bland life. Mobility was low—no golf, no tennis, no long walks—but curiosity about people and politics was high. And there were such activities as practicing scales on the piano, playing bridge, reading, and agonizing with friends over America's current quagmire. Not too bad a life for a nonagenarian.

What was missing were expectations. Everything was going to be the same until the final downhill slide. My beloved husband, Nat, was already on that slide. What was there to expect?

What, indeed! In my most cloud-nine dreams I could never have imagined what awaited me. I was sitting on my patio in Florida one glorious April afternoon when the phone rang. An unknown voice greeted me when I answered. "Hello, my name is Lily Koppel. Are you by any chance Florence Wolfson— now Howitt?"

I thought, Do I want to admit that I am? Was this going to be some marketing nuisance I regretted ever saying hello to? Well, I was a little curious, so I owned up to being me. Said Lily, "I have some old things belonging to you that I picked up at 98 Riverside Drive, and I thought you might want them

back." "What things?" I asked. "An old red leather diary, short stories you wrote when you were fifteen, and your master's thesis from Columbia. I'll be happy to send them to you."

Those words changed my life. I told her not to bother sending them because my daughters would pick them up on one of their many trips to New York. So, waiting to hear from Valerie or Karen, she didn't send them. She read the diary. I had totally forgotten about it and couldn't imagine anyone finding it of interest.

But in the meantime, Lily had arranged to do a piece for the *New York Times* based on this seventy-six-year-old relic. When I came back to Westport for the summer, she handed the diary to me. That was a moment! How do you feel when a forgotten chunk of your life, full of adolescent angst and passion, is handed to you? How do you feel when you see your striving, feeling, immature self through your now elderly eyes? It stopped my heart for a moment. That was *me*?

This tempestuous girl who did pretty much what she wanted was now walking slowly and not really wanting to do much of anything. I was stunned and a little sad—I read the diary avidly and came to love that young girl. What happened next was a surprise measuring ten on the Richter scale, my own earth-moving experience. Lily's article turned out to be a mesmerizing piece of journalism, provoking enough interest to be developed into a book—which you are now holding in your hands, and I hope you will savor as you read about the New York I knew and loved.

When I heard the news, it was as though I had been hit by lightning. From no expectations to being written about, from being hidden in a diary with a key, fourteen-year-old Florence

was going to be revealed in a book! And how did I feel about so many intimate thoughts and acts on public display? Here's how I felt.

I am now ninety-two—my husband of sixty-seven years died last April—and I am fighting to keep my fingers in the pie of life. Young Florence would have agreed that this is a positive. She would have said, "Go for it." It has been fun, it has added zest to my life, it has brought back some of the passion of my youth and made me feel more alive than I have in years. I am probably one of the most excited old women in the world. Thank you, Lily.

Florence Howitt
Westport, Connecticut
September 3, 2007

THE
RED LEATHER
DIARY

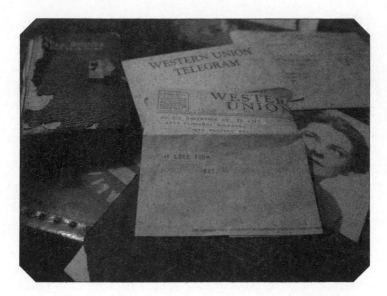

Fished out of a Dumpster, a 1930s diary brings to vivid life the world of a privileged New York teenager, obsessed with the state of her soul and her appearance. The cover of the diary originally read "Mile Stones Five Year Diary." A portrait of the actress Eva Le Gallienne lies underneath a telegram from Nathan Howitt. (Photo: Don Hogan Charles/*New York Times.*)

THE DISCOVERY

Once upon a time the diary had a tiny key. Little red flakes now crumble off the worn cover. For more than half a century, its tarnished latch unlocked, the red leather diary lay silent inside an old steamer trunk strewn with vintage labels evoking the glamorous age of ocean liner travel. "This book belongs to," reads the frontispiece, followed by "*Florence Wolfson*" scrawled in faded black ink. Inside, in brief, breathless dispatches written on gold-edged pages, the journal recorded five years in the life and times of a smart and headstrong New York teenager, a young woman who loved Baudelaire, Central Park, and men and women with equal abandon.

Tucked within the diary, like a pressed flower, is a yellowed newspaper clipping. The photograph of a girl with huge, soulful eyes and marcelled blond hair atop a heart-shaped face stares out of the brittle scrap. The diary was a gift for her fourteenth birthday on August 11, 1929, and she wrote a few lines faithfully, every day, until she turned nineteen. Then, like so many relics of time past, it was forgotten. The trunk, in turn, languished in the basement of 98 Riverside Drive, a prewar apartment house at Eighty-second Street, until October 2003, when the management decided it was time to clear out the storage area.

The trunk was one of a roomful carted to a waiting Dumpster, and as is often the case in New York, trash and treasure were bedfellows. Some passersby jimmied open the locks and pried apart the trunks' sides in search of old money. Others stared transfixed, as if gazing into a shipwreck, at the treasures spilling from the warped cedar drawers: a flowered kimono, a beaded flapper dress, a cloth-bound volume of Tennyson's poems, half of a baby's red sweater still hanging from its knitting needles. A single limp silk glove fluttered like a small flag. But the diary seems a particularly eloquent survivor of another age. It was as if a corsage once pinned to a girl's dress were preserved for three quarters of a century, faded ribbons intact, the scent still lingering on its petals. Through a serendipitous chain of events, the diary was given the chance to tell its story.

The first time I came to 98 Riverside Drive, an orange brick and limestone building set like a misty castle overlooking leafy Riverside Park and the Hudson River, I felt I was entering a hidden universe awaiting discovery. Under the maroon awning, I entered the red marble lobby, pockmarked with age like the face of the moon. I passed an old framed print of a gondola gliding under Venice's Bridge of Sighs, the early August evening light that filtered through stained-glass windows illuminating a young gallant displaying a jeweled coat of arms, with a dagger stuck in his belt. He was carrying a locked treasure chest.

My gaze wandered to the building's rusted brass buzzer. There were fifteen stories, each floor divided into eight apart-

ments, A through H, where I half expected to find Holden Caulfield's name. Among the residents were several psychoanalytical practices and an Einstein. Floating through the courtyard airshaft, I heard Mozart being worked out on piano. The building seemed to have an artistic soul.

I was twenty-two. I had just landed a job at the *New York Times* after graduating from Barnard College. An older woman I had met at the newspaper had put me in touch with a friend who wanted to rent a room in her apartment at 98 Riverside. The building was on the Upper West Side, which has long held the reputation of being Manhattan's literary home, although few young artists could still afford the rents.

I rang the pearl doorbell to 2E, waiting in front of the peephole. The red door bordered in black opened, and my new landlady introduced herself. Peggy was in her fifties, with a Meg Ryan haircut. Midwest born and bred, she was glad to learn that I was from Chicago. She was still wearing a pink leotard and tights from Pilates, and her pert expression was hard to read behind a black eye patch. "The pirate look," she said, explaining that a cab had hit her while she was biking through Midtown. Peggy shrugged. "Just my luck."

It was a marvelous apartment with an original fireplace, high ceilings with ornate moldings, Oriental carpets, and antiques. Her collection of Arts and Crafts pottery and vases covered every available surface. When turned upside down, they revealed their makers' names stamped on the bottom— Marblehead, Rookwood, Van Briggle, Roseville and Door. I admired a faun grazing on a vase. "All empty." Peggy giggled, since none held flowers. "I know, very Freudian." She opened French doors, showing me the dining room with a parquet

border, and led me through the kitchen, past a no-longer-ringing maid's bell. Down the hallway, she pointed to her own paintings, acrylic portraits and rural landscapes. "The building even has a library," added Peggy, who had just finished Willa Cather's *A Lost Lady*, which she recommended.

Over Brie with crackers and red grapes set out with silver Victorian grape scissors, we became acquainted on the couch, a pullout, where Peggy said she would sleep. I offered to take the living room instead of her master bedroom, but Peggy insisted. She mentioned rigging up a Chinese screen for privacy. This way she could watch TV late or get up if she couldn't sleep. She told me that when she was my age, she had also come to New York to become an artist. There was a short-lived marriage in her early twenties to a jazz musician. Peggy admitted she lived quietly now, designing Impressionist-inspired napkins and guest towel sets painted with café chairs and names like Paris Bistro, which she sold on the Internet.

"This will be your room," announced Peggy, showing me into a large bedroom with two windows hung with filmy curtains billowing out, ushering in a warm breeze off the Hudson. She fluffed the new bedding on the antique white iron bed piled with lacy throw pillows. It was everything Virginia Woolf had ordered in *A Room of One's Own* for the young woman writer. The lavender walls gave it a Bloomsbury charm. There were two walk-in closets smelling of potpourri and an old vanity, which would serve as a good desk. Not wanting to spend another night going through the crawlspaces of Craigslist, I moved in. I hoped the Tennessee Williams setting and resident Blanche DuBois would only improve my writing. Hanging on the wall opposite my new bed was an oil painting of a sleep-

ing teenage girl, her blond hair a storm cloud around her face on the pillow——a Lolita creature reminiscent of Balthus, from Peggy's earlier period.

"Say hi to Miss Teeny." Peggy held a gray ball of fur up to my face as I was unpacking my one bag. Over the next few weeks, other things came up, like the no-men-allowed rule. I could tell Peggy was a good person. I could also tell when tension was high by the determined hum of her whirring Dirt Devil in the morning. Two single women and a blind cat was hardly an ideal situation. Feeling shelved away in someone else's life while my friends were living downtown or in Brooklyn with their boyfriends, I was beginning to wonder if I had set myself up to live out my worst fear.

I left the apartment early and returned late at night. At the *New York Times*, I started getting my own articles in the paper while working as a news assistant on the Metro desk. I had carte blanche into the city's glamorous nightlife, reporting for the *Times* celebrity column, traipsing from red-carpet movie premiere to party to after-party, interviewing hundreds of boldface names—Martin Scorsese, Meryl Streep, Jack Nicholson, Helen Mirren, Clint Eastwood, Jim Jarmusch, Sofia Coppola, Scarlett Johansson. "Dahling," Mick Jagger called me. On a love seat, under a chandelier, in an empty ballroom, Shirley MacLaine tried to convince me of my past life.

Opening up the *Times* in the morning and seeing my name in print gave me a surge of hope. Other publications started writing about me, since I was now part of the scene. "The Bravest Gossip Reporter Ever" said Gawker, a popular media Web site, describing my relentless interviewing style when James Gandolfini, better known as Tony Soprano, asked me out on a date.

The *New York Observer* wrote, "Bluish TV lights were installed in the furniture stripped parlor—they made flame-haired and pale-skinned Boldface Names legger Lily Koppel look like a divine space-age ballerina."

Although I took none of this too seriously, the image spoke to my fantasy of superheroine feats to come. Since setting foot in the celebrity world, I had abandoned the novel I was working on. Fiction seemed strange when my reality felt so unreal. But despite all of the frivolity around me, I wanted to report on life not found in the pages of glossy magazines or in news recycled at the end of each day, and moment to moment on the Internet. I really wasn't interested in celebrities any more than I was eager to run around the city covering crime scenes, which is how young reporters are broken in. I wanted everything to slow down. I was searching for a story that completely touched my life and those of other people. More than ever, I had no idea what to write about. What was I doing here?

⌂

It was almost eight a.m. on a crisp fall day, October 6, 2003, a couple months after I had moved in, and I was late getting to the *Times*. I would spend the next eight hectic hours answering phones on the Metro desk, helping editors coordinate news coverage, while writing my own articles, trying to break into the paper's ranks. As usual, after another late night and one too many glasses of champagne, I was in a hurry to get to the subway and make it to the newsroom before the editors, to find out where a fire was blazing or a murder was under investigation.

I had just stepped out of my building. Parked in front of 98 Riverside's awning was a red Dumpster brimming with old steamer trunks. One of the sides was collapsed. At a glance, I counted more than fifty trunks and elegant valises piled high like a magic mountain, just a polishing away from their descendants at Louis Vuitton. At the top, a tan trunk studded with brass rivets glowed in the sun with such luminescence that it appeared spotlit. With a copious skin of grand hotel labels, it betrayed its age like a sequoia. The world had been rounded.

Each label was a miniature painting, a dreamy portal into a faraway destination. Elephants paraded past exotic geishas twirling parasols. Pink palms swayed, hypnotizing passengers aboard the Orient and Round the World Dollar Steamship Line. Flappers frolicked. Seagulls working for I.M.M. Lines hawked "Cruises to Every Land Through Every Sea!" An orange ship sailed through a fuchsia pagoda. Two women sat under an umbrella in Cannes. Giraffes kicked off the Around Africa Cruise. A classic ruin in a desert signaled the Grand Express Europe-Egypt. The Hotel Schwarzer Bock in Wiesbaden pictured a single-horned mythological ram staring boldly into the distance above dark trees and puffy clouds. A ship shot like a bullet from a kaleidoscopic Statue of Liberty. The red Italia Prima Classe sticker stood out with a first-class *F*.

I felt a pang of longing. I was seized by the impulse that at this moment, nothing mattered but seeing what lay inside the trunks. They wouldn't be around for long. I pulled my dyed red hair back in a ponytail. Slinging my bag across my shoulders, I grasped the Dumpster's grimy edge and found toeholds with my embroidered Chinese slippers. I pulled myself up. Careful to avoid a tangle of lamp cords and a shattered gilt mirror, I

Trunks in the basement of 98 Riverside Drive headed for the Dumpster. The diary was found inside one of the trunks. (Photo: Don Hogan Charles/*New York Times*.)

balanced each foot on a different precariously lodged chest in the shifting maze. Lost among the trunks was a wooden stage prop of the White Rabbit from *Alice in Wonderland*, wearing what looked like a Marc Jacobs plaid coat, checking his pocket watch.

There were about a dozen trunks across and six deep. Testing my path with several taps of my foot, I crossed from trunk to trunk as if they were bobbing in the middle of the ocean. I gazed down my street, dotted with pots of magenta impatiens, a quiet path leading from West End Avenue to Riverside Park, lined in brownstones distinguished by polished door knockers sculpted as winged cherubs, dolphins, rams' heads, and Victo-

rian hands. A woman walking her black Lab, which was carrying the newspaper in its mouth, didn't seem to notice anything out of the ordinary.

I fumbled with rusty brass locks and latches, running my hands over chests jumbled at odd angles. The dusty wood and metal surfaces felt rough, like sandpaper. I was searching for hidden treasure. Out of the darkness, a ghostly apparition of a woman's sheer nightgown appeared as if floating. Lace curtains clung to sharp edges like Spanish moss. There was a man's charcoal gray dress coat with a worn velvet collar, a lost satin slipper, watercolor sets, cloudy champagne glasses preserved in tissue paper from someone's wedding, a chipped demitasse, and a still-fragrant bottle of Morrow's pure vanilla. A typed manuscript and old scalloped photographs surfaced, as well as a sepia panoramic group portrait of a tough-looking crowd in black tie and sequins wearing paper cone hats and bibs at a beefsteak dinner at the Hotel Astor in 1922.

I struggled to make out owners' initials stamped in gold beneath locks speckled green with patina. Names were written in a careful hand on labels dangling from the handles of trunks. "Mrs. Frances . . . Biancamano, Genova," I read on an Italian Line tag displaying a majestic ocean liner gliding past Mount Vesuvius.

Each trunk weighed as much as a large TV. I managed to move a few, barely escaping a near avalanche. One black trunk, heavy as a boulder, with a charred-looking domed top ribbed with wooden slats, appeared too weary to move again. It had already come so far. I read its surface like a map. It seemed to tell of a trip across the Atlantic carrying everything one family owned. This was news. I called the *Times*, arranging for

a photographer to take pictures of the scene. In the meantime, the doormen came out to watch as if I were performing the high-wire act. "What do you want with that old stuff? Please, come down."

The doormen helped me lift several chests. They also filled me in on what was happening. Ninety-eight Riverside's management had decided to expand the bike room. All unclaimed tenant storage, some going back to the early twentieth century, was being cleared out. One by one, the building engineers had dragged the trunks up from their longtime resting places to the Dumpster, which would deliver them to a barge for their final journey down the river to a landfill with the city's thousands of tons of daily trash. Neighbors stopped to ask what I was doing, and several climbed in. An old couple told me that clearing out cellars had long been a common, somewhat secretive rite among Upper West Side landlords bringing their buildings up to snuff.

Peeking out from under a reef of gnarled drapes accumulated like seaweed, a swatch of orange caught my eye. Nearly slipping through the cracks, I tried to remember when I had my last tetanus shot, reflecting momentarily on the three-dimensional puzzle I had entered. Careful not to catch myself on anything, I fished out a tangerine bouclé coat with a flared skirt and a single Bakelite button. "Bergdorf Goodman on the Plaza," read the label sewn into its iridescent lining. I saved the coat, a pale pink flapper dress, and a black satin bathing costume with the intensity of a rescuer at an archaeological dig. There were wardrobe trunks, one stacked on top of the other—a vintage clothing lover's fantasy. I pushed with all of my weight on one chest, but it didn't even budge. No wonder

they had porters in those days. Its leather straps crumbled into red dust in my hands.

Finally, I got it open. It was from Saks Fifth Avenue, designed to stand upright for packing, like a miniature closet in one's cabin. Half was filled with drawers, and the other half was fitted with wooden hangers and a presser bar holding gowns in place. There was a built-in shoe box and a travel iron. The trunk's ornate blue-gray seashell lining hinted at past grandeur. Each drawer revealed evidence of someone's life lovingly folded and stowed away for another trip, season, or child. Tucked carefully inside were a stiff wedding dress, a twisted pair of gold-rimmed glasses, a riding jacket, and a pair of saddle shoes. I fingered a red paisley bandanna, not the stiff replicas sold by street vendors, but the soft cotton kind worn by real cowboys. I figured I'd give it to someone special, if he ever showed up.

Boxes from Anna's Hats on East Fifty-sixth Street (Plaza 3-8369) protected never-worn feathered confections with pins topped by a pearl. I inherited an entire collection of handbags. There was a sleek evening bag with Grace Kelly elegance scaled with silver beads, a Lucite box purse, a doctor's bag, and a black Bienen-Davis pocketbook with a matching coin purse attached on a gold chain and a pocket mirror in a silk envelope. I shook out the purse's contents. A portrait of an era scattered before me, clues to how life was lived in Manhattan during the 1920s and '30s.

This time capsule held a bitten pencil, a gold tube of Revlon lipstick (in "Bachelor's Carnation"), and a Parliament cigarette, never smoked, but considered, as someone's lips had left a kiss. There was a 50¢ Loew's movie ticket stub, *The National Mah Jongg League Official Standard Hands and Rules*, an ossified

stick of Beech-Nut peppermint gum, "Always Refreshing," an Old Nick chocolate bar wrapper, a matchbox from Schrafft's— a coffee shop chain where ladies lunched before a matinee or after shopping. Tobacco shavings covered everything, including a package with a woman's long, seductively lashed gaze, asking, "Does smoke irritate your eyes? Use Murine." Some lucky girl had taken a weekend jaunt, staying at the Shelburne Hotel in Atlantic City.

Business cards listed old phone exchanges—Don Le Blanc School of Dancing (Trafalgar 7-9486) and Oscar's Beauty Salon (Susquehanna 7-9489), "Permanent Waving," with a sketch of a lady whose coiffeur was a surface of flat curls. Countless crumpled to-do lists still conveyed their urgency. "Thurs.: 12:30 Selma, present Doris, Saks—Bathing suit, bra, call Ryan. Girl: change bedding, press dresses. Eggs, cream, bread & rolls, radishes, bananas, lemons, sugar, oranges, toilet paper. Next week: carpets down, piano tuned." A gift card fell out. "To Mom— May this lighter continue to light the way for many years to come. Love—"

"Mom, get down, we already have enough junk at home, we don't need other people's garbage," a teenager loudly complained to her mother, who was gravitating toward the trunks. She sounded just like me talking to my parents when they dragged my younger brother and me from one antique shop to the next.

By dark, the Dumpster was illuminated by a streetlamp. Vans bound for flea markets loaded up. Completely exhausted, I headed upstairs. Prophetic of the larger story I had climbed into, although I didn't know it yet, was the typewriter under my arm, which I had retrieved from the Dumpster. In a pile of

papers spilling out of a trunk, I reached for one last thing—a brittle Western Union telegram addressed to a "Miss Florence Wolfson," signed, "I love you. Nat."

Amid the chaos, a young woman's diary was found. As I rode up in the mahogany-paneled elevator, a doorman, Hector, mentioned to me "some girl's diary from the '30s." We made a detour to the basement, where it was stashed in his locker, and he gave it to me wrapped in a plastic Zabar's grocery bag. Back in my apartment, I sat down on my bed. "Mile Stones Five Year Diary" was written in gold letters across the book's worn cover. Holding my breath, I released the brass latch. Despite the rusted keyhole, the diary was unlocked. Little pieces of red leather sprinkled onto my white comforter.

"This book belongs to . . . *Florence Wolfson.*"

Inside, a blue vine grew around the frontispiece, stamped with a zodiac wheel. The diary seemed to respond to being back in warm hands, its pages becoming unstuck and fanning out. I flipped through the faded entries dense with girlish cursive. I could tell it had been cherished. I located the date Florence began writing: August 11, 1929. I had kept journals, but never like this. Not a single day was skipped in the diary's five years from 1929 to 1934. The book was fragile, but remarkably sturdy, considering it was three quarters of a century old. On the cover, where the leather had grown brittle, yellowed newspaper stock listings showed through from its lining.

Its nearly two thousand entries painted a portrait of a teen-ager obsessed with her appearance and the meaning of her

existence. Meeting friends for tea at Schrafft's. Nightclubbing at El Morocco. Dancing at the Hotel Pennsylvania, the New Yorker Hotel, and the Savoy Ballroom.

January 16, 1930. *I bought a pair of patent leather opera pumps with real high heels!* April 8, 1930. *Bought myself a little straw hat $3.45—it won't last long.* April 20, 1931. *Dyed my eyebrows & eyelashes and I've absolutely ruined my face.* March 13, 1934. *A fashion show for amusement and almost overcome with envy—not for the clothes, but the tall, slim loveliness of the models.*

Observations about frivolous matters were interspersed with heartfelt reflections about the books she loved—Balzac and Flaubert were particular favorites. August 3, 1932. *Spent all day reading something of Jane Austen's—how refreshing—how novel—has her breed died out?* March 12, 1934. *Slept long hours, read "The Divine Comedy" and for the most part too exhausted to think or even understand.* Four months later, *Reading "Hedda Gabler" for the tenth time.*

Music, a recurring theme, scored her life with exclamation points. Beethoven symphonies! Bach fugues! June 28, 1932. *Have stuffed myself with Mozart and Beethoven—I feel like a ripe apricot—I'm dizzy with the exotic.* February 6, 1934. *Hours repairing torn music books and they look perfectly hideous with adhesive plastered all over them—But what beauty within! My love is so sporadic.*

The young woman who emerged from the diary's pages had huge ambitions, even if chasing them proved daunting. February 21, 1931. *Went to the Museum of Modern Art and almost passed out from sheer jealousy—I can't even paint an apple yet—it's heartbreaking!* January 16, 1932. *I couldn't study today & went to the museum to pass a morning of agonizing beauty—Blown*

glass, jade and exquisite embroideries. April 10, 1932. *Wrote all day—and my story is still incomplete.* September 2, 1934. *Planning a play on Wordsworth—possibilities are infinite.* October 12, 1934. *How I love to inflict pain on my characters!*

What she craved most was to be enveloped in a grand passion that would transform her life. July 3, 1932. *Five hours of tennis and glorious happiness—all I want is someone to love—I feel incomplete.*

Although written at a time when sex was a subject discussed discreetly, the diary was studded with intimate details of relationships with both men and women. April 11, 1932. *Slept with Pearl tonight—it was beautiful. There is nothing so gratifying as physical intimacy with one you like.* April 19, 1933. *Dear God, I'm sick of this mess! What am I—man or woman? Both? Is it possible—it's all become so hard, so loathsome—the forced decision—the pain.*

The diary's "Memoranda" section included pages for "Birthdays and Anniversaries" and "Christmas Cards Sent." The "Index of Important Events" was only "to be used to schedule outstanding occurrences." It revealed the roller coaster that was Florence's emotional life.

Fire in old house, February 14, 1927
My first dance, December 30, 1929
My first cigarette, January 12, 1930
My first high heels, January 16, 1930
Spotted Eva LeG, May 8, 1930
Fell in love with her, May 8, 1930
My first evening dress, May 20, 1930
Manny came to New York, July 19, 1930

Spoke to Eva again—and was refused, November 14, 1930

My first love affair, November 11, 1930

George came back, June 29, 1931

Absolute End of George, July 1931

Slept with Pearl, April 11, 1932

End of Manny, April 23, 1932

Won $40 for a short story, June 8, 1932

Reconciliation with Manny, August 26, 1932

Dismissed Pearl, September 7, 1932

Marjorie, September 1932

Evelyn's Death, March 31, 1934

Suddenly, I realized that in one of the trunks, I had salvaged an inscribed photograph of Eva Le Gallienne, who I later learned was a famous avant-garde actress and the founder of the Civic Repertory Theater on Fourteenth Street. Le Gallienne, openly lesbian, had played Alice in Wonderland, Peter Pan, and Hedda Gabler. It certainly seemed the actress had made more than a cameo in Florence's life. Who was George? Evelyn? Pearl?

My bedroom filled with an orange glow from the streetlamp outside my second-story windows. Florence had probably lived in this building. Maybe she had written at a desk and slept not far from where I was right now. Was the flapper dress I had found Florence's? I gave it a twirl until pearls from its frail fringe started hailing onto the floor. The straps of the black satin bathing costume designed for an hourglass figure crisscrossed my back like X-marks-the-spot. My gaze fell on the Bergdorf's coat in a pile under the painting of the sleeping teenage girl. I wrapped myself in its sumptuous folds, admiring its smart cut

The diary included pages for the "Index of Important Events," which was only "to be used to schedule outstanding occurrences." It revealed the roller coaster that was Florence's emotional life. (Photo: Lars Klove for the *New York Times*.)

and luxurious warmth. I had never worn such elegant clothes. Had Florence? Buried under its layers of paint, 98 Riverside Drive seemed to be coming back to life.

As I slipped under the covers, a newspaper clipping fell out from between two stuck pages. In it was Florence's picture. She looked like a 1920s starlet. Except for her waved hair, she appeared completely contemporary. Her eyes were sensual and intelligent. I followed Florence late into the night, savoring each of her well thought out words and quicksilver observations. Florence's writing possessed the literary equivalent of perfect pitch. Her handwriting was looping, soaring, sometimes scribbled, dreamily, across the page in blue and black ink.

I couldn't help but read it as if it were a personal letter to

A clipping found in the diary reads, "Florence Wolfson, of 1391 Madison Ave., who was graduated from Wadleigh H.S. at 15, is the recipient of a state scholarship."

me. Florence and I shared many of the same longings for love and the desire to carve out our own paths. Her entries confessing loneliness spoke to my insecurities about being single and on my own in New York. We were both writers and painters. We both felt the need to create lasting beauty out of our daily

experience. Florence seemed so alive, intensely internal and fully engaged in the world around her.

The diary's golden "Mile Stones" title crumbled to "Stones." It was obvious it hadn't been touched for a very long time, probably not since Florence penned her last entry on August 10, 1934, the eve of her nineteenth birthday. I thought of the White Rabbit lost among the trunks. How had Florence become separated from her diary? Could she possibly still be alive? Who were all of these men and women whose hearts Florence had chipped, if not broken? Who was Florence? Her eyes would not let me go.

For three years, as I walked around New York, wondering about her, Florence remained unknown to me. Nights when I couldn't sleep, I closed my eyes, picturing the mountain of trunks. I wished I could have gone through every single one. It seemed like a dream, except for the red leather diary in a soft Chanel shoe bag in the drawer of my bedside table. I was drawn into Florence's world. I wanted to recapture her New York. I set out to find the diarist, the words "This book belongs to . . . *Florence Wolfson*" my only clue.

At the paper, I worked my way up, hitting the streets and writing stories. Searching out remnants of Florence's time was the beat I carved out for myself during my free time. One afternoon at work, in March 2006, I received a chance call from a lawyer, Charles Eric Gordon, who specializes in tracking down missing persons. I shared the diary with him.

After a few weeks of investigation, we struck gold. Searching

the city's birth records, Mr. Gordon discovered only one New Yorker named Florence Wolfson, who was born in New York City on August 11, 1915, to a pair of Russian immigrants who had come to the city in the early twentieth century. Following a trail of voter registration records and using his collection of old phone books, he led me to Florence Howitt, with homes in Westport, Connecticut, and Pompano Beach, Florida.

Florence was an unexpectedly glamorous ninety-year-old. In Westport, where I met her for the first time in May 2006, she and her husband, Nathan Howitt, a retired oral surgeon, one of her many admirers from the diary, lived on Long Island Sound, in a private community near the Cedar Point Yacht Club, in a gray cottage over a one-lane wooden bridge. The walls of their living room were filled with figurative and abstract paintings, among them her pastel of their daughter Valerie as a young girl.

Florence was wearing well-tailored fawn pants, red lipstick, and tinted gold and tortoise Christian Dior glasses. Clutching the diary with hands still supple enough to practice scales daily on the piano, she caressed the book's fragile cover and gently thumbed through its pages. She sat by the window and journeyed back to the girl she had once been. "*I'm 14 years old! 1929!*" she read in a husky voice. She read from the next year's entry, "*At last I've arrived! The year has left me wiser, less happy, but still I'm 15!*"

Florence seemed both shocked and delighted by the accounts of her early love affairs. "*Am quite a busy young lady*," she read an entry written when she was fifteen. "*Had a visit from George again and a lecture from Dad who walked in at the wrong moment.*" Among those taken with the brainy and beautiful

young woman was the poet Delmore Schwartz. James Atlas, in his biography of the poet, wrote of "the 'salon' of Florence Wolfson, the daughter of a wealthy doctor who allowed her to entertain friends in their large apartment."

"I started this when I was fourteen," said Florence. "My husband's ninety-five years old." As she fingered the pages of the red leather-bound book crumbling in her hands, she reflected on the creative young woman brought to life so vividly in its pages. "You've brought back my life," confessed Florence, and she began telling me her story.

Each page of the diary allowed for entries over five years. The first page of the diary, August 11, 1929, "This is my first entry in this beautiful diary 'cause today I'm fourteen years old!" *(Photo: Lars Klove for the* New York Times.*)*

THE DIARY

This is my first entry in this beautiful diary 'cause today I'm fourteen years old!

Florence made a wish and blew out all fourteen candles and one for good luck on the rosette-frosted cake. Her white summer frock with butterfly sleeves fell in light folds over her small breasts and the gentle curve of her hips. A bouquet of flowers was on the table, an easy still life. The phonograph was playing *Boléro*. Florence was mad about the piece by Ravel, which had premiered the previous year in Paris. She first heard it in a private listening booth in a store on Radio Row. She returned several times to see the adorable salesman before buying the record. The music swelled through every cell of her body.

A tall slender woman with dark bobbed hair handed Florence a present wrapped in pink tissue. She slipped off the white satin ribbon, modeling it as a necklace for the small family party. She opened the box, letting out a high-pitched sigh. "A diary!" The wrapping fell to the floor. She caressed the diary's red cover. Her fingers traced "Mile Stones Five Year Diary" in script matching the gold-edged pages. Twin keys dangled from a string looped through the latch. She brought the soft leather

to her cheek before sliding a key into the brass lock, turning it, until its tiny spring released.

Inside, a blue floral vine meandered around a zodiac circle of dancing animals—Virgo's virgin, Libra's scales of justice, Pisces' interlocking fish symbolizing infinity—revolving around the watermark of the Standard Diary Company, established 1850. Florence found the lion, her sign. She tucked away the extra key. Florence turned back and forth through the blank days, so many possibilities. The diary was the perfect place to lock away her deepest secrets, a chronicle of desire and longing. Anything could be written inside its pages, as thick as a novel, for charting a course as unpredictable as the life of its owner.

The "Mile Stones Five Year Diary," its U.S. patent number noted, was unique in allowing for five years of entries to be chronicled side-by-side on a single page. The diary's 365 pages, one for every day of the year, were marked at the top with the month and date. Passage through time could be measured at a glance. Each fleeting day would be logged on just four pale blue lines.

The Standard Diary Company's introduction advised Florence to record her "Mile Stones" within its pages. *"How often we try to remember matters of interest and importance from the past, and how frequently our memory fails! But an event recorded is one forever preserved. Let this book remember for you—that is its purpose. It may be started at any time, and is arranged for a five-year period. Note the items and events of interest from day to day. What a delight to read later the unfolding of your school and college career, your experiences in society, the development of your family year by year, your business trials and triumphs. These are truly the MILE*

STONES of your life—worthy of recording—a satisfaction to be able to relive the past and compare year-by-year progress by reading your entries—otherwise much is lost to you and yours forever."

Florence had never kept a diary before. In five years it would be 1934. She would be nineteen, practically grown up. It seemed like ages! Everything was changing. She was bursting with plans for the future. Her diary came with a poem.

What an easy thing to write
Just a few lines every night!
Tell about the fun you had,
And how sweetheart made you glad.

Write about the party gay,
In the sail-boat down the bay;
The motor-trip, that perfect dance;
The week-end at the country manse.

Courtship—then wedding time,
Honeymoon in southern clime;
Home again in circles gay,
Till "Little Stranger" came your way.

So day by day the story grows,
As on-ward your life-journey goes,
Lights and shadows—memories dear,
These are MILE STONES of your career.

Florence rushed over to Frances Boruchoff, Mother's thirty-one-year-old friend, who had picked out the red leather diary

from dozens of others made on the hand-turned presses at the Standard Diary Company's factory in Cambridge, Massachusetts. Florence thought Frances spoke beautifully and admired her refined taste. She pulled Frances by the arm to get her to dance, something impulsive and rhythmic known only to the two of them. Frances winked at her young friend.

Through the window, Florence could see the lighthouses of Far Rockaway, where the Wolfsons were vacationing. They had arrived the previous week with a flood of doctors, lawyers, and clerks, all eager to escape sweltering Manhattan for Rockaway's bungalows and palatial hotels, said to rival anything in Europe when they were built for wealthy New Yorkers in the nineteenth century. Passengers poured off the Long Island Rail Road at Arverne-by-the-Sea, Belle Harbor, and Breezy Point, towns strung like pearls along the serene peninsula in southern Queens. "Edgemere! Beach Thirty-sixth!"

Edgemere, originally called New Venice, was envisioned by its developer as the twin of the Italian city of dreams, filled with canals and gondolas—just an hour outside of New York City—although this was never fully realized. Now New Yorkers, like the Wolfsons, were content to spend their vacations in bungalows like the Hollywood Cottages and the frame houses along waterfront Florence Avenue. Luggage in tow, the small, hot party had walked the short distance from the sandy shingled station, passing hundreds of seaside cottages, to their bungalow on the beach.

Florence's birthday was on a perfect night with heat lightning and thick blue-gray clouds. The ocean rode high over the beach in frothy white-capped waves. Florence wrapped

her arms around Frances. She loved making Frances laugh. Frances threw back her auburn curls, exposing an impossibly creamy neck. Her hair tickled Florence's ear. With crazy abandon, Florence kissed the older woman on the lips.

"My God, Florence." Her mother, Rebecca Wolfson, a sturdy woman of forty-two in a floral dress, behind round gold wire-framed glasses, didn't need to utter her disapprovals out loud. She objected to almost everything about Florence. Rebecca looked at her husband, forty-five-year-old Daniel Wolfson. There was nothing she could do to control this wild spirit, whom she barely recognized as her own. Florence's parents were only staying for the weekend, since they needed to get back to their work, Father to his busy Manhattan medical practice and Mother to her successful couture dress shop, Rebecca Wolfson Gowns on Madison Avenue. During the week, the family's housekeeper stayed with Florence and her ten-year-old brother, Irving.

Florence was used to being on her own. From the time she was a little flapper of six, Mother and Dad had put her on a Pullman car at Pennsylvania Station, shipping her, all alone, to visit Aunty Frances in Boston. Under the enormous ticking clock with Roman numerals, Mother handed Florence a Crimson Chest of her favorite marshmallows bought at the candy counter at Schrafft's. Dr. Wolfson tipped the porter five dollars to keep an eye on his daughter.

Florence would hug her doll, which she had dressed up for the trip in her outgrown clothes, black patent leather Mary Janes and knee socks. As clouds rushed by her compartment, Florence stuffed as many marshmallows as she could into her

mouth. Strangers got on and off at the stops between New York and Boston. "Be brave," whispered Florence to her baby.

When she saw Frances, she hugged and kissed her, letting out her need for affection. Florence never remembered Mother or Father kissing her. Frances was the youngest daughter of a family Mother knew from her village in the old country. Mother had come to America alone at nineteen, and Frances had come as a girl. Frances lived in one of Boston's elegant town houses with her husband, Henry, an ophthalmologist. In her paneled dining room with light streaming in through the curtains, Florence played on the Steinway grand piano. Frances was so unlike Florence's parents. Mother and Father would never go back to the old country, but Frances delighted in travel. She toured Europe in 1923, bringing back wooden Dansko clogs and thousands of nearly worthless German marks, which the girls of Weimar were burning in their stoves because the currency was cheaper than firewood.

Far away from home, cocooned in Frances's warmth, Florence felt safe and most secure. It was with Frances that special things happened. On one visit, ten-year-old Florence awoke to find her sheets spotted with blood. "Aunty Frances! I'm bleeding!" In the old country, mothers slapped their daughters hard across the face when they began to menstruate. They claimed it restored circulation from blood loss, but really it was a warning against the dangers of womanhood. Frances stroked Florence's damp hair. "It's okay," Frances soothed. "You're becoming a woman." Mother had never told Florence about periods. The body was to be covered, not discussed.

Now that Florence was a teenager, she looked forward to those trips that once seemed so frightening. One year, Florence

sailed to Boston. It was an overnight trip, and she had her own cabin. Frances took her to the theater at night, and afterward they dined at a smart new restaurant with a cabaret, where they spotted famous actors and actresses. Mother and Dad never wanted to go out to dinner. They had a live-in maid to cook for them. "Why go out?" said Mother.

Florence and Frances also visited Little Nahant, a pretty beach town on a rocky peninsula jutting into Massachusetts Bay, fifteen miles north of Boston. Nahant was an Indian name meaning "point" or "almost an island." Frances's mother owned a rambling house clad in red shingles with white trim halfway up a hill, overlooking the ocean, and quite a climb from the street. The house's five bedrooms were always filled with family and visitors. Cots were placed in the hallway and in tents on the second-floor porches over the front and back decks to accommodate the overflow of friends.

Across the street lived a sculptor whose garage studio, filled with erotic nudes, Florence explored. She set up an easel on the wooden wrap-around porch facing the water and painted. Nahant's sea-foam palette and salty air reminded her of Far Rockaway. There was a lighthouse on a small whitish gray mass of rock rising out of the ocean like a whale, called Egg Rock.

Florence was also close to Frances's older sister, Ray. Aunty Frances and Aunt Ray led perfect lives. They were always entertaining. Both were wonderful cooks, and gave elegant parties. Florence met a whole new group of boys at the beach at Nahant. She threw parties as well, playing the role of hostess, the only girl surrounded by a dozen boys. She baked her first cake. It would have been easier to paint one on canvas. Aunt Ray's son, Arnold, dressed up in tails, took Florence to a

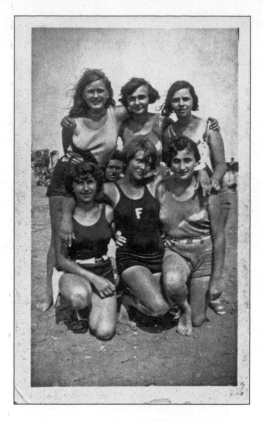

Florence in her bathing costume with the F *patch, on the beach with friends in Far Rockaway, dated July 1929, the summer she received the diary.* (Photo: Courtesy Florence Howitt.)

formal at a dance parlor called the Castle. When Florence returned home from dates, she and Frances would have girl talk. Florence had always wanted a sister, and Frances, who had two young sons, treated Florence as her own daughter.

On the night of Florence's birthday in Far Rockaway, when

the adults finally went out to the porch, she was left alone in a rare, private moment. She picked up her pen, dipped it into an inkwell and began to write.

"This book belongs to . . . *Florence Wolfson.*"

Tonight the boys mention a stag in pajamas and carried me on their shoulders on the boardwalk.

A loud crowd rushed in, singing "Happy Birthday." Moe, Sol, Henry, Sylvia, Sophie, Lola. The same group Florence had known since they were building sand castles and swimming in Jamaica Bay. She said good night to her parents and kissed Frances on the cheek. Florence's little brother, Irving, ready for bed, was desperate to come along.

The group paraded down the moonlit boardwalk under incandescent lamps that shone against the dark sea like glowing jellyfish, passing wooden saltwater tubs and bathhouses that would be swarming by morning.

The boardwalk blazed with magical cities, Cinderella Park and Rockaway Playland with its serpentine roller coaster and carousel. A few years earlier Florence would have been eager to claim her fiery pink steed. Admission to Playland was ten cents. Young men dove off the Tower of Jewels into the Olympic-sized pool. They walked past the Hall of Mirrors and Madame Miriam beckoning with her Weight Guesser. There were performing Siamese twins and midget boxers. The Caterpillar whirled around with crazy painted eyes. A butterfly spun boys and girls overhead.

Most nights, the group ended up at Seaside, the most popular stretch of boardwalk, a mile-long pleasure zone. Seaside

teemed with young people, all looking for excitement in its dance halls, vaudeville houses, arcades, and shooting galleries. There was miniature golf with spinning windmills, game stands painted with scaly sea monsters and modern mermaids with sculptured breasts and lips, hole-in-the-wall crystal ball readers, and photo booths to make memories last. Concessions sold corn on the cob, sizzling hot dogs, frozen custard, and saltwater taffy. Racy postcards of burlesque dancers were for sale next to scenes painted inside pearl shells beside Indian moccasins and Kewpie dolls. Older boys smoking cigarettes stared at Florence with crooked smiles. She could tell at a glance a local from a Manhattan boy.

We all went to Playland and had a wonderful time. Sylvia and I picked up boys this evening.

"Florence," someone called. Bernard Enver stepped into the citrine light. He was sixteen, with dark curls and an eager face above his argyle vest. Florence preferred them older. She followed Bernie to a game stand, where he paid a nickel for a bow and ten arrows, competing with the other boys trying to hit the bull's eye to win a teddy bear for their dates. He smiled at Florence, inviting her to head over to the Thunderbolt, the wood-framed roller coaster painted with the sign, "The Best Entertainment for Young and Old."

Florence and Bernie began the slow clickety-clack ascent up the creaky track. The riders lifted their arms into the summer night. There was a slight pause at the top. Florence could see all

of Playland's colorful fantasy reflected in the moonlit ocean, a vibrating purple world upside down. With a sudden lurch, the car started its descent, hurtling left and right. Florence's body was still shaking when Bernie helped her out of the car with his sweaty hand. Bernie wanted to go up again.

Since I've been here, Bernie hasn't kissed me yet. I can resist.

A bonfire signaled a beach party. Couples necked around the fire as a wisecracking kid, Moe, told about the Mohawk chief who haunted old "Reckowacky," named by the tribe of Canarsie Indians who once lived there. In Rockaway, there were decaying hotels and once opulent mansions with names like Tranquility Cottage and Solomon's Castle. When Florence was younger, she had been afraid to walk past one boarded-up Victorian, where there had been a fire. She imagined a burned corpse inside.

We explored a haunted house this evening. What thrills we had!

One of the boys broke a window with a stone. Florence climbed in, followed by Bernie. It was dark and smelled of mildew. Remembering the summer's bat alert, Florence shielded her head. The two wandered through the dilapidated mansion as if it were their own. Grasping the banister, gazing into a cracked mirror, Florence imagined what it would be like

to be the wife of a rich man. Closing her eyes, she heard boat shoes shuffling on raw floorboards. Chanting with their hands cupped over their mouths, the boys danced around her like a bunch of wild Indians.

Tonight Bernard told me he loved me better than any other girl and I said the same. It sounded like what we read in books.

On the sandy boardwalk steps, Bernie offered Florence his jacket, draping it around her with an easy sweep of his lingering arm. It was her first open mouth kiss, just a light brush of his tongue over her teeth. They sheltered together against the wind, exploring, locking and relocking lips.

Suddenly, Florence was yanked up. She turned around to face her father, Dr. Wolfson, who had her by the arm and was calling her all the names in the book. They had only been necking, not even petting, just kissing. She waited under the Bathers Office sign where lost children were found, just out of earshot of the heated words Father was firing at Bernie. Bernie was so innocent, like a Hardy boy. Florence felt worse than the time she had walked barefoot over broken glass on the beach, and when she finally reached the bungalow, scarcely able to stand, Dad poured iodine on her cuts.

Florence remembered one other night. When she was ten, she had gone with Mother to a friend's party, smoky, lots of women complaining about their husbands and children over highballs, playing cards and mah-jongg, yelling, "Pung" and

Florence in the company of a young man on the boardwalk in Rocka-way, dated July 1931. (Photo: Courtesy Florence Howitt.)

"Chow." Bored, she wandered upstairs, where the teenagers were in a circle intently playing spin the bottle. An older boy invited her in. As she sat down, the wavering Coca-Cola bottle pointed to her. The boy crawled over the Oriental carpet on his hands and knees. He had acne, and his breath smelled sour. He put his hand on her breast. She screamed, "Get your hands off me!"

On the way back to the bungalow after her night with Bernie, Florence received a terrible lecture from Father. How could she go with a boy she scarcely knew? She was educated and refined. Bernie and that crowd were vulgar. Father was

reciting the old fears. He was afraid she was going to turn into a bad girl. Florence felt chilled and sick.

⬛

Spent the p.m. with Gertie telling risqué stories. Boy was she hot!

Florence stayed around the bungalow the next day, sketching and reading. At night, her friend Gertrude came over with her mother, Mrs. Buckman, a good friend of Rebecca Wolfson's from the old country. Gertie pounced onto Florence's bed, her brown ringlets settling around her dimpled face and excitable eyes. Gertie had heard about Florence's escapades the night before while eavesdropping on their mothers' conversation. When they were little girls, Florence and Gertie played duets on the piano; now they both wrote poems. Gertie, a late bloomer, shy around boys, greatly admired her adventurous friend. Gertie was always begging for details. Oh, it felt so good when Bernie put his tongue into her mouth! Florence couldn't wait to see him again.

⬛

On the beach, Florence combed her way through the bathers, round, thin, beautiful, grotesque, like Picassos. Women wore navy, gray, and buff bathing costumes with a little belt, revealing only half their thighs, and paired with rubber caps decorated with daisies. Old Victorian ladies waded into the surf

in loose dresses instantly darkened by the sea. The American flag pulsed in the breeze. Whistles followed Florence in her red wool jersey suit with the white *F* decal. A bridge game of young mothers in terrycloth beach pajamas looked up.

Florence stood with her ankles swiveled, as if for a hidden camera. She had gained nine pounds since last year and didn't want to lose an ounce. She was born a blonde, but had started sneaking peroxide from Daddy's medicine cabinet in his office, ignoring Mother's repeated inquiries about whether her hair

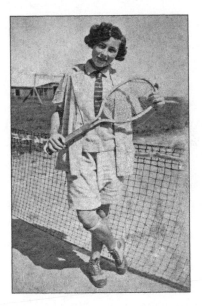

Florence's childhood friend, Gertrude Buckman, taken in Edgemere, in Far Rockaway, dated 1926. When they were little girls, Florence and Gertie played duets on the piano. As teenagers, they wrote poems. In 1938, Gertrude married the poet Delmore Schwartz. (Photo: Courtesy Florence Howitt.)

was getting lighter. "Who are you posing for?" Mother often asked.

The lifeguard, whistle in his teeth, kept a sharp eye on the bathers from his chair. Florence leaned against his boat, surveying his muscular, tanned body in an orange one-piece tank suit. She buried her toes in the wet sand. The air was hot and bright. "Florence . . ." A pale freckle-faced boy with a bare chest and skinny white legs sticking out of his bathing trunks came up beside her.

> *Bernie took a haircut and he looks terrible—I used to like him so, but now he actually repels me, and I feel so bad about it—oh, why did he do it!*

She'd kissed this boy? Bernie seemed so wet behind the ears, small, naked, pathetic. Without his adorable brown locks, he looked like a sheared dog. Florence left him on the shore, capping off the day with a sudden mad plunge into the surf.

> *How I long to get home! I'm disgusted with Rockaway and all its inhabitants—How pregnant the contrast between the boys here and home is!*

> *I said goodbye to Bernie today—what a parting it was, so sad and sweet! I told him I'd never see him again and he acted just as he should have.*

On her last day in Far Rockaway, it rained. Bernie was soaked when he came to say good-bye. Florence was dressed for her return to Manhattan in a white dress with a scalloped cape, stockings, and three-quarter length gloves. Bernie's brown eyes welled up under his blue fishing cap embroidered with his name. Florence rode the Long Island Rail Road home with her brother and the housekeeper. Her parents had already driven back to the city in Dad's shiny black Dodge with the spare nestled on the side and M.D. plates. She stared out the compartment's window, thinking to herself. Tomorrow was the first day of school. Florence had skipped three grades and was a senior in high school this year.

I went to school today and met all of my old friends. Everyone was so charming . . . but still I miss some of the boys from Rockaway. How changeable I am.

In 1929, Florence, at fourteen, was a sophisticated young Manhattanite. (Photo: Courtesy Florence Howitt.)

MODERN MERCURY

On top of every traffic light along Fifth Avenue stood a bronze statuette of the Roman god Mercury, the winged messenger in his tiny helmet, determined to find his way through the steep cliff of buildings. Like Mercury's armor, Florence's dark peach taffeta hat sat on her golden blond head at a provocative angle. Sunlight playing off limestone and marble appeared to radiate from her. She wore her new black velvet coat on which Mother had sewn a big silver fox collar, creating a fuzzy heart around her high-cheekboned face and bright mouth. Manhattan was her world. Arrogant steel towers rose to the sky. Bridges straddled the rivers throbbing with barges, tugs, and ocean liners. The streets of the Lower East Side and Chinatown were filled with pushcart peddlers. Midtown was a stream of working girls and businessmen. Florence strode along, clutching her envelope purse in her pale gray six-button kid gloves. Men and women shot her admiring glances. At fourteen, Florence looked like a grown woman.

Filled with wanderlust, she was buoyant with the glorious possibilities life had to offer. It was thrilling simply to be walking around the city. She was a loner. Artistic. Different. Florence heard the Philharmonic play at Carnegie Hall. She went to see dance and to the theater.

To the "Ballet Russe" tonight—stereotyped and unimaginative dancing—but the exquisite grace of the human form more than balanced the sterility.

To a dance recital of Star-Ron, a Hindu of such exquisite beauty and grace as to seem almost as planned as his dances—what a body! As slender as a woman's and exceedingly chaste, I am certain.

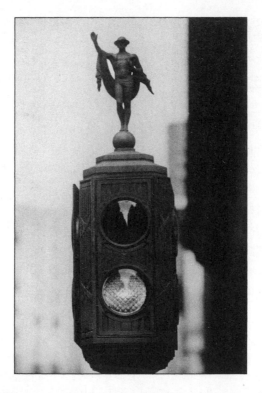

Along Fifth Avenue there were Mercury figures atop the traffic lights. The lights were designed in 1930 and removed in 1967. (Photo: New York Times.)

Times Square pulsated with incandescent messages. Chew gum. Drink beer. See the world's most beautiful girls. The Camel man blew out gigantic rings of smoke. Through his monocle, the Planter's Peanut sized her up. Coca-Cola. Lucky Strikes. A gypsy reached for her palm. A fifteen-foot cup of coffee advertised the Atlantic & Pacific Tea Co. The fur-framed face of the Eskimo Pie boy enticed with a chocolate-dipped ice cream bar. Mr. Kool, a penguin in a top hat and bow tie, rapidly blinked his icicle eyes: "Willie the Penguin says, even if you cough like crazy, Kools still taste fresh as a daisy." Down a few dingy steps into LeBlang's drugstore basement, a landmark, discounted theater tickets were sold for one dollar. The counter boy flipping burgers could pass for a cousin of Florence's favorite matinee idol, Ramon Novarro.

Saw "Mourning Becomes Electra" and took a rather mal-iced satisfaction in its gruesome tone—a dynamic play, nevertheless.

Saw "Oedipus Rex" tonight and its marvelous passion triumphed easily over inferior acting and inferior directing—and we pretend to write!

Saw "Dinner at Eight"—a great hit—written by an experienced dramatist—and it was foolish, banal and empty—very encouraging.

Saw "Berkeley Square" which was perfect. Almost the best play I've ever seen. I hope I dream about it tonight!

At the Lyceum on Forty-fifth Street, one of the oldest Broadway theaters in New York, Florence saw *Berkeley Square*. It was about a young American man, played by gorgeous blond

Leslie Howard, living in a house on the London square in 1928. Meandering by candlelight and reading old diaries, he found he could travel back in time by entering into an oil portrait. He was transported to the Enlightenment, when the house's original owners lived there. He fell in love with a beautiful young woman. Only one hundred and fifty years separated them! Every time there was time travel, the stage lights flashed and the wind howled.

Florence's city had a heartbeat. She was there, at the center of things. The sexy, steely city operated like a well-oiled machine before her eyes. The thundering El tracks created a filmstrip of sun and shadows on Third, Sixth, and Ninth Avenues. Boxy automobiles with names like Pierce-Arrow, Stutz, Packard, and Studebaker drove down the streets. One young man taking her for a ride in his new roadster dared to rev up to forty!

The streets were crowded. Men wore fedoras and women wore gray, brown, and occasionally maroon suits, with calf-length skirts cut on the bias and razor-sharp pleats, all clicking along on high heels. They seemed to be walking too fast, like actors in a jumpy old black-and-white reel. Not a strand of hair protruded from under the hard line around the faces. The world was spinning faster and faster. No one wanted to be left behind.

On Fifth Avenue, fur abounded, mink, chinchilla, Persian lamb, and leopard, each denoting the status of its wearer. The most desirable was broadtail, with a price tag into the thousands, made from the tiny stitched-together pelts of premature lambs, resembling crushed velvet, tightly curled and glossy. For women of more moderate means, there were smaller pieces on cuffs and muffs.

Florence sailed gracefully down Fifth Avenue, block by block. The Sherry Netherland was marked by a gold sidewalk clock, and next door was the Savoy Plaza. Florence danced through the ballrooms of the hotels standing along the northern section of Fifth Avenue, the city's elegant enclave catering to travelers as well as debutantes and society matrons. Across the Fountain of Abundance, graced by Pomona, goddess of fruit, where Zelda and Scott Fitzgerald splashed around one night, was the famous Plaza Hotel.

The double-decker Fifth Avenue coach was the posh ride in New York because everybody, for a dime, not the usual nickel, got a seat. The Washington Square Arch provided a convenient turnaround downtown. One conductor collected Florence's fare, and another ushered her upstairs. On the second tier, where couples rode just to neck, Florence warmed her hands in her muff, staring into the lavish apartments along Fifth, known as Millionaire's Row, home of Astors, Vanderbilts, and Whitneys. In one apartment, a French maid in a lace apron haughtily drew the tasseled drapes.

Florence window-shopped at the department stores and elegant shops—Tiffany's, Saks, Bonwit Teller, Bergdorf's, which had just replaced the grandest Fifth Avenue mansion of the Gilded Age, William Vanderbilt's French Renaissance chateau. The Goodman family resided in the penthouse on top of their store, with vistas of Manhattan's roof gardens of roses only the select few would ever enjoy.

The Fifth Avenue window displays were like the dioramas at the Museum of Natural History, where Florence had spent many rainy weekends as a girl fascinated by dinosaur bones. Instead of primitives in war paint and velvet-horned antelope

among the potted palms, there were silken Amazons sheathed in charmeuse and crêpe de chine. Florence caught a glimpse of herself in a window displaying a mannequin with hard yellow hair, rouged lips, and bands of diamonds snaking around her arms. The figure was modeling a sleek ultramodern satin gown, tight in the hips, flooding out at the hem. That fall of 1929, Paris decreed the overthrow of the flapper. Women desired a new, graceful femininity, worshipping the ample-hipped Venus silhouette with gowns glued to the figure—in chiffon, lamé, moiré—much white, much black, and a great deal of flesh pink. The hourglass was the new coveted shape.

Mother owned Rebecca Wolfson Gowns on Madison Avenue and Fifty-second Street, where she stitched up frocks for clients who paid up to one thousand dollars an outfit, an obscene amount of money. Mother's taste and skill were impeccable. Florence, with a flair for the dramatic, was outfitted in the most exquisite clothes, cut from the best silks with hand-sewn seams and hand-turned hems. All Florence had to do was sketch an outfit she had seen in a window and Mother could re-create it perfectly. Vionnet, Chanel, Lanvin.

I bought a pair of patent leather opera pumps with real high heels!

Bought two adorable dresses (Mother paid for them) and a pair of slippers ($23.50) for which I paid. No more money left!

Pushing through Bergdorf's revolving doors, inhaling the lingering scent of perfume, Florence brushed past a woman hidden in her caramel sable coat. The store was a hall of mir-

rors, a vast human beehive. Crystal chandeliers hung from lofty ceilings supported by an arcade of Corinthian columns. The main floor, lined in tidy glass cases displaying flasks of perfume, chiffon handkerchiefs, and millinery, would make a good perspective study for drawing. Florence tried on walking hats, zany caps, aviator's helmets, and formal crêpe designs decorated with feathers, jeweled aigrettes, or "tailored" flowers with silk petals. There was the straw hat that "rode into town from the country," dictated *Vogue's* fashion editors.

I bought myself the cutest little blue turban and started another story—I finished one yesterday.

A white-gloved elevator operator brought Florence up to her desired floor, Women's Lingerie and the Corset Department, filled with French confections and girdles made to fit by expert corsetieres, bearded, religious-looking men working in the department store's hidden workrooms. A saleswoman used a tape measure to fit Florence for a brassiere. She was assured she had a lovely shape. On the top floor, the Writing Room, for women patrons only, was outfitted with graceful secretaries holding engraved stationery to meet the most exacting requests of the shopper who needed to post a letter or jot down a thought. On her way out, Florence checked herself in a mirror.

A magnificent day—I still can't get over the beauty of New York—at dusk.

Everywhere she looked there was a scene ripe with artistic possibility. Around her neck dangled her new Leica camera

with a Zeiss lens from a brown leather strap. Florence snapped a photograph of a man in a Magritte hat scanning a store display, which she titled on the back, "Reflections," for a competition she entered by mail. Off Fifth Avenue, streetcars buzzed diagonally across intersections on brass rails powered by live wires. Florence reached her arm out the trolley's window to feel the breeze. Wires also transmitted phone calls, courtesy of New York City's thousands of telephone girls, easy to flatter with a joke as they plugged in the right exchange. "ATwater 9-5332" reached the Wolfsons. At the Horn & Hardart Automat, sticking a nickel in a slot opened a little glass door for a slice of pie. Silver dolphin spouts poured hot coffee.

Skyscrapers were going up everywhere. Florence took a photo of Rockefeller Center's seventy-story RCA tower, which she called "Old & New." Standing before the bronze gilded Prometheus hovering above the ice skating rink, she read Aeschylus's words engraved in art deco lettering on the granite wall behind the statue: "Prometheus, teacher in every art, brought the fire that hath proved to mortals a means to mighty ends." Pacing back and forth, Florence stalked her prey at the Central Park Zoo, taking a photo of a bored lion through the rusting bars and one of a growling black bear standing on two legs. A pair of leopards wrestled. At the seal pool, she watched two sleek sea lions applauding each other, letting out high-pitched barks. They rested together on a heart-shaped rock, a little Capri, until one dove off, alone, into the blue.

People disappeared into the subway. Underground was another world of subterranean power plants generating enough electricity to light an entire city. Below the nightly procession of elegant men and women in Peacock Alley at the Waldorf-

Astoria, a private railroad tunnel ran to the hotel from Grand Central, where hotel guests who could afford their own private Pullmans arrived in royal style.

Deep under the buildings and busy streets of New York, and the subway's labyrinthine tunnels and decoratively tiled IRT and BMT stations, lay the geologic foundation that made the famed skyline possible. Manhattan schist, the silvery bedrock of the island, formed 450 million years ago in the earth's molten core, an extremely strong and durable rock, poked out of Central Park in outcrops perfect for picnics. New York was rich in surprises. The largest garnet in the country was mined in Herald Square. A laborer, excavating a sewer on a hot August day in 1885, found the red stone, which now rested in the Museum of Natural History.

Bought several books today and feel quite proud of my tiny library. Alice and her adventures in Wonderland are included—and why not! There's so much to do—music, art, books, people—can one absorb it all?

Florence escaped into the rare booksellers on Fifty-ninth Street off Lexington and along lower Fourth Avenue. She searched the musty stacks of the cluttered shops, losing herself within the pages of leather-bound books filled with sinuous art nouveau illustrations. She ran her hands over the thick hand-laid paper, feeling the texture between her fingers. Each page had weight. She noted poetic-sounding details, like the names of printers, Manhattan's Rarity Press and the Three Sirens Press. Florence had a passion for books. When she saw the book she was seeking, she would recognize it, as if the volume had belonged to her in a previous life.

She glimpsed Flaubert's *Salammbô* and Oscar Wilde's *Salomé*

illustrated by the Victorian artist Aubrey Beardsley. *Franken-stein; or, The Modern Prometheus*, written by Mary Wollstone-craft Shelley when she was nineteen, was illustrated by Lynd Ward's haunting woodcuts of desolate, snowy mountain ranges. There was a new book on Byron. *Painted Veils*, a portrait of New York's art world. Florence was keeping up with each latest installment of Galsworthy's *Forsyte Saga*.

Finished "Dorian Gray" and think it is the most insidious book I've ever read—but fascinating! And just a little mad.

A young bookseller in a three-piece tweed suit looked up from his reading, setting down his page cutter. What an in-teresting face, Florence thought. She felt he understood she was on a quest. He led her to the book *Against the Grain*, the ultimate example of decadent literature, and possibly an inspi-ration for Wilde's *Picture of Dorian Gray*, about the hedonist whose oil portrait grows old instead of him.

Downtown again and bought an exquisitely bound book— Huysmans' "Against the Grain."

"This edition privately printed for the Three Sirens Press is limited to 1500 copies, of which this copy is No. 330," Florence read. It gave her a powerful feeling to hold something so rare in her hands. In one illustration, a daring female acrobat soared high above her audience. *Against the Grain* was the fictional confession of another hedonist, the French aesthete Des Es-seintes, who was assembling a treasury of exotic delights. He had a live tortoise inlaid with precious gems and a collection

of perfumed liqueurs, each corresponding to an instrument in an orchestra, on which a symphony of the taste buds could be played. He took his mistresses in a pink mirrored bedroom where the constant chirp of a cicada in a cage reminded him of his mother.

The book was nothing like the popular book *Serena Blandish; or, The Difficulty of Getting Married* by A Lady of Quality, which Florence had read.

"Serena Blandish" a stupefying untrue book from an unmarried girl who wasn't a virgin.

The cover of *Serena Blandish* pictured a group of young women praying to a gold wedding ring in the sky. It opened to an etching titled "The Suicide," of one of the girls diving off a bridge.

She paged through the Roman poet Ovid's *Art of Love*, written for men around the year 1 B.C., easing herself into the art of seduction. Ovid dealt with winning women's hearts. She left the shop with a few books in brown paper tied with string.

Started Ovid's "Ars Amatoria" and have become absolutely mad for a beautiful body. To see and feel is all I demand.

—

Went to the Museum of Modern Art and almost passed out from sheer jealousy. I can't even paint an apple yet—it's heartbreaking!

The Museum of Modern Art opened in 1929. It occupied six rooms on the twelfth floor of the Heckscher Building on

the corner of Fifth and Fifty-seventh Street. Florence saw her first Matisse show there and it is where she discovered Picasso. The white-walled galleries were hung with Legers, Modiglianis, Hoppers, Bentons. There were primitive masks, furniture by Le Corbusier, and Brancusi's sculptures. Florence watched Calder's black puddle shapes orbit each other on wires. They would never touch. It was almost sad. In front of a small canvas of apples by Cézanne she felt the stirrings of her desire to be an artist.

An artist began to draw me and then asked me to go out with him. I said "no!" Saw "Greta Garbo"—she was wonderful.

Florence browsed the drawings of a sidewalk artist, the fruit of winters spent in drafty lofts. The young bohemian picked up his Conté crayon and began outlining her lips and intense gaze. She walked by posters for *The Trespasser* starring Gloria Swanson, and Greta Garbo in *The Kiss* outside the Great White Way's movie palaces, the Rialto, the Capitol, the Astor, and the Strand. She wondered what it would feel like to be famous. The Paramount was topped by a globe balancing above Times Square.

"The Cathedral of the Motion Picture" glowed in a galaxy of bulbs on the Roxy's marquee on Fiftieth Street and Seventh Avenue, the largest dream palace in the world. "Seating in all parts of the house," bellowed a young usher in a tight red bolero with gold *R* buttons, armed with a flashlight and a vial of smelling salts. "Take the grand stairway to your left." Vendors hawked matinee idol dolls and waved souvenir programs, advertising the smoking pleasure of Chesterfields on the back.

A languid Venus sleepily flirted with her entourage of cupids above her pedestal, engraved "Le Sommeil."

The Roxy was draped in acres of red velvet that the theater's famous founder S. L. "Roxy" Rothafel called "dream cloth." Mirrored corridors led to smoking lounges appointed with divans suggesting the glamorous, easy life of the rich. At six p.m. patrons watched the ushers' changing-of-the-guard ceremony as if they were at Windsor Castle. No major theater was without its infirmary. The Roxy's hospital had rows of beds and a staff of nurses and surgeons ready to perform an operation or deliver a baby during intermission.

On either side of Florence were tiers of box seats adorned

"The Cathedral of the Motion Picture" from a sketch by the architect, Walter W. Ahlschlager. The Roxy opened in 1927, playing a silent film starring Gloria Swanson, The Love of Sunya, *about a young woman at life's crossroads who is granted mystic visions in a crystal ball.*

with vine-entangled goddesses displaying the movie temple's *R*. Clutching her ticket, she made her way down the center aisle of the 6,200-seat Spanish Renaissance auditorium. The air was scented with coats damp from the rain and a whiff of perfume. The shimmer of marcasite earrings and the embers of lit cigarettes glinted in the dark. The packed theater was a cross between an opera house and a public bath. In the balcony, couples fed each other tufts of cotton candy. Boys wore colorful college scarves over their shoulders like medieval banners. The Roxy's 10,000-pound organ was ready to crank out the overarching emotions of silent pictures, releasing the appropriate buttons, "Love (Mother)," "Love (Romantic)," and "Love (Passion)." Draped on a seat in front of Florence, a little fox stole seemed to stare out from its glass eyes.

Florence could see half a dozen shows for fifty cents, and any number of live opening acts that came before the main attraction. There was "Poet of the Piano" Carmen Cavallaro, violin virtuoso Fritz Kreisler, the Harmonicats, the Refined Swiss Bell Ringers, Japanese tumblers, dog acts, and acrobats. She might hear the overture from *Faust* or see *The Dance of the Hours* ballet. There were cartoons—Betty Boop in a strapless dress scolding her little dog Bimbo, Mickey Mouse in his little shorts, Dick Tracy and Little Orphan Annie. Newsreels set to piano music explored modern-day miracles and the wonders of the ancient world, taking Florence along on excavations of the Pyramids, arctic expeditions, and underwater explorations.

The Roxy's red velvet curtain rose and fell between performances. Before her eyes, the chorus line of near-naked Roxy-ettes, alternating blondes and brunettes, kicked in unison. The girls rotated like a kaleidoscope, blossoming into the petals

of a giant Busby Berkeley–like flower. Legs rippling together in satiny sequence like synchronized swimmers, daughters of Neptune, New York mermaids, the girls created a wheel, breaking into a human wave. The audience was awed by the clocklike precision of the dancers.

The tireless Roxyettes donned Roman helmets and showed off their profiles, shiny as freshly minted coins. In a sparkling background change, their pointed legs formed the New York skyline. Men whistled like crazy. A couple danced the Lindy Hop in the aisle. The dancers fit themselves back together like the pieces of a puzzle. Chimes announced the start of the show. After the third bell, the house went black. The curtain went up.

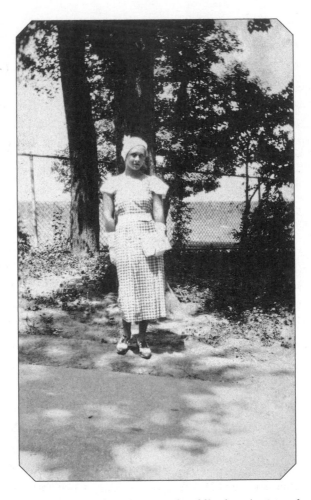

Florence in a beret, gloves, and saddle shoes in Central Park, at sixteen. (Photo: Courtesy Florence Howitt.)

A PORTRAIT OF THE ARTIST AS A YOUNG WOMAN

Had an amusing day writing my novel. You didn't know I was writing one did you—but what adolescent is an adolescent without a novel?

New York City and time rushed by in a ghostly blur of yellow cabs and people going about their business. Commuters streamed under huge clocks at Grand Central and Pennsylvania Station. Skyscrapers soared, looking at once medieval and eerily futuristic. The lush green rectangle of Central Park divided Manhattan into East and West, North and South. Florence lived in the city's most desirable neighborhood, the Upper East Side. The Wolfsons' large apartment was on the corner of Madison Avenue and Ninety-sixth Street, the absolute outer limit of acceptability.

In her bedroom strewn with dresses, Florence compared herself to Greta Garbo, "the Sphinx," looking into the oval mirror above her dark wooden dresser. She took her time choosing what to wear for a date, changing her mind, turning to examine her profile. She sat at Mother's vanity table, which had a center mirror and two side mirrors that opened and closed like wings. She flipped them around to see herself from all angles, always

searching, performing for herself. She tried on expressions of glamour and seduction. Trying to become complete and true to herself was not easy. Her diary was ready on her bedside table.

Living in New York City made her grow up fast. The Chrysler Building and the Empire State were in a race to reach the clouds, and so was Florence, who spontaneously expressed her innermost thoughts on each pale blue line of her book. Her diary was just that—her book. Sometimes she would lie on her twin bed. Other times she felt like sitting at her desk, an antique writing table with hidden drawers and a secret compartment, which held the diary's key. She decorated her bedroom with fashionable hunter green bedspreads from Bloomingdale's and hung matching plaid curtains on her two windows overlooking imposing Madison Avenue.

All day long with the Victorians—how to absorb the essentials, or the facts, necessary for an exam—When there is so much else—so much.

Her desk was covered with piles of homework, movie stubs, playbills, and the morning's crossword puzzle, all evidence of a life outside of school. "Lie on your back, arms stretched out at shoulder level, with two books of equal weight, one in each hand": Florence followed the exercises in a magazine to keep her waistline trim, stretching her svelte five-foot-three frame out on her bedroom's Persian rug. In the corner was her armchair. When it wasn't piled high with silk stockings with blackened toes and crumpled balls of half-finished poems and stories, she loved to curl up on the upholstered silk for an orgy

of reading, *Alice in Wonderland* or *Against the Grain*. The magazine directed, "Slowly lift the books until they meet; then slowly lower them to the sides again. Relax and repeat." Her once beloved doll was flung to the other side of the room as if dead.

How my heart's wagging! I have no right to complain——Four boys called last night and there were many moments when I would have preferred solitude——but. I made three or four appointments for next week. I'm so glad that I have somewhere to go and with someone.

The Wolfsons' telephone, a heavy black Bakelite French model, had recently replaced the old candlestick kind with the receiver hanging from a hook. It was always ringing, its loud, clear bell announcing new admirers for Florence. There was a constant stream of invitations over the phone and by mail to tea dances and parties. Her father, who had his office in their apartment, answered calls at night in case it was a patient, but usually it was for that "boy crazy girl." She ran down the hall from her bedroom to pick up in the living room.

Went to the Expo today and had more fun! A man asked me if my husband was in the show! I almost dropped.

The living room was also home to the radio Florence had convinced her parents to buy. She had chosen it at the Radio

World Fair at Madison Square Garden, where she had gone with a friend from her high school. Salesmen explained that radios were not allowed to be demonstrated in the Exposition Hall because of the pandemonium that might be raised by so many sets playing at once, but each manufacturer had a suite of rooms in an adjoining hotel. Every floor of the hotel was packed with people and radios going from morning until night, three or four sets in a room. Sellers announced that static was on the decline and that fall 1929 was going to be the best listening season ever. Florence settled on an attractive art deco design with a golden grill, which stood on feet, capable of reproducing the rich tones of the Philharmonic, which her family could now listen to in their slippers and robes.

Bought a sketchpad and drew all afternoon. Marvelous!
I bought water colors and dabbled with them all evening—
I could live on painting. I adore it!
Bought pastels today and got all colored up with them.
Took pictures, read, wrote a great deal, and finally jumped into bed. I don't mind—where I cried last year, I laugh now.
I fixed over two hats and they're simply beautiful. I think I'll make my own hats hereafter.

Day turned into night and another day. Florence dyed her old hats, adding trim from Mother's store to enliven their look. Under the warm glow of her bedside reading lamp was a polished plaster statuette. The Greek ideal of beauty had found her way into the Wolfson home. The nude was a classical reproduction, made to look like marble with hard, perfect molded breasts. Ready with her Leica, Florence arranged a photograph.

She positioned the figure on the surface of Mother's octagonal perfume mirror, as if the goddess were gazing into a reflecting pool. Florence draped one of Mother's embroidered floral silks around her vignette, adding her own string of pearls and a pair of white kid gloves. The final touch was her portrait, taken with her family every year at Epstein's Photography Studio on Park Avenue.

After a really absorbing day at school I "created" for hours!

Bought oil paints and several additions to my water color supply. My attempt to paint Irving, however, was highly unsuccessful.

Cut out pictures, painted pictures, saw pictures, pasted pictures—Is this actually I? My capacity for work.

Read until my eyes ached—it was hardly important—but proof again that there is always an escape.

Florence was constantly sketching. Seated at Mother's vanity, she found a fresh page in her sketchpad and opened her tin of pencils. She began outlining the round curve of her cheek with a pencil labeled "honey beige." She shaded her eyes, smudging them into a smoky look. She worked for hours, studying the contours and planes of her face, memorizing her eyes, bringing herself to life on paper. Keeping the diary was like drawing a self-portrait. There were nights when she would awake in the middle of a dream, reach for her pen and diary, and write.

Went to Art School this morning, shopping this afternoon, theater this evening, in fact, a perfect day.

In the fall of 1929, Florence enrolled in a life drawing class at the Art Students League on West Fifty-seventh Street between Seventh Avenue and Broadway, modeled on the atelier system of nineteenth-century Paris. There she drew for a few hours several days a week after school and on Saturday mornings. Once it was raining, and great silver drops pounded the skylight of the chilly studio. Canvases leaned against the walls. The gray eyes of a reclining nude stared out at Florence from one painting. Still-life studies were set up on cloth-draped wooden crates. There was a vase of white flowers, a golf ball, and a skull. Florence set up her easel and broke off a piece of charcoal.

Drawing from life is much easier now—thank heavens! I could draw forever!

She had loved drawing since she was a child, but now she was learning all over again to "see," "follow a line," and "create a rhythm." It was like music or dance. She studied the drawings of Leonardo da Vinci, his sepia sketch of a woman's hands and his design for a flying machine. The way she saw things was changing, not only on the page.

With a tap of his cane, the instructor directed the model to begin. The young redhead wore no makeup except for Egyptian kohl around her eyes. She dropped her kimono to the dusty floor.

God!—but that girl's got the most exquisitely white arms &
legs I've ever seen.

Her startling whiteness reminded Florence of her good
friend Caryl, in her high school, whose coarse but attractive
features Florence had sketched before. Florence associated
Caryl, whose twin brothers had been killed in a fire before she
was born, with tragedy.

A rainy, rainy day. Found a new technique in charcoal and
am trembling now in the balance—so far it has been superbly
successful.

The studio was silent except for the gentle scratching of
pencils and the rubbing of erasers. The teacher timed each
of the model's poses with his pocket watch, starting with one
minute. The class worked up to longer studies of five, ten, fif-
teen, and twenty minutes, which was challenging. The model
switched poses with direction from the teacher. She alternated
the leg she placed her weight on. No one looked into the girl's
eyes. She stretched her arms behind her head with the cane the
teacher positioned. She bent over, using the stick for support.
She curled up into a contorted ball, an excellent study of loneli-
ness.

The other students were older than Florence, serious about
their art, but seemed defeated by life. They were weighed down
by unhappy marriages and boring office jobs. A few drank.
A thin man in his thirties with creases in his forehead looked
lovesick. Florence was impressed by their ability but knew,
as they must have, that they would never achieve greatness.

When time was up, the model, the Greek ideal of beauty herself, began speaking in a shrill voice as she fished in the pockets of her kimono for a pack of cigarettes.

Florence's sketchbook filled with charcoal nudes of men and women, young and old. She found poignant beauty in an old woman's skin, which looked like crinkled brown paper. When Florence returned home from her classes, her parents would not discuss or ask about her art. Mother felt drawing was a childish activity Florence should have outgrown by now. Their response made her feel as if her drawings were a guilty secret she had to hide. Florence wondered whether her art would ever be recognized.

<center>▭</center>

Mother gave an informal dinner party and yours truly blossomed out like a flower—It's about time!

Several nights a month, Mother had company over, her clients, regulars who were outfitted at Rebecca Wolfson Gowns. These were very rich women, society types like Mrs. May, married to the real estate magnate William B. May. Even their brassieres were custom-made by Edith Lances. They bought their fancy hats piled with fake fruit or a little bird from Mother's friend Hattie Carnegie. They lived in luxurious penthouses and duplexes on Park Avenue and Central Park West.

The Wolfsons' spacious apartment on Madison Avenue was still a world away from the art deco elegance in which these women spent their days, lounging in white-fox-trimmed dressing gowns, contemplating the color of their fingernails and planning

Florence loved to draw since childhood. As a teenager, she drew many self-portraits, like this one in pencil. (Sketch: Courtesy Florence Howitt.)

soirées straight out of George S. Kaufman and Edna Ferber's play *Dinner at Eight*. The women had their eyebrows electrically removed and then redrawn with the sweep of a pencil at Helena Rubinstein's Fifth Avenue salon. They kept masseuses, beauticians, and plastic surgeons busy.

Rebecca Wolfson idolized her rich clients. She envied their pampered lifestyles and longed to be one of them. She was respected for her creativity as couturier, as well as for her status as the wife of a physician. But Mother knew that the honored doctor wasn't the earner. She was the breadwinner.

Mother had company this evening and they all raved about my drawings! How I love to draw, I'm going to be an artist!

One evening, the women asked to see Florence's drawings. Setting down their teacups, they invited her to spread out her pictures in the living room. These powdered faces went to auctions and collected modern art. They practically had a bidding war over Florence's simple pencil sketch of a young woman with her hair swept up in a bun. Alone in her bedroom, Florence had worked for hours setting just the right mood, skillfully smudging her lines to bring out light and shadows. The drawing was a beautifully rendered, revealing self-portrait.

"Florence will be an artist," the women agreed. Florence could picture her future, painting in a studio in Greenwich Village. No husband, no children. Just living for her art. Only Mother didn't say a word. Her expression was the same as when Florence went with her to the garment district and picked out a bolt of velvet for an evening dress in one of the shops. After rubbing it admiringly between her fingers, Mother decided it was overindulgent.

Played piano for Mother this evening & enjoyed myself enormously.

Bought Chopin's preludes and tried some of the simplest. Like a tremor of clean air & the silver sheen of fresh water. I love them.

Played Chopin's waltz in A-minor and cried—it's so beautiful!

One of the few intimate moments Mother and Florence shared was listening to music in the large, dimly lit living room. Mozart, Beethoven, Brahms, were trusted names. Mother had designed the brocade drapes dressing the tall windows, making sure to match the room's mother-of-pearl-inlaid armoire, which she posed Florence in front of to take her photograph before formal dances. The black Steinway baby grand was a gift from Frances, who had shipped it all the way from Boston. When it was uncrated, Florence had examined its felt hammers and steel strings. She had always loved to play it on visits. She had started lessons when she was six and attended performances regularly.

I went to a concert this afternoon at Carnegie Hall with a girl from school—we heard an orchestra in which women played!

Mother attended every opening night of the Metropolitan Opera. She felt it was too expensive to subscribe, and would join a line that stretched from the opera house on Broadway around Thirty-ninth Street. She waited for hours to see sellout premieres, sipping steaming coffee in the cold, ready to snap up her two-dollar ticket for standing room.

Trolley cars clanged in the background as old society members in ermine and top hats stepped out of their polished limousines at the "carriage entrance." Like a celebrity columnist, Rebecca scrutinized the titled dignitaries and their wives in tiaras sweeping into the Met's crystal-chandeliered lobby. The moneyed names of debutantes sitting with their escorts in the Diamond Horseshoe were always printed, along with their box numbers, in the next day's *New York Times*.

Shifting from one foot to the other, Rebecca stood for an evening of music, which transported her to a faraway place. Even after her business became successful, she kept on waiting in line. The *Times* ran a story about the Met's perennial stand-ees, students and elderly tuxedoed gentlemen who had been queueing in the cold since the days of Caruso. Rebecca's picture was published. At intermission, she would dash to the lobby to rest on one of the satin settees before the lights flashed.

Am going to take piano lessons in a famous institute of music connected to a Damrosch.

When Florence turned fourteen, Mother announced she was going to send her to the Institute of Musical Art, founded by Dr. Frank Damrosch, the godson of Franz Liszt. The school rivaled the European conservatories and would later become part of Juilliard. A few days later, Mother changed her mind. Florence would be taking lessons from a Russian pianist that a friend had recommended.

Took my first piano lesson from my new teacher—thought it was ever so interesting and I'm sure I will love it.

Mr. Berdichevsky started coming over to the Wolfsons' once a week. "You're very gifted," he said in his thick accent, keeping a close eye on his pupil's fingering and her legs sensitively working the pedal during the legato.

Florence posing in a gown and a velvet coat with a fox-fur collar made for her by her mother, a couturier who owned Rebecca Wolfson Gowns on Madison Avenue. (Photo: Courtesy Florence Howitt.)

Played much piano—it is strenuous when one really concentrates & such intense study is really new to me, but I love it.

Tomorrow's the concert and I'm scared stiff. I know I'll forget half the music or sneeze or do something equally rash—woe is me!

I wore a new evening dress and looked stunning and I played well—It was fun too, I can't wait for next year.

Rustles of Spring was the first concert piece Florence performed. She wore a beautiful form-fitting silver gown. Watching her onstage, Mr. Berdichcvsky lavishly complimented her parents. In immigrant families, it was not uncommon for

young women to become concert pianists. Mother knew girls whose parents had taken them out of school to train for hours every day.

An extremely unpleasant scene with Mother over my piano—I vow, as soon as I make money, I'll pay her for the lessons & the piano.

Florence moved on to Bach and Beethoven. Mr. Berdichevsky sat next to her on the piano bench, turning the pages of her music books, which she repaired when they grew worn from so much playing. His clammy fingers guided hers over the ivories. She followed his every direction. When he asked for more pedal, she responded, and when he told her to speed up, adjusting the metronome, she kept up with the harder tempo.

"You have beautiful legs." Florence was shocked. She didn't want to stop playing for fear of leading him on. Mr. Berdichevsky continued turning the pages while his other hand vanished beneath the keyboard, exploring under her skirt, strumming over her stockings. "What the hell do you think you're doing?" The lesson ended early. When Mother came home from work, Florence confided, "He made a crack about my legs."

Mother told Father. They set up a meeting with Mr. Berdichevsky, who denied everything. Father was embarrassed by the row Florence had caused. He apologized profusely to Mr. Berdichevsky and wrote him a check, arranging for the next lesson. When Florence found out, she buried her face in her pillow and let her tears flow. She thought of Frances. Her intentions were so good, giving her the diary and sending the Steinway.

I felt perfectly miserable today. Everything went wrong, everyone was so mean, I felt like flying away.

Mother eventually hired a new music teacher. She also traded the piano Frances had given them for one handpicked by the new instructor at Steinway Hall on Fifty-seventh Street, showcasing Steinway & Sons' "Instruments of the Immortals" in the two-story rotunda with a hand-painted ceiling across the street from Carnegie Hall. Florence first heard Beethoven's *Waldstein* Sonata and complicated Bach fugues on this grand, which she played on for years.

Music—music—until I become limp with awe —there is nothing so great, nothing so human and deep!

The Remington Portable No. 3, known as "The Ideal Personal Writing Machine," was introduced in 1928 by the Remington Typewriter Company. According to the manufacturer's ad, it came in dozens of colors. It sold for $60 and was marketed to students and women.

THE LAVENDER REMINGTON

Am going to get my typewriter because I write poetry, and I need one.

Florence became serious about her writing. She ordered a Remington Portable No. 3, "The Ideal Personal Writing Machine," two-tone lavender and purple, a sleek eleven pounds eight ounces. The model had circular white keys and French accents. She had an argument with her parents over whether the typewriter was necessary. She won and snuck a glass of red wine, kept in the pantry for company, to toast her victory.

In the Wolfsons' dining room, Florence sat at the head of the massive, polished mahogany table, part of an elaborately carved set. Her elbows rested on the cool black marble surface next to her copy of *Hedda Gabler*. She made a pact with herself to read all of Ibsen's plays. Florence started to write a short story. It was different from writing in her diary. As she worked on her Remington, many new feelings surfaced. Already her story overwhelmed her. She longed to capture what she felt. She recorded, *I began to write my story.*

I never quite realized what a tragedy my parents' lives are.

Florence viewed the dining room as the set of her family's tragedy. It held all sorts of painful associations. When she was in grammar school, the family had a menacing dog named Prince who didn't get along with either of the children. When they arrived home, Prince welcomed them at the front door by going straight for their ankles. Florence and Irving raced to the dining room and jumped onto the table to escape Prince's teeth.

Dinners were always difficult. Photographs of stern bearded relatives from the old country were on display around the room. Their cold, judgmental eyes seemed to demand, "Why weren't we invited?"

"Money, money, money," was all Florence heard pass between her parents. Florence and Irving called them "Mommy" and "Daddy" until Florence decided "Mother" and "Dad" were more dignified. Once, when the whole family took a trip to Little Nahant to visit Frances, Irving kept a tally of how many days his parents spent bickering. Their fighting took up the entire vacation.

Mother was a strong, competent woman who got things done and built a highly successful business, but she emotionally castrated her husband for his charitable nature.

"Oh, I have to work. It's a terrible thing your father can't make enough money," Rebecca bitterly complained to Florence and Irving, in front of Daniel. "Why do I have to work while everyone else stays at home?"

Mother had brought up the children to regard her work as a disgrace and something they should hide from their friends. Rebecca's refrain poisoned dinners, causing family quarrels. They later recognized it as an unusual accomplishment.

In the middle of one of their Jamaican housekeeper Eglin's

famous chicken dinners, Dr. Wolfson would throw down his fork and cry out, "Is this kosher?"

Mother would shoot him her icy glare. They all knew Eglin never set foot in the kosher butcher shop. Father tried unsuccessfully to hold on to ancient beliefs. Mother had little patience for any authority higher than her own. The frightened children followed Mother's example and kept eating. Eventually, Daniel put his napkin back in his lap and finished the food on his plate.

Dad's mood at home was dark. Florence sensed that her father, with his heavy eyes behind tortoiseshell glasses, was not a happy man. Daniel Wolfson was generous to his patients, many were old-country acquaintances from when he first started his practice. He treated those who couldn't pay for next to nothing, one or two dollars a visit.

One night, the telephone rang at three in the morning. On the line was the father of a poor family whose child was seriously ill. Daniel got dressed and collected his black medical bag. He roused his chauffeur, the husband of Eglin's sister, who drove him up to the Bronx. Dr. Wolfson didn't charge the family and left them money to buy medicine.

When he called the next day to see how the child was, the father informed him, "We used the money to get a real doctor." They figured only a quack wouldn't charge. Daniel hated discussing money, instilling in Florence the belief that it was something dirty. This put him at odds with his wife, who wanted wealth for the status she believed it would bring.

Between patients, Dad sat at his desk with his head in his hands. Florence often found him like this, or poring over religious texts, when she came to call him for dinner. It made her feel nervous. She tried to cheer him up, but couldn't reach him. She used to beg to play doctor in there and to listen to her heart with his stethoscope.

When she was ten, she began sneaking into Dad's office while he was out on house calls. Opening the glass-paned doors, she stepped softly out of habit. Since she was little, Florence had been told to be quiet during office hours. She was met by the smell of the alcohol and ammonia used to disinfect his instruments. The world had opened to her when she discovered his leather-bound medical books, disclosing the secrets of human anatomy and sex. There was *Gray's Anatomy* and shelves of others stamped with the symbol of modern medicine, the serpent-entwined staff of Asklepios, god of healing.

No one had told Florence about sex. She searched the pink and purple diagrams for clues to the mystery. The elaborate plate of the vagina made it look like a small theater. The clitoris was described as containing a universe of nerve endings. She found the Bible thrilling reading for the same reason. "And he went onto her"—Florence tried to visualize it—"And Abraham went in onto her." She was enamored of a passage from the Song of Songs, "Thy thighs are like jewels, the work of the hands of an artist."

Wrote ten more pages this evening and have made up my mind positively to complete that story. It's essential—for my own happiness.

Finally, she was alone. While her family slept, Florence kept writing on her purple machine. She changed ribbons. Her fingers became stained with ink. She cranked in flimsy typing paper. Cups of coffee trembled in cold puddles on their saucers. She was hot and bleary-eyed, but her fingers rapidly found their keys. When she felt inspired, writing was like playing the piano.

The museum all day—then Molière & again those damned études—it irritates me to practice them, but I cannot stop— what provoking technique—so tricky.
Burned oil tonight over that story and after working over the 6000 words at least 10 times—I am ready to hand it in.

As she slaved over her Remington, Florence's short story, which she titled "Three Thousand Dollars," was coming. The words were beginning to flow. Her story would be published in *Echo*, the Hunter College literary journal. It was about an idealistic man, Adam Gregg, modeled on her father, who closed his small grocery store early one beautiful spring day to take a walk in Central Park.

Mother objects to the theme—but I enjoy it.
I cannot feel discouraged—and willingly labor for beauty.

In her story, she wrote, "In the park he stopped to gaze with rapture at the cherry trees. They had begun to bloom and were already a fine, warm pink shot through and through with creamy white. Year after year Adam came to gaze at the cherry blossoms. And year after year he experienced the same peculiar twinge, the sudden mental weakness and longing to cry because their beauty was something he knew so little.

"Then a squirrel raced across his path. He tried to follow it and found himself near a small embankment. He detected two or three squirrels hiding behind the shrubs and he was delighted as a boy with his discovery. Down on his knees he went, to beguile the little animals to approach him, but they were timid and no amount of whistling could force them to come near. As he leaned forward . . . he sensed at once that it was an article peculiarly out of place and he reached for it . . . and found himself in possession of a small leather wallet.

"As impulsively as he fed the squirrels, he now opened the wallet. Its contents staggered him. Searching within for a name and address, he thought people should be more careful with three thousand dollars and not carry such extravagant sums through the park. That was his only reaction. That and a mild wonder, for the sum was remarkable to behold, strange and astonishing as the most exotic treasure. . . . He found a bankbook in the wallet and a card bearing a name and address. Without a moment's hesitation he turned and left the park."

Florence imagined what she might do if she found three thousand dollars. She would sail around the world.

Her character, Adam, had no trouble discovering the rightful owner of the wallet, who lived on Fifth Avenue. After he returned it, he was elated. Adam had never been so satisfied

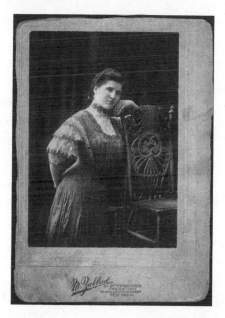

Florence's mother, Rebecca Wolfson, not long after she arrived alone at nineteen in New York, taken at St. Petersburger Photo Studio at 64 Essex Street, on the Lower East Side. Rebecca, born in 1886, a talented dressmaker, most likely made her lace bodice. Her pose shows a gold band on her ring finger. (Photo: Courtesy Florence Howitt.)

with the world and his own capacity for good. It was only later, when his wife found out, that there was hell to pay. Anna never ceased berating him for his stupidity and weakness. Even his teenage daughter, Alice, and his son, Fred, joined in.

Florence worked on her story all night. She felt if she could write, she could live. Before bed, her wrists aching from typing, Florence still managed to write in her diary.

Worked hours on my story and have almost completed it. It seems good—I am certain that it is the best I have done, although that is little enough, but I have progressed!

Perhaps I am wrong—I have only to feel—and I can write—Reading something I did about a character I knew well encouraged me.

If she was to do it, really write, she would have to delve deeper into herself. Her parents rarely spoke to her about the lives they left behind in the old country. When they did discuss it, it was usually in Yiddish, which they spoke when they didn't want Florence to understand what they were saying.

Florence pictured her mother aboard a tramp ship in 1906, nineteen-year-old redheaded Rebecca Loewenbach, with a black silk ribbon tied around her neck, looking toward the land of golden promise, dreams, and wealth. She was a very appealing young woman, bright and vivacious, not a helpless creature. She would have made a wonderful model for the figurehead of a ship.

Rebecca wanted to prove the naysayers wrong. In America, she planned on becoming rich. She had left her family of redheads, her poor rabbi father and overworked mother. Florence imagined the black looks and taunts from some of the villagers, calling a young woman going alone to America foolish, lusty, prideful. Only bad would come of it.

Perhaps most difficult for Rebecca was parting from her identical twin sister. They were two peasant girls from Lithuania, near Vilna. Florence had seen the portrait Rebecca had brought with her to America of her twin, taken in a photographer's studio. In it, her sister wore a wide-brimmed black hat

with two tall dark feathers like strange antennae. Florence was intrigued by this woman who looked so much like her mother. She wished she could have known her. Mother's twin wore a handmade cape in the shape of a lily pad. Her hands were stuffed into a bristly fur muff the size of a drum. She had on a black choker, tight around the neck, cut from the same spool as Rebecca's.

Any competition between the twins ended when Rebecca left. Rebecca had won. Her sister stayed behind. Probably the family was too poor to send both daughters at once. After Rebecca left, her family was killed in a pogrom. Florence was named after a relative from the old country. Mother's sister? She was never told.

Daniel Wolfson, a clean-shaven young man of twenty-two with a barrel chest, came to America around the same year. He and his nineteen-year-old brother, Nathan, left their family of prominent rabbis in the Ukraine. It was rumored that Nathan had been involved in revolutionary activity, perhaps with Daniel, who was sent to America to "watch over" his younger brother. Arriving at Ellis Island, they joined the seemingly endless lines of people, old women, crying babies, and girls with long braids wearing colorfully embroidered dresses.

Uniformed officials peered into the immigrants' eyes. Their cold instruments inspected ears and throats and listened suspiciously to lungs. The stories of the weak ones being sent back must have made an impression on Daniel, who had said his final good-bye to his rabbi father, Wolf Wolfson.

Daniel was well educated and spoke Hebrew as well as Yiddish, but no English. It was strange for Florence to think of the first time her father uttered his name in this alien land.

"Wolfson." The official at a wooden podium entered his name into a ledger, finishing with a stamp. Daniel and his brother were finally permitted into America.

They went to the railroad station with their trunks and boarded a train for Cincinnati, where they had relatives who were kind enough to help. There were other cousins in Saskatchewan and a big-time lawyer in Baltimore, later counsel to the Gershwin family. In Cincinnati, Daniel worked odd jobs while going to night school to learn English and then on to medical school. His brother stayed in Cincinnati and became a butcher. Eventually, Daniel moved to New York.

In a pantomime in Florence's mind, Rebecca entered a dressmaking shop under a canvas awning, where a woman was sticking pins into a muslin-draped mannequin. Florence never knew where her mother worked before she started her own business. Most likely she was a seamstress on the Lower East Side, New York's bustling immigrant neighborhood, with a pushcart market lining Orchard Street.

The owner asked the young woman what she wanted. Rebecca spoke only Yiddish. She explained her skill with a needle and thread, turning up the hem of her dark silk dress, a heavy, constricting Victorian pattern, which she had been wearing for weeks, but beautifully made, showing her eye for fine detail. At some point in her life, Florence remembered being told, Mother had to "cross a river to go to work."

Florence only saw Mother wearing her own designs. She probably was married in one. The new Dr. Daniel Wolfson was at her side. The rabbi performed the marriage ceremony under a chuppah, and simple gold bands were exchanged. Toasts were made over a banquet set on a special tablecloth. How had her

parents met? There were matchmakers then. Florence never knew for certain.

Dr. and Mrs. Wolfson moved into a furnished apartment in the Bronx, a name evoking greenhorns, immigrant cooking odors, screaming children, and distant relatives all piled together in drab buildings. The laundry hung between the fire escapes, undergarments like so many national flags. Rebecca's determined expression said it all. Just the beginning of the hard climb up Manhattan's rocky face.

A formal portrait of Irving, Daniel, Florence, and Rebecca Wolfson taken on the family's yearly sitting at Epstein's Photography Studio on Park Avenue, dated 1927. Florence and Rebecca wore clothes designed by Mother at her business, Rebecca Wolfson Gowns on Madison Avenue. (Photo: Courtesy Florence Howitt.)

CHAPTER 6

THE AMERICAN DREAM

Florence was born on August 11, 1915, at Montefiore Hospital in the Bronx. That year's most popular names for girls included Alice, Lillian, Evelyn, Rose, Frances, and Florence. In 1919 there was a baby boy, Irving. The family moved to quiet 113th Street between Fifth and Madison, just north of Central Park. Their brownstone housed Dr. Wolfson's office. Their car was the only one on the block. Harlem had become fashionable with flappers during the Jazz Age, but it was still an immigrant neighborhood, and had not fully emerged as an African-American enclave. In the nineteenth century, New York, with its expanses of brownstones, was known as the Mahogany City, and many areas like theirs were still chocolate-colored.

Irving pedaled his yellow toy automobile around the block, racing by the connected brownstones like cutout houses. When it snowed, the children went sledding down the front steps. Florence wore the wine-colored winter coat Mother had made her with rabbit trim and a matching hat. Edith Wharton, in her essay "A Little Girl's New York," described how these "little brownstone houses, all with Dutch 'stoops' . . . and all not more than three stories high, marched Parkward in an orderly procession, like a young ladies' boarding school taking its daily exercise."

Irving's earliest memory was of being bathed in a sink by his mother, as a little girl, sucking her thumb, looked on. Leaning in the doorframe was Florence, four years old, her silvery pageboy fitting her face like a medieval cap. Their mother, now thirty-three, had put on weight and lost most of the youthful red in her hair. She was busy starting her business, which she ran out of the top floor of their house. There, following Mother's patterns and sketches, young women pumped away at the lacy ironwork treadles of Singer sewing machines with their shapely legs. Baskets held needles and thread, thimbles and pincushion dolls.

Florence loved the old trunks filled with fragile laces, feathers, and funny old-fashioned clothes. She spent hours playing dress-up in front of the mirror that reflected Mother's rich clients modeling their new wardrobes. Florence wanted to learn how to sew, but Mother said she would rather kill herself than let that happen. During a game of hide-and-go-seek, Florence climbed into a trunk. She shut the top, withdrawing into her imagination. Careful not to let it lock, she listened to her breath, waiting for her seeker to find her.

Florence's wonderland was the backyard. Her oasis of green was shaded by a leafy ailanthus, a Chinese tree of heaven, known in New York as the backyard tree. It was hung with a swing and a hammock. Morning glories grew on the high fence separating the Wolfsons' yard from their neighbors. In her ruffled white dress with the big bow on her backside, which served no useful purpose as far as she could tell, Florence

The diarist as a child, standing beside her little brother, Irving. Their mother stood behind him, next to Frances Boruchoff, a family friend who gave Florence the diary. (Photo: Courtesy Florence Howitt.)

expertly scaled the wooden fence with a little vertical running motion in her black button boots. She was Alice, wondering what was on the other side of the looking glass.

Over the fence lived a big immigrant family with a daughter Florence's age. One afternoon, the little girls met face-to-face. Both named Florence, they became best friends, traveling from one side of the fence to the other to play with their dolls. Their favorites were the little ones with articulated arms and legs sold at the five-and-dime. They had a collection of rhymes, from which they would choose one to recite. "Ladybug, ladybug, fly away home, your house is on fire and your children are home!"

At dusk, on a bench in Central Park, Florence used her skate key to tighten the toe-clamp screws of the other little Florence's metal skates. She secured her friend's brown leather ankle strap. The Florences skated alone until ten p.m.

Perhaps Florence inherited her independent streak from Rebecca. Florence was always as smart as a whip. Once a year, she was dropped off at Columbia University for "the test." She thought that every kid took it. The test came in the form of index cards with ink blots, colorful tessellations, and charts of complicated words that quizzed her memory, verbal proficiency, and spatial visualization skill. Florence was studied as if she were a little mouse, identifying patterns and finding reason in long chains of numbers. Her early musical training helped, and Florence loved puzzles. She devoured crosswords and had a natural affinity for language. Eventually, she learned that the test was only given to those who scored in the highest percentile. She was part of a Teachers College study of intellectually gifted children. Florence's IQ was 150, which meant that by the age of ten, she had the intellectual ability of a fifteen-year-old. From this time forward, she was aware of being one of the special kids.

When Florence was older, she wrote a short story titled "Eglin." On her Remington, Florence typed, "No matter where she lives, a child's landscape is peopled like every other child's, mainly with giants good and bad. The good giants are those who love her and those she fears are the bad giants. For most children the loving superhuman figures are mothers and fathers."

For Florence, the friendly giant in her life was a tall Jamaican housekeeper named Eglin (pronounced like the eggs she made Florence eat) who had come to live with the Wolfsons when Florence was four. Since her parents were always busy, Florence and Irving were left entirely in Eglin's care. Florence enjoyed blissful hours rocking on the glider in the backyard while Eglin told stories about Jamaica and its eternal summer. Sometimes a relative of Eglin's, returning from a trip home, would bring sugarcane for the children to sample. Eglin fed, bathed, and dressed the kids and made sure that they got to grammar school a couple of blocks away on time.

Jewish mothers are known for their passion for getting food into their children, and Eglin could have been an honorary member of the tribe. After school, she fed freshly baked chocolate cake to the neighborhood kids who crowded into the Wolfsons' large kitchen. Florence loved to watch Eglin hum her way around the pantry as she gathered ingredients from scattered cupboards. Rising early, Florence and Eglin listened for the hooves of the milkman's horse. Later, they greeted the iceman who came, slinging his heavy sawdust-covered block into the icebox.

Eglin did not permit Florence to leave for school until she had finished a bowl of hot oatmeal, cooked all night on the wood-burning stove, an egg, a glass of milk, and Dr. Wolfson's prescribed tablespoon of cod-liver oil. Rebellion was out of the question. Eglin sat across from Florence, and there was nothing to do but swallow. Eglin made it a little easier by appealing to Florence's vanity. "You want to be beautiful when you grow up, don't you?"

Every night Eglin put the children to sleep, tucking them into their twin beds in the room they shared on the third floor.

When there was a splinter to be removed or a scraped knee to be dabbed with burning iodine, Eglin was tender, her strong arms encircling Florence a little tighter when she knew it really hurt.

Eglin was an ardent churchgoer, very proud of being Episcopalian. Christmas was the big event of her year. Dressed as Santa Claus, Eglin filled the children's stockings with little gifts. She roused Florence and Irving at midnight to see Santa for themselves, a tall black woman in a red suit with a white surgical cotton beard muffling her jolly Jamaican laugh.

Left to her own devices by the Wolfsons, Eglin serenely ignored the fact that she worked in a Jewish household. She taught Florence the Lord's Prayer, convincing her it was the only way she could safely survive the night. "Our Father, who art in heaven, hallowed be thy name," recited Florence on her knees at bedtime. She enjoyed the routine. There was something appealingly dramatic about it that reinforced her sense of special protection. Florence was unquestioning until one night when she asked God for a small favor. "Dear God, please give me curls."

When Florence awoke the next morning, she ran to look at herself in the mirror, shaking her hair out while rubbing the sleep from her eyes. Staring back at her was yesterday's hair, the same bowl cut as her brother's. If God couldn't do something as simple as that, how powerful was he? That night, Florence felt too tired to kneel and skipped the routine. When she awoke to discover that she was alive, she was through with the Lord's Prayer.

Because of their parents' remoteness, Florence and Irving had an unusually close relationship. They would talk for hours about how their parents fought and how Mother bullied Dad. It was a fact of life. Florence and Irving were like "The Cat and Mouse in Partnership" in their Brothers Grimm fairy tales until Florence learned she could dominate her little brother. She used to say to Irving, "If you don't go and get what I want, I'm going to beat you up. I'm not going to speak to you."

In one of the books in their library, Florence loved the poem, "Curfew Must Not Ring Tonight," written by Rose Hartwick Thorpe in 1887. It told the story of a girl whose lover was sentenced to be hanged when the curfew bell tolled, but the young maiden climbed up the tower, lunging, dangerously, to hang on to the swaying tongue of the bell until curfew passed and Cromwell took pity and let her lover live. Florence imagined herself swinging back and forth, reciting, "Curfew must not ring tonight!" That poem fired up her imagination. It had impact, drama, and emotion, all that she needed to feel.

The Wolfsons knew Eglin was unusually reliable. While they were often shadows sliding down the long hallways of their children's lives, they never suspected the intensity of the bond between the kids and Eglin. She gave Florence and Irving all the love and emotional nourishment Rebecca and David never had time for. One day, when Florence was eight and Irving was four, Eglin announced that she was leaving to go back to Jamaica. Dr. and Mrs. Wolfson took the news coolly enough, but when Florence found out, her world fell apart.

"Eglin not with us?"

That loving laugh, those warm embraces, no longer there! Florence refused to accept it. She took Irving aside, into the

Florence, age six, next to her brother, Irving. Taken at a photography studio against a painted backdrop of the sea. (Photo: Courtesy Florence Howitt.)

pantry, next to the dumbwaiter. "This can never happen," Florence told Irving. "We have to prove to her that we love her too much for her to go away."

What could they do? They had no money for gifts. They really couldn't offer to go with her, although they would have liked to.

Irving was too young to be of much help in the Eglin crisis, so it was up to Florence to find a solution. She led Irving into the kitchen. Florence placed a teacup on the kitchen table in front of Eglin and made an announcement.

"Irving and I are going to shed tears into the teacup, the tears we will always weep if you leave."

Florence and Irving took turns weeping into the cup with its matching saucer from Mother's pink floral china set. The cup filled with their tears. Eglin was so overcome by their demonstration of love that she abandoned all plans to depart.

Eglin stayed on until a fire in the house on Valentine's Day, 1927, when Florence was eleven, forced the Wolfsons to move to the Madison Avenue apartment. Before she left for Jamaica, Mother sent Florence with Eglin to see *No, No Nanette* with the hit song "Tea for Two." It was Florence's first Broadway musical. Florence never saw Eglin again, but thought of her often eighty years later.

A page from Florence's Wadleigh High School for the Performing and Visual Arts yearbook, the Owl. *The students, all female, were called "The Owlets." Florence, known as a "literary Owlet," is pictured here with the publications staff.* (Yearbook: Courtesy Florence Howitt.)

THE SNAKESKIN COAT

ire in old house, February 14, 1927, was the first item Florence noted in the diary's "Index of Important Events."
In the middle of the night, she woke up. Smelling smoke, Florence yelled to Irving as she raced down the dark hallway. The wooden floor was cold under her toes. Florence stood at the foot of her parents' bed in her nightgown, "There's smoke!" She shook the lumpy forms under the covers, waiting as they felt around for glasses, tied on robes, and shuffled groggily into slippers.

Mother and Dad hurried to their children's bedroom, at the back of the brownstone, where seven-year-old Irving was still sleeping. Instead of rousing him and calling the fire department, they lingered, wondering what had caused the fire. While they were speculating, flames continued to wind upward around the banister. They tried to reach the front of the house. They couldn't open the door. They were trapped. It was hard to get a breath. Irving started to cry. The family bunched at the window, gasping in the freezing air. It was a bitter cold February night. The backyard was covered in snow.

Flames lapped at the first two floors of the brownstone. "How are the firemen going to save us?" asked Florence. The only telephone was in her parents' bedroom. They started

yelling out of the window in the direction of their neighbors. "Help! Fire!" After what seemed like forever, they heard the eerie wail of sirens. Her parents still remembered the days when firemen arrived with the clip-clop of hooves. They saw firefighters in the adjacent yard, trying to contain the blaze. Other firemen called to the children from the neighbors' third-story window, giving Florence and Irving instructions.

Florence climbed onto the windowsill. Glimpsing the net below, she grabbed the hands of the young fireman reaching out to her. He caught her and swung her around through the neighbor's window. Below his red helmet decorated with a Maltese cross, an old crusader insignia, she could see blond stubble and his Adam's apple, and smell his sweat. In the dark garden, firemen were working the hose, spraying water into the flames. Florence saw the water turn to icicles.

She almost fainted. "My snakeskin coat!"

The first time Florence saw the coat, she fell in love with it. It had never occurred to her to even want a snakeskin coat—wet, silvery black, with a belt that fit her waist as if it were made for her. At the time, Florence, although only eleven, was a freshman in high school. Rebecca had never so perfectly anticipated her daughter's desire. The coat was a valentine, Mother's way of expressing her affection.

That night at dinner, Mother had repeatedly told Florence to take the coat upstairs. She hadn't listened, and now it was too late. It could have been saved. If she had only hung it in her bedroom closet. "The most gorgeous snakeskin coat!" cried Florence. "It burned up, it burned up." She was overcome with guilt.

Her parents were still in her bedroom, waiting to be res-

cued. They were too heavy to be swung around. Florence watched as the fire chief coaxed Mother, then Dad, down the ladder into the neighbors' yard. Florence was instructed to take deep breaths. The neighbors offered blankets, coats, and warm clothes. The Wolfsons watched their brownstone burn. Dr. Wolfson's patients' records were destroyed. Their precious immigration papers, gone.

The Wolfsons moved into the Lucerne Hotel on Seventy-ninth Street and Amsterdam Avenue, where they lived for two months while getting back on their feet. Guarded by an ominous gargoyle above its portal, the Lucerne's lavish red stone facade conveyed an air of European luxury. Florence enjoyed breakfasts in the opulent dining room.

Finally, under Mother's guidance, the Wolfsons moved to the apartment on East Ninety-sixth Street on the corner of Madison Avenue, listed in the *New York Times* as a "classic six" with three baths "near Park Avenue" for $2,800 a year, no small sum. They were inching closer to Park Avenue and the largest concentration of names in the *Social Register*, a directory of the social elite. The move from the Bronx to Harlem had been a stepping stone, but in Rebecca's eyes, both were tainted as immigrant neighborhoods. Now the family was moving to the Upper East Side, the wealthiest part of town.

The day after the fire, Mother told Florence that she could skip school, but there was no way Florence was going to pass up the opportunity to play out the drama of the fire to its full effect.

Wadleigh High School for the Performing and Visual Arts, on West 114th Street, rose before Florence like a castle capped with small flèches engraved with flying banners displaying the school's *W*. Wadleigh's 125-foot tower gave it a commanding presence. The tower's crumbling interior walls were scratched with prophecies and the names of girls bold enough to ascend its dark stairway. Scribbled dates went back to 1902, when the school opened as New York City's first public high school for girls. It was named for Lydia F. Wadleigh, a pioneer in women's higher education, who took pride in transforming immigrant girls into proper young ladies.

Powder blue moldings decorated the corridors, echoing with the shrieks and laughter of teenage girls beneath cloche hats. Students were known as "The Owlets" after the high school's mascot, the daemon of Athena, Greek goddess of wisdom. Over the years, their ranks included Anaïs Nin, Lillian Hellman, and Jean Stapleton.

Wadleigh was the first school in the city with an elevator, and Owlets were always looking to sneak a ride to avoid climbing up five flights. Eighty classrooms accommodated 2,500 students. Flanked by broad banks of windows, each room held forty wooden desks arranged in rows. Outside the laboratory, with its strong sulfurous smell, were cases filled with taxidermy. There was a human skeleton and a baby shark in formaldehyde, its pinkish yellow fin pressed against the glass jar like a cling peach in a pantry. Perched on a branch in a corner, a great horned owl watched over the rows of girls hard at their lessons.

Eleven-year-old Florence, the youngest in her freshman

class, was taken under the wings of the fifteen-, sixteen-, seven-teen-, and worldly eighteen-year-olds, who seemed as divine as the Greek priestesses on the Parthenon plaster casts monitoring the halls. Some young women seemed impossibly ethereal. In Florence's *Owl* yearbook, which she kept for years, these girls were likely to have written next to their portraits, where future plans were published, "Indefinite" or "Uncertain," and were headed for programs like Gregg Shorthand, which advertised in the yearbook. "It's a personal accomplishment of the high-est order—easy to learn and a pleasure to use. All you need is a good educational foundation and shorthand and typewriting."

Lighting each end of the hall was an elaborate stained-glass window cut from harlequin diamonds of pink, purple, and phos-phorescent green. In the west window, a barefoot girl with long hair clutched her book of milky blue. A winged female stood behind her, holding a torch to light the younger woman's way. At the east window, Minerva was illuminated in violet. Dangling from her neck was a golden key. Upstairs, Goethe stared out from candy-stained glass, next to a rose Victor Hugo.

It's great to be something bright at school and love everyone looking to me.

"Florence Wolfson for President" was plastered down the hallways, thanks to her growing popularity and Wadleigh's Poster Squad. Everyone knew Florence. She was gutsy, more courageous than most, and good-natured. She was plainspoken but intolerant of mediocrity, a natural leader. In her opinion, the world consisted mostly of fuddy-duds, frauds, and fools

posing as authorities. Florence had observed this phenomenon back in grammar school. Sick for two weeks, she missed instruction on the rigid Palmer Method, a penmanship course developed in 1888 by Andrew Palmer, introduced in *Palmer's Guide to Business Writing*. The five- and six-year-olds were taught to copy Mr. Palmer's uniform cursive using "rhythmic circular strokes." Left-handers were forced to use their right hands. When Florence returned to school, she had no choice but to invent her own unorthodox style of writing, which explained why her handwriting in the diary often resembled hieroglyphics.

Had my picture taken for the "Owl." What an ordeal! Got a telephone call inviting me to join some boy's club.

As a member of Wadleigh's Poetry Club, she was known by her classmates as a "literary Owlet." She was recognized for her quick mind and tongue, which brought her success in debates like "Resolved, That Four Years of College in Pursuit of an Undergraduate Course Is More Beneficial Than the Equivalent Four Years in Business." A student newspaper reporter summed up Florence's performance: "Miss Wolfson's convincing arguments, delivered with lightning, though effective rapidity, were instrumental in clinching the argument in the negative." Florence was also in the National Honor Society, known as Arista in New York, which required straight A's.

*Didn't go to school this morning. Cut and went at about three
for the play. It was superb and I almost burned up with envy
of Edna! Hell.*

The stage, with its blue proscenium arch crowned with a
W, was where school plays, like the classical pageant of *Dido
and Aeneas*, starring Florence's rival Edna Beck as Dido,
were performed. "From one cat to another," Edna signed
Florence's *Owl* yearbook. Virginia Redding, who played
Aeneas, wrote, "May you never outgrow your quaint naive-
ness."

*I felt so blue all day that finally Mother had to take me to the
movies. I feel so useless and superfluous.*

*How miserable I am—because I didn't usher Mother to
her seat in school this evening she called me all the names in
the book and beat me!*

*God! Mother and I were such good friends yesterday
(A.M.) and now! She slapped me this A.M. and made me so
mad, I told her I hated her.*

*Mother and I made up very prettily due to Irving—went
to the movies this afternoon and had loads of fun—to bed
12 M.N.*

Florence saw the play twice. She was jealous of Edna's
stardom and confided in Mother, who for once was com-
forting. The play, which Florence had been too busy to try
out for, was announced with a picture of Edna in the *World
Telegram*.

My first cigarette, January 12, 1930, Florence added to her diary's "Index of Important Events."

Some freshies spied Edna and Mildred smoking. Lord help them if they tattle.

Florence learned a lot at Wad, mostly from her friends, Mildred, Caryl, and pretty Muriel, down in the basement. Their teachers tended to stay away from the *Observer* newspaper office, where Florence smoked her first cigarette.

"Think of the beginning of the end of everything in one little moment in the Observer Office," stocky Mildred Teuerstein wrote in Florence's *Owl* yearbook. Mildred lit Florence's cigarette. Flo coughed. Mil laughed. Mildred had stolen the pack from her mother's purse. Florence looked at Mildred, who was watching to make sure her pal smoked down the whole stem. Florence moved to put out the cigarette. Mildred shot her the evil eye. Florence coughed it to the floor and stubbed it out with her saddle shoe.

Florence's *Owl* yearbook spoke simply and directly. The *Owl*'s editorial quoted from *The People*, a play by Susan Glaspell. "We are living now. We shall not live long. No one should tell us we shall live again. This is our little while. This is our chance."

The day after the fire, Florence came into class and announced very dramatically, "Our house burned!" The girls at their ink-stained desks stared at her. Most were first- and second-generation immigrants, Jewish, Italian, German, and Irish. Beatrice Katz, with a wide, dark face and braids, looked more like Pocahontas than the daughter of Eastern European Jews. Hefty Nordic Helen Blanchard seemed to have wandered off from a party of Alpine mountaineers. With the smile of someone who had just hidden snakes in her teacher's lunch box, she was headed for the Savage School of Physical Training after graduation. Iris Birch was African-American, birdlike, with bright, darting eyes.

There was Ada Bizzarri. Rachel Carmel. Alma Chambers. Adele Conversa. Pietrina Chiocchio. Dottie Contente. Lillian Fidler. Ruby Facey. Eleanor Lustgarten. Rose Profita. Selma Schnapp. Violet Simmerton. Lovelia Thompson. Lola Tortora. Cleo Wooldridge.

Florence let them feel the full weight of her family's loss. "Everything was destroyed!" Flooding the inner areas with natural light from the courtyard, a bank of windows between the classroom and the hall served as a theater box for passing girls. Florence was a modern actress improvising. Owlets gasped. Florence's teacher wrote a letter to Dr. and Mrs. Wolfson informing them that their daughter had an unhealthy need for attention. They did not respond. The autograph page in Florence's *Owl* yearbook read like testimony in praise of her performance.

"To an impetuous artist—Don't forget me—I'm glad you and I will get through together—Yours—Jewel."

"To a girl with real 'punch'—Love—Muriel."

"To Flo, My precious steam engine."

"Best wishes to a peach from a Pear," wrote Lillian Pear.

"To a sweet little Arista girl (But just how sweet is she?)."

"Here's to the girl who's pure and chaste; the more she's pure the less she's chased (that's blank verse—very blank)—Hell-en," wrote Helen Streifer, *Owl* editor in chief.

"Love to Flo from Flo . . . To Flo: of the charming voice that is only too still for me," wrote Florence Smart, *Owl* art editor.

"You're like Tennyson's poem 'The Brook'—Chatter, chatter, etc. etc. ad infinitum—May it go on forever—K," penned Katherine Weintraub, editor in chief of the *Observer*.

"Here comes Spring Beauty!"

"To a very puzzled child in search of the truth. May she soon find it. Heaps of Love."

Under her own picture, Florence wrote, "To myself, the nicest girl I've ever met. Lovingly, me."

My piano lesson wasn't so bad, it could have been better though—there was a terrific crash on the Stock Exchange today. Mother lost.

After the crash, Florence had an encore performance at Wadleigh.

A young German client of Mother's, Mr. Franck, who bought dresses from Rebecca for lady friends, convinced her

to get into stocks in the late 1920s. Daniel followed his wife's lead. On the day of the crash, the Wolfsons lost all of their money on Wall Street. The Depression headlines of the morning and evening editions provided steady kindling for their fights: "Stock Prices Break on Dark Prophecy," "Prices of Stocks Crash in Heavy Liquidation, Total Drop of Billions," "Stocks Break to Mob Psychology."

A bitter tragic evening at home with talk of suicide, wills, insurance from supposedly mature parents—it was horrible—terrible.

"I know what to do when things get bad," Dad said at dinner on more than one occasion. He considered suicide. There was the gas from the stove, and Florence knew he kept a brown glass bottle of morphine in his office medicine cabinet.

"My parents lost every cent they had in the stock market yesterday," Florence declaimed to her classmates.

Many girls seemed distracted, others visibly disheartened. While their daughters were at school, fathers were facing ruin. Each had a story. Florence expressed what they feared most.

"We lost everything."

Went to the rehearsal for Sunday School was given the part of Pierrot. Isn't that lovely? Decided that Ira has a crush on me.

Florence's friend Dick convinced her to try out for a play. His cousin Ira Eisenberg, a frustrated young Broadway playwright, who dreamed of being the next Eugene O'Neill, ran a theater group out of Rodeph Sholom, a Reform congregation on the West Side. Synagogue was a purely social event for Florence. The temple's Romanesque design provided the perfect stage. In the sanctuary, Dickie introduced Florence to tall, pale Ira, in a seersucker suit hanging off his lean frame. Ira immediately saw possibilities in Florence as a muse. He stumbled to make conversation, telling Florence about the script he was writing, a New York parlor drama told as a Greek tragedy. Florence took Ira's attention lightly.

He cast her as the tragicomic clown singing his sad song to the world. She worked hard to master the role, practicing Pierrot's mournful expression in front of the mirror.

Another rehearsal tonight—Ira was simply ripping and he almost made me cry. Oh lord, I wish the play were over.

During rehearsals, Ira was merciless, attacking her every effort. Maybe he had noticed something vulnerable underneath her outward confidence.

Tonight was the dress rehearsal, and we all had to use books (Applause) Heaven knows what we'll do tomorrow night!

Tonight was the play, and it was simply awful. No one knew his part and we got stuck so many times.

On the big night, Florence's face was powdered white. Fat globular black tears were painted beneath her eyes. Alone on-stage, she took her place under the papier-mâché half-moon wearing a satiny white tunic with black pompoms and buffoon-ish pantaloons. After a few hisses and boos from the audience, there was only silence. Florence stared into the darkness.

Florence admired Eva Le Gallienne and eventually came to know her. The actress gave her this headshot, which she inscribed, "The theatre should be an instrument for giving not a machinery for getting—Eva Le Gallienne." It was later found in a trunk with the diary (Photo: Don Hogan Charles/New York Times.)

EVA LE GALLIENNE

Florence turned fifteen on August 11, 1930, marking one year of keeping her diary.

I'm absolutely wild about Eva Le Gallienne and it's not hero worship. I dream about her and oh, if those dreams would ever come true—I love her, I love her—I've got to know her! When boys make love to me, especially Manny, I never cease wishing that it was she who was kissing me and embracing me. I close my eyes to make believe she's really there and I could die of joy, but when I open them—she's gone—I will know her, wait.

Eva Le Gallienne swooped over Florence in a skimpy periwinkle jerkin, appliquéd with leaves scarcely covering her bare thighs, exposing her emerald panties. The great actress soared up to the balcony. Short reddish hair stuck out at odd angles from under an elfin cap, shaped like a bluebell, framing her snow white complexion and orange mouth. A roguish dagger was stuck in her belt. In the dark audience, Florence felt a flood of warmth pouring over her. Le Gallienne was the most entrancing creature!

When Le Gallienne flew back to the stage, Florence reached for Eva's toes, pointed in pink suede sandals. The actress had

to hold her body in just the right position, pulling herself into her core, like a dancer, to avoid smashing into the side of the orchestra. Florence recoiled at the thought. The playbill, described Pan as "The Boy Who Wouldn't Grow Up," leading his band of Lost Boys who refused to be mothered. It was also pointed out that a single hidden stagehand controlled a complicated web of ropes, invisible wires, and weights to make the daring flight possible. Le Gallienne cried out, "I'm sweet, I'm sweet, oh! I'm sweet! Cock-a-doodle-do!"

Miss Le Gallienne, known as LeG, thirty years old, was the founder of the avant-garde Civic Repertory Theater on Fourteenth Street. There was no missing the Civic, a dilapidated neoclassical structure, the old home of the Théâtre Français, once the most elegant theater in New York, which had performed for the high society written about by Edith Wharton. Peeling white Corinthian columns guarded the Civic's entrance, where Le Gallienne was known as "The Abbess of Fourteenth Street." Except for her theater, Fourteenth Street was stark, lined with factories, secondhand clothing stores, and a lone Childs restaurant.

Since opening in 1926, the theater had built up a repertory of about thirty-five plays, offering ten new productions a season. A balcony seat was fifty cents, the cost of a movie ticket. Orchestra was $1.50. Le Gallienne was known for classical revivals, *Peter Pan* and *Alice in Wonderland*, also specializing in works by Ibsen, Chekhov, and Shakespeare. Florence tried not to miss a single one. She saw Le Gallienne perform as Camille, Marie Antoinette, and Anna Karenina, and as the female leads in Chekhov's *The Three Sisters*, *The Cherry Orchard*, and *The Seagull*.

Eva Le Gallienne's theater on Fourteenth Street, taken by Berenice Abbott in 1936, published in Changing New York. *(Photography collection, Miriam & Ira D. Wallach Division of Art & Photographs, The New York Public Library.)*

The *New York Times* theater critic Brooks Atkinson, a loyal fan of Le Gallienne, described the audience. There were young women in fur jackets pinned with orchids, students with paperbacks stuffed into their camel's-hair coat pockets, young men who looked like they haunted the reading room of the New York Public Library at Forty-second Street, and old downtown

spinsters. Before the curtain rose, a spark of excitement leaped from row to row.

Le Gallienne was a great actress and a commanding personality. Florence relished her as Ibsen's vivacious young Hilda Wangel in *The Master Builder*. Dressed in work clothes, Le Gallienne climbed to the top of the builder's ladder center stage and screamed, "And that's the builder!" Le Gallienne was dramatic and passionate. Florence savored her élan and boyish charm. Le Gallienne was known as a "Shadow Actress," which meant she was a lesbian. Le Gallienne lived independently of men and their arrogance, and Florence loved the idea of living with the same freedom. Florence felt she and Eva were destined to know each other.

"Eva Le Gallienne: 9:30—fencing, 10:30—letter-writing, 11 to 5:30—rehearsing." The *Time* magazine headline of November 25, 1929, summed up the actress's daily schedule. Eva's blue eyes stared at Florence from the newsstand.

Eva Le Gallienne was the daughter of the poet Richard Le Gallienne, known as the "leader of the English decadents," a member of the Oscar Wilde circle. In the 1920s, starlet Eva was poised for meteoric success. She received rave reviews for her leads in *The Swan* and *Liliom* on Broadway. In Paris, she played Joan of Arc and Pierrot, modeled on Madame Sarah Bernhardt's portrayal.

The exotic, hot-tempered Hollywood actress Alla Nazimova, famous for her film *Salomé* and playing Camille opposite Rudolph Valentino, had a reputation for taking starlets into her bed. Nazimova pursued young Eva, who lived for a time at Nazimova's Garden of Alla mansion on Sunset Boulevard with a pool

in the shape of the Black Sea. But by the time Eva reached her mid-twenties, she was through with the Great White Way. Eva told reporters that she had no desire for mere fame or fortune. Her dream was to create the first American repertory theater. Le Gallienne wanted people of all means to experience the transformative power of the theater at her "library of living plays."

Stretched out on her bed in a turquoise dressing gown, Eva responded to a reporter from the *Boston Herald* about her plans after she was done revolutionizing the American theater. "Oh just to live," said Eva. "You know, just live my life the way I want to live." Reporter Rena Gardner wrote, "She evokes another age, far removed from our restless today, a time when Leonardo lay for hours watching a tiny flower unfold, when living itself was a fine art." Florence also felt her true calling was to be an artist. She saw all the greats on Broadway—Helen Hayes, Katherine Cornell, and Lynn Fontanne. No one came close to the purity and force of Le Gallienne. As a swaggering Hamlet in a scarlet camisole embroidered with ravens, Le Gallienne seemed to be speaking to Florence when she asked: "To be, or not to be: that is the question."

I went to see "Hedda Gabler" straight from school. It was marvelous.

Florence made a habit of scanning the *New York Times* theater listings. She circled the evening's performance of Ibsen's "female Hamlet."

CIVIC REPERTORY

14th St.-6th Ave. Eves. 8:30

50¢, $1, $1.50 Mats. Thurs. & Sat., 2:30

EVA LE GALLIENNE, *Director*

Mat. Today & Tom'w Eve. "OPEN DOOR"

and "THE WOMEN HAVE THEIR WAY"

Tonite "HEDDA GABLER"

Sitting in the audience, Florence read Ibsen's description of his heroine printed in the playbill: "Hedda is about 29. She is a woman of breeding and distinction. Her complexion is pale and opaque—her eyes, steel gray, express a cold, unruffled repose. Her hair is medium-brown, not especially abundant." The play takes place in the Oslo villa of Hedda and her new husband George Tesman, a young academic, financially secure, but not brilliant. The set is their handsomely furnished drawing room with mahogany furniture and a piano, not unlike the Wolfsons' dining room, where Florence wrote on her lavender Remington.

With a puff of smoke from her cigarette, Eva made her entrance in a slippery silk gown with black pearls dangling from her ears. She looked like a cat ready to pounce. Hedda and Tesman had just returned from their honeymoon. Clearly, Hedda did not love her husband. Florence thought of her own mother's plans for her "to marry a nice man," which meant a wealthy doctor or lawyer.

On the edge of her seat, Florence winced at the reappearance of Hedda's former lover, Eilert Lövborg. Hedda had

Florence went several times to see Eva Le Gallienne star as the femme fatale in Henrik Ibsen's Hedda Gabler. *Le Gallienne's girlfriend, Josephine Hutchinson, played Thea Elvsted. Florence wrote in her diary,* "Reading 'Hedda Gabler' for the tenth time."

known Lövborg as a struggling bohemian artist and a drunk, but since Hedda's marriage, he had been reformed by another woman, Thea Elvsted, a former schoolmate of Hedda's. Thea had helped Lövborg complete his "masterpiece," a book on the future of civilization. Feeling trapped in her marriage, Hedda

seethed with jealousy. She knew she would never achieve greatness. "Bored, bored, bored," complained Hedda, rocking Lövborg's manuscript, which her husband had found in the street, to her breast.

In the next scene, Lövborg confessed to Hedda that he had lost his book in a drunken haze. Not revealing that she had it, she pressed a pistol into his hand, urging him to kill himself. Once gone, Florence watched Hedda tear into the manuscript with her black-varnished nails, ripping page after page, throwing them into the fireplace burning onstage. The flames consumed the entire book.

At the end of the play, Hedda learned of Lövborg's death. Instead of the classically tragic act she had hoped for, he died in a brothel when her pistol accidentally discharged into his bowels. "What curse is it that makes everything I do ludicrous and mean?" screamed Hedda. She exited the stage. Florence jumped at the sound of her gunshot. It was a tragic ending after all.

Saw "Romeo and Juliet" and tried to see Eva LeG again— couldn't but had a lovely conversation with Donald Cameron— "Romeo."

Florence was back at the Civic to see *Romeo and Juliet*. The gossip columnists speculated whether Eva had the feminine tenderness to play Juliet, but Florence knew Le Gallienne would bring something great to Shakespeare's teenage star-crossed lover. When the curtain dropped, Florence rose from her seat, applauding each of Le Gallienne's curtain calls. Flowers rained onto the stage and shouts of "Bravo!" rang out. That night, the Civic's rococo lobby was crawling with fledgling actresses and

actors. Florence recognized some of the Civic's stars and made her way into their inner circle. She had a conversation with Donald Cameron in his bulging tights and velour tunic. But it wasn't Romeo for whom she longed.

∎

Manny came to New York, July 19, 1930, Florence listed in her diary's "Index of Important Events." Manny Lipman had an intriguing face. He looked like a Modigliani portrait, dark, with Cubist cheekbones and Siberian eyes. He was twenty and wanted to become a writer. Florence thought him avant-garde.

Florence first met Manny and his two brothers on the beach while visiting Frances in Little Nahant. Florence was sunbathing in her red suit with the white *F* patch.

On the beach all day, under the sun—how I love it! And the semi-nudism—the physical freedom— I'm so happy!

Sensing someone watching, she lowered her shades to the shadows of three boys. They had beautiful bodies, but their bathing costumes were full of holes, as if moths had eaten through them. The Lipman brothers introduced themselves. Louis was the oldest, Manny was in the middle, and the youngest was Sidney. Florence noticed an especially big hole near Sidney's penis. The boys had grown up in Lynn, Massachusetts, just over the causeway from charming Nahant. Industrial Lynn gave the seaside a bad name.

The Lipman boys' torsos were molded from playing tennis on the cement courts by the beach.

Sidney & Manny, after a brilliant exhibition, reached the finals in the tennis tournament—their power amazed me. Sidney & Manny won—I'm so glad—they live for victory.

Lynn's oceanfront was overshadowed by the General Electric plant. The town was known as "the shoe capital of the nation." It was also home to a creamery, the maker of Marshmallow Fluff, which made the hot air smell sweet, but the boys could never escape the pervasive fumes of burned rubber from its shoe factories. "Lynn, Lynn, city of sin. You never come out the way you went in. Ask for water, they give you a gin . . . it's the darnedest city I ever been in," went the taunting rhyme. "Lynn, Lynn, city of sin. You never come out the way you went in. The girls say no and then they give in."

The boys were raised in a tenement in dire poverty. Their mother was rheumatic and spent her days in bed. Their father, Harry, a scholar, lived in the kitchen, losing himself in the Talmud while the boys subsisted on canned sardines. When the cupboards were bare, Harry would trade a case of Ginsburg Brothers Paper Products toilet paper, which he got from his wife's family business, for a kosher chicken. Florence thought that it was a miracle that all three boys made it to college on scholarships, Lou and Manny to Harvard and Sidney to Amherst.

When Manny came to New York, he brought Florence *The Magic Mountain* by Thomas Mann. He had just graduated summa cum laude from Harvard. Florence thought he was the most brilliant of the three brothers. Books and ideas

Lily Koppel

took priority over combing his hair or even wearing fresh underwear. Manny took her down to Greenwich Village, where they danced and drank beer in speakeasies in former carriage houses.

A few months earlier, Florence had mailed Manny a picture of a woman's face she had drawn. It reminded her of him. He loved it. He wrote back that no one had ever sent him anything like it. Throbbing letters followed.

Am going up to Manny's room on Wednesday and am beginning to have qualms. He was rather violent the other night.

One hot August night, Florence visited Manny in his small room on Riverside Drive, falling spontaneously into his arms. She was in heaven being close to him, just lying there, kissing and caressing him with the fan whirring. She ran her fingers over his hard, sensitive body. Opening her lips, she imagined Le Gallienne's boyish figure stretched out beside her. When Florence closed her eyes, it was Eva she was kissing. She was running her hands over Eva's sculptured face and through the actress's short, feathered red hair. The sensation made her feel powerful.

Home today and somewhat sad. Thought of Eva and Manny and my own irresponsibility and became frightened.

Wrote a passionate letter to Eva—I hope she answers.

Felt miserable so I wrote another letter to Eva—Oh, if she'd answer—what ecstasy!

Daily, Florence checked the mail, but after waiting for weeks, nothing. Florence scratched out three consecutive entries in black pen in November 1930.

Bad—bad
 Lost, lost, lost!
 My Dream

Lost to thinking of Eva again and became extremely restless. The only solution is that I meet her!
I drew a simply gorgeous picture today. The bust of a woman—I mean her face, neck and shoulders.

Florence opened her tin of pencils. She propped up the *Theatre Magazine* cover of Eva as Pan. Turning to a blank page in her sketchbook, Florence began. She worked for hours, studying the picture, creating her portrait of the actress. She thought she noticed a resemblance between Le Gallienne and herself. The intensity of their eyes, their resolve to let nothing get in the way of what they wanted.

Back at the Civic, as the audience filtered out, Florence approached an usher with her drawing.

"Give this to Miss Le Gallienne. Tell her I want to see her."

Florence waited in the lobby. After a while, the usher returned, asking her to follow. They climbed onto the stage,

Eva Le Gallienne played the lead in her theater's production of Peter Pan. *She made the cover of* Theatre Magazine *on March, 1929.* (Magazine: Billy Rose Theatre Division, The New York Public Library for the Performing Arts.)

entered the wings, and walked down a long black hall hung with exposed bulbs and ropes and weights for Pan's flight. Outside Miss Le Gallienne's door, marked with a gold plaque, a few fans dispersed. Eva's dressing room was crammed with

costumes, poorly lit, except for a frame of lights around the actress's reflection. Eva was biting on a stubby cigarette. Her vanity table was littered with jars, brushes, powder puffs, and her lucky rabbit's foot for applying rouge.

"Eva, I've wanted to meet you for so long."

Florence moved closer. Eva's dressing table was like a shrine. At the center was a framed photograph of the mystic Italian actress Eleonora Duse, Le Gallienne's idol, who had taken Eva under her wing, bestowing a special pet name on her, "chère petite Le Gallienne." Duse was second to Eva's other inspiration, La Grande Sarah. As a teenager, Eva had been infatuated with Sarah Bernhardt just as Florence was with Le Gallienne. Eva had copied, by hand, all 800 pages of Bernhardt's memoirs, *Ma Double Vie*. When Madame Bernhardt learned of this, she invited fifteen-year-old Eva backstage, marking a lifelong connection between the two.

Florence had imagined something just as life-changing for her meeting with Eva, but she was suddenly aware that she didn't have Eva to herself. Leaning against the wall by the radiator was a scantily clad strawberry blond Civic actress, Josephine Hutchinson, twenty-six years old, whom Florence had seen play Wendy Darling in *Peter Pan*. Josephine wore a peach negligee with deep insets of lace exposing her breasts and pert nipples.

Almost wept when I saw Eva—making love to Josephine.

"Jo, baby," Eva cooed. Svelte fifteen-year-old Florence looked robust next to Eva's anemic "dear." Jo meandered over to Eva, hanging her arms around Eva's neck, kissing her teasingly. Moving Eva's cairn terrier over, she sat on her leg.

Lily Koppel

Josephine Hutchinson in Eva Le Gallienne's production of Alice in Wonderland. *Eva's lover startled Florence when she met Le Galli-enne backstage.* (Photo: Billy Rose Theatre Division, The New York Public Library for the Performing Arts.)

Florence had read about Jo in the tabloids, when the young actress was smeared during her breakup with the actor nephew of Alexander Graham Bell. "Bell Divorces Actress, Eva Le Gallienne's Shadow" read the *Daily News* headline. Eva and Jo were known as the "Botticelli Twins."

Le Gallienne thanked Florence for the portrait, tossing it on her pile of scripts, cards, and dead bouquets.

"I love you!" managed Florence. Eva held the young woman's gaze before breaking into a high-pitched laugh shared with Jo. They found Florence quite amusing.

"But what can I do about it?" said Le Gallienne, smearing greasepaint off her eyelids. "My dear, you're a baby."

Le Gallienne changed the subject to the stage, the need to banish selfish desires and completely give herself to the people, to the audience.

"Do you want to be an actress?" asked Le Gallienne.

She invited Florence to join the Civic's apprentice troupe, an honor, highly competitive for professionals. Eva handed Florence a signed head shot of herself, in a jacket and tie, and bid her goodnight. There would be no romantic relationship. On the deserted subway platform on her way home, Florence read Eva's inscription. "The theatre should be an instrument for giving not a machinery for getting—Eva Le Gallienne."

> *At last I saw Eva—But all she could say was, "But what can I do about it?" I could have shot her. Saw Eva tonight and pff! went another of my visions—One by one they crumble—my youth is all I have left.*
>
> *Told the girls at school about my experience last night and they said the nastiest things about Eva. The filthy creatures!*

At school the next day, Florence's friends' reaction proved disappointing. The verdict at home was no better. That evening, Florence entered Dr. Wolfson's office. Father was sitting at his desk.

"I want to be an actress," Florence announced.

Father exploded. The mere suggestion of Florence becoming an actress caused shock waves. She was supposed to be a good daughter. Her mission in life was to get married and repay her parents for their suffering.

*Decided I want to run away if only for a few hours. I'd like
to buy a ticket for somewhere else—and ride off. Oh, damn.
I wish I were in love.*

Florence graduated from Wadleigh in June 1930. Her grad-
uation present from Aunty Frances was a black patent leather
weekend valise. As usual, Frances seemed to know exactly
what Florence needed. Florence had been making plans for
travel. She longed to escape the dullness of her home.

Florence's first choice for college was Cornell, but it was the
Depression, and her parents were watching their money. She
was accepted by the University of Wisconsin with its politi-
cally active campus in Madison, filled with young poets, artists,
Marxists, and Trotskyites, known as the Bohemia of the Middle
West. The tuition was less expensive, but her parents insisted
it was too far for a young woman to go on her own. Florence
set her sights on Barnard, Columbia University's prestigious
women's college.

*I wonder where I shall be next year at this time?
 Took an exam at Barnard despite the most devastating
cramps I experienced last night. When duty calls—!*

Florence was invited to take the entrance exam and come
back for an interview at Barnard. The fifteen-year-old strode
into the elegant parlor of Milstein Hall. Barnard was across
the street from Columbia, where, as a child, she used to take

"the test" and impress faculty members with her genius. Florence wore a tuxedo jacket paired with a black silk necktie borrowed from Irving. She was not modest. She liked to dress eccentrically, like a boy. Her hair was slicked back. The garçon look was stunning on her. If only Eva could see her now!

She told the admissions director that she wrote plays and short stories. She loved riding along the bridle paths in Central Park, saddling up at Claremont Riding Academy on West Eighty-ninth Street. She rode alone or with one of the stable hands. The rider had to be in control during cantering, but galloping was another matter. The horse took over! One time her horse got spooked by a taxi. She had taken out a young stallion. She should have noticed the flattening of his ears against his dark head. She clung to the mane as they bolted through the Ravine. A mounted policeman grabbed her reins.

"Miss Wolfson," said the woman. "Do you play any team sports?"

Florence shifted in her seat.

"No," answered Florence.

"Why?" It had never occurred to her. Her interests were more solitary. Why was this woman grilling her about team sports? Florence had to say something, so she blurted out the first thing that came to mind.

"I don't like the way the girls smell when they sweat."

The woman's face darkened. Florence watched her square jaw drop and her enormous bosom heave under its shirtwaist. Despite her graying Gibson Girl hairdo, she suddenly ap-

peared to have the ideal build for a wrestling coach. The interview was over. A few days later, a thin envelope arrived from the admissions office. Barnard had rejected her. Their reason was simply stated: "Too brilliant and individual." *Talked my way out of admission—I'll never learn discretion—never.*

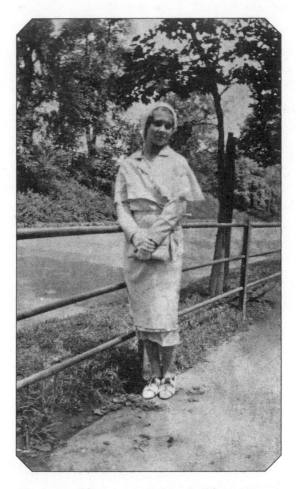

Florence at fifteen in Central Park. (Photo: Courtesy Florence Howitt.)

MY FIRST LOVE AFFAIR

Five hours of tennis and glorious happiness—all I want is someone to love—I feel incomplete.

Through the diamonds of the chain link fence, Florence watched the handsome Park Avenue boys serving on Central Park's tennis courts at Ninety-sixth Street, surrounded by Manhattan's stony jagged crown of apartment buildings. She admired the easy grace of their movements and their effortless strokes. White spheres popped and hissed across the net. New York was a playground for the well-to-do and upwardly mobile middle class, and the Central Park courts were their country club. Florence joked with her friends that she was becoming a jock. She hardly ever left the park without thinking about a new conquest. There was Howard Hairy, an artist from Indiana, sweet and terribly courteous. Refreshing. She went to art exhibitions with him, but he lacked a big apartment and invitations to dances.

I'm off again on another infatuation. This time with a boy who doesn't even know I'm living.

George Kinzler was naked from the waist up. His skin glistened like burnished copper. His raised arm caused tiny muscles

to swell along his back, catching the strongest rays of the sun. The girls called him the "Jewish Casanova." George was seventeen, two years older than Florence. He slammed the ball crosscourt. As she dashed after a fuzzy talcum-white ball, she was struck by how unfair it was that she didn't seem to exist for this trophy boy. "Keep your eye on the ball," called out an instructor.

Standing by the new tennis house, Florence mused on the term of endearment called out to establish the score. "Love." It was all very strange, like the conversations she overheard at the water fountain. It was revolting how boys discussed girls' bodies. The attitude of boys toward girls was so superior. It was discouraging not to have a boy sincerely admire her for her mind. What made it worse was that Florence usually preferred the company of boys.

Met an extremely annoying girl tonight—one who plays tennis with George—she suffers from a Narcissus complex.

Florence studied the society debs lounging by the canteen, perfectly groomed in their pleated tennis dresses and matching bandeaus, which playing would only mess up. She despised their endless chatter about hair and clothes. At least boys didn't talk about the silly things the girls did. George's old flame was here, the tall leggy blonde with thin ankles. Was she even Jewish? Some girls had all the luck, money and looks. Florence heard the nastiest things about George. He sounded like a real snob. Florence assessed her Wimbledon white skirt and socks with pompoms, as nice, if not nicer, than what the debs were wearing.

*Bought me a new tennis racquet and feel able to conquer those
so-called tennis players at the park.*

Florence was up. Crossing to her side of the net, she felt the
entire court watching her. She had to be perfect. She checked
her wooden racquet strung with genuine gut. She had been
shown a few models in the turf-green-carpeted Tennis Depart-
ment at B. Altman before settling on one at the top of the line
for fifteen dollars. She was a good tennis player, the only girl
she knew who consistently hit a ball low and straight, so that it
rarely popped up in the air. She loved to hit the ball hard.

I think I'm going to become a champion——Whoopee!
 *This morning George Kinzler walked me up to the bus.
He's rather nice——but——*

In front of her building, on East Ninety-sixth Street, with its
red-and-white-striped window awnings, was George Kinzler.
He was walking his dog. She could have kept hurrying to the
bus stop, but it would have been obvious she was avoiding
George, with his dark hair hanging like a low branch over his
eyes. She felt his stare penetrating her breasts under her angora
sweater. His cocker spaniel was pulling on its leash, eager to
jump on her.

The Kinzlers were wealthy and lived down the block in a
building later named the Gatsby. Florence was impressed by
its tall, elegant silhouette. A dark green awning reached to
the curb, where the doorman assisted men in tails and their
sequined wives in the perilous journey from marble foyer to
car and, later, from car to marble foyer. Unlike the Wolfsons,

Florence's first love, George. On December 17, 1931, Florence wrote in her diary, Today is George's birthday and he's finally attained the hoary old age of 17. Sweet and simple 17. The dear boy! (Photo: Courtesy of Peter Kinzler.)

who arrived in America with next to nothing, George's father, Kalman, was born into a wealthy New York family. George's grandfather, Moses, lived in two side-by-side Madison Avenue town houses and owned most of his Upper East Side neighborhood, Hunter Hill and the land under Mount Sinai Hospi-

tal. The Kinzler wealth was passed down from father to son. George's father had cornered the world's salt market before the Great War, until the federal government stepped in to regulate the lucrative mines. Now the Kinzlers were in the rope business, importing coils of waxy manila, twisted and braided for better pulling. Florence was sure George's family had enough rope to tie a knot around Manhattan.

George walked Florence to the bus, talking about his plans to go to Yale the following year with his best friend and tennis partner, Jules Wacht, after they graduated from exclusive Townsend Harris High School in Gramercy Park. Florence's bus lumbered to the curb. As she searched for a nickel, George demonstrated his backhand, smacking her backside by way of farewell. Florence found a seat near two Russian ladies talking under floral headscarves. If this rich boy who lived in a penthouse found her so fascinating, maybe she was okay.

When Florence came home from Wadleigh that day, her parents informed her that they were moving, again, to save money. They were not going far, just around the corner, to a building connected to theirs, on Madison Avenue and Ninety-seventh Street. Arthur Hall was the building's name. Its heavy glass doors were grated with wrought iron flowers and two golden *A*'s. The apartment was bigger, but they were no longer on Ninety-sixth Street. It was a step down, and a step away from George.

I'm at Hunter at last and I despise it. The last college I ever expected to land in—it's fate! Feel like crying buttons over it. I wish I went out of town.

In September 1930, Florence entered Hunter, the city's women's college, the largest in the world, academically rigorous, but a subway school. Many Wadleigh graduates attended Hunter because Lydia Wadleigh had been the first dean of Hunter. Instead of escaping home as she had longed, Florence was living in her bedroom among her childhood belongings.

Classes were a short walk away. A lonely, crooked tree grew outside of Hunter's fortresslike red Gothic building on Park Avenue and Sixty-eighth Street. Florence was greeted at the entrance by grotesque, scowling gargoyles, believed by medieval stonemasons to protect a building from harm. The hallways were filled with Hunterites threatening to crush Old Pat, the lame elevator man, who the students had nicknamed "Quasimodo."

To school today and I read some more. I'm resigned by now—I have no hope left. They call it a college—it's a sweat-shop!

Began to work for Mother and believe me, it's tough! I'm earning my $6 all right! Went downtown again and expect to do the same tomorrow. Travel broadens one's mind, you know.

That fall, Florence also started working for her mother, shopping for her in the garment district and delivering dresses to wealthy clients. Mother reminded her that art classes, books, and concerts all cost money.

One afternoon, Florence strode into the white marbled lobby of a ritzy Park Avenue building. She could easily see herself living there, coming home after a hard day at Hunter. She was admiring a dragon on a Ming vase when she heard

Long years of young feet scurrying to class had worn grooves in the stairs, and older generations had gazed wistfully out of these windows. The old red-brick Gothic Hunter building on Park Avenue and 68th Street was destroyed by a fire on the night of Valentine's Day 1936, the sixty-sixth anniversary of the founding of the college. (Photo: Hunter College Archives.)

the deep, Irish-inflected voice. "May I help you?" Florence gave the woman's name. "She's expecting me." The doorman shook his head, jutting his chin in the direction of the package under her arm, stamped "Rebecca Wolfson Gowns." "Service

entrance is around back," he said, picking up the white and gilt lobby phone to ring the maid. Florence felt humiliated. Later, she wrote a short story about her experience.

Florence knew girls who lived on Park and slept in frilly pink bedrooms with canopy beds. She had been going to the birthday parties of Mother's clients' children since she was little. The only difference between her parties and theirs was that the rich kids always seemed to have magicians. Once, one of these black-caped leased Houdinis, his face painted white, turned a glass of milk upside down on the birthday girl's head and made a dove fly out.

When Florence was ten, Mother enrolled her in a ballroom dance class, certain this step would ensure invitations from the right sort of crowd. Florence entered the large studio and was shown to a chair, where she waited while the other children were finishing their class. Why did she have to learn to dance? "You're going to go to balls one day," predicted the teacher. In the corner, a Victrola was droning *The Blue Danube* waltz. Florence stared down at her size-four white gloved hands clasped in her lap. "You're going to marry a very rich man," reminded Mother time and time again.

At thirteen, Florence attended her first dinner party at her friend Sylvia Livingston's Central Park West apartment. The socially ambitious Livingstons were known for throwing extravagant parties for their daughter. There was dancing to a three-piece orchestra in the living room with an Olympian view of Central Park. The formally attired young guests sat at the family's dining room table as waiters served each course. Mrs. Livingston stopped at Florence's place card. "You know how lucky you were to be on the list, don't you?"

Our friend George paid me a visit—in fact two, and I became very confidential—he loves it.

After another rough day at Hunter, George walked into the Wolfsons' new apartment. Florence was surprised. She hadn't seen him since he walked her to the bus stop a year ago. What about Yale? Grandfather Moses had taken a beating in the stock market, and so had George's father Kalman. George's mother, Rose, was forced to sell her prized diamond ring. This was hard on Mrs. Kinzler, who was from a humbler background than her husband. Rose's father was in the garment business. George's father ruled over their house like a despot. He decided George was going to City College, Hunter's brother school, "the poor man's Harvard." Its campus was a quadrangle of late English Gothic buildings cut from glittering Manhattan schist with gargoyles and dragons on St. Nicholas Park at 135th Street and Amsterdam Avenue.

George was unhappy. Why should he be forced to attend classes with the children of New York's struggling masses? It wasn't right. His tennis buddy, Jules, was having the time of his life at Yale. Florence would also have enjoyed being cloistered within ivy-covered walls—with boys.

Florence was suddenly elevated in their rich boy/poor girl game. They no longer belonged to different social worlds—not that they ever really had. Florence hastened to tell George that she was leaving Hunter in two years. She was planning on attending Smith to study social work. She was interested in helping people with their problems. George was expected

home for dinner. While Florence was getting ready for bed, George returned, all fired up. Florence gathered that dinners at the Kinzlers' were just as tense as at the Wolfsons'. George gave Florence a hungry kiss. She wrote, *Methinks he's falling fast!*

<hr />

School again and it's rotten—But George came and we passed the most delicious afternoon. He's adorably romantic and gorgeous.

Florence's days between home and Hunter were made bearable by her time with George. He was her one consolation, her first real love. It was Florence and George against the world.

George was here when I came home from school and was simply irresistible. He came back this evening and saw me to bed. I wish he could have come with me.

They clung to each other after school, spending hours together undisturbed, since Mother was at her shop and Father was busy with patients. Once, when she got locked out of her apartment, Florence and George passed the afternoon together in the hall.

I've gotten into the most delirious habit of laughing for no reason at all. It's George. When I think of him I—well, "It must be love."

Another Maupassantish evening with George—what next.

Lily Koppel

*Mother and Dad went out last night and Georgie and I were
left alone for five hours we—oh God—I'd ruin the beauty of
it by writing—it is enough to say that we LOVE.*

When the Wolfsons spent a rare night out, George and
Florence had the living room to themselves. George got on top
of her on the couch. His hand groped under her peach crêpe
blouse, trying to figure out whether she was wearing a full slip
or one of those half-ones that might prove more accessible.
Florence let him struggle with her frothy pink brassiere's tiny
silver hooks. He was mesmerized by her naked breasts. There
was a holy sort of pause before he began kissing and fondling
them, making small panting noises.

Unexpectedly, Dad came in, and they jumped apart. Flor-
ence smoothed her hair and dress. She didn't apologize. Why
should she? She was in love with George. Sometimes she had
to telephone her parents before bringing him home after a date
to ask them please not to be fighting when they walked through
the door.

*It's been "George, George, George" for the longest time and
it still is—Sorry, but I hope you're not bored.*

Florence's diary became a log of her feelings for George.
Romantic tributes to him filled the "Memoranda" section.

*November 21, 1930—I just want to say something about
George—although I guess my writing about him continually*

speaks for itself—I never thought I'd actually want to love anyone as much as I do him—I mean throw my arms about him and kiss him—I sit and think of myself in his arms and I begin to feel so glad, that I wriggle all over. No longer am I satisfied with merely seeing him and talking with him—it's either love in action—or nothing—but I don't care—It's really too exciting.

January 11, 1931—I'm just so happy—gloriously happy—more than I deserve to be—It's George—George and his arms and kisses. We spent an evening of ecstasy lying in each others' arms caressing each other. I never knew what joy could be gotten out of such love and love making. Oh, my passionate George—how I loved you tonight. Your tousled hair—your warm, moist lips. Your strong, eager arms—your dazzling white teeth—I loved you and everything about you—all I hope is that your affection for me is as deep and strong as mine for you—I'm sure it is—I believe in you.

The paints and brushes for my art course came and so did George—I'm awfully fond of him—what would I do alone!

With a mind for figures, Florence declared herself a math major at Hunter. She adored calculus, which George could relate to—not that he was good at it, but it was businesslike. With George taking up all her spare time, the closest Florence came to drawing and painting was sending away for a home study course in art, which she saw advertised in a women's magazine lying around Dad's waiting room. Florence was sent a picture to copy. Just about everyone who responded was told that they had talent. The tuition payment was expected to follow. Florence decided not to leave it up to the course's

experts to determine whether she had what it took to be a great artist.

Had an extremely pleasant day with George in the park. We read over children's fairy tales together and felt like 2 angels.

Although she tried, Florence felt that she couldn't share her artistic side with George. One afternoon, she dragged him to the park to read fairy tales under a tree. They didn't get past "Once upon a time."

Saw "Peter Pan" for the third or fourth time and Eva wouldn't see me. What has George compared to her? Oh Eva—my dear! Told George as much as I dared about Eva and that was enough.

Florence was back to the Civic to see *Pan*. She hadn't completely given up on her infatuation with Eva. An usher informed her Miss Le Gallienne wasn't receiving visitors. Florence tried telling George about Eva, but didn't get far. He was disapproving of "perverts."

It's really pitiful that I love George so much—I'm absolutely nothing in his hands.
Two beautiful letters from George this morning. And I cried like the devil—when he came, well, I just know we're really one.

Went to a frat dance with George and learned how much his mother objects to me. But I don't care—he loves me.

Florence attended a dance with George at City College, where she finally met his best friend, William Schiff. Billy, who planned on going to dental school after college, was trying to see how far he could get with Florence. Billy let it slip that George's mother objected to her. Mrs. Kinzler thought she was not good enough for her son. This explained why George never invited her to his apartment. Florence felt awful.

The following day, Florence passed Mrs. Kinzler on the street. Her cold expression made her distaste for Florence clear.

Saw Mrs. Kinzler and she favored me with a horribly unpleasant smile—my darling George—do you mind her very much?

Was up at George's house—Mrs. K didn't say a word.

Florence convinced George to have her up to his penthouse. Mrs. Kinzler sat at a desk with her back to Florence. George explained that his mother had gone deaf when she was a young woman, but her senses were acute. She claimed to hear nothing, but if her husband or a guest said something critical of her, even in another room, her hearing somehow returned. George showed Florence his tennis trophies in his bedroom.

*George came twice today and brought my letters back. He's in
a rather desperate state and I couldn't leave him.*

A silent war was declared on Florence. Her involvement
with George intensified his mother's love for her only son. Mrs.
Kinzler was determined to end the relationship.

*George's grandfather died and oh God! I thought he would
go insane. He needs comfort more than anything else and he's
come to me.*

There were obituary notices in the *New York Times*. "Please
omit flowers." "Members kindly attend."

*Today was the funeral and George called about 9 A.M. to
get courage. After it was over, he came again—I glimpsed a
bit of hell today.*

Before the funeral, George stopped by. Mrs. Kinzler was
waiting outside, her face covered by a veil dotted with black
velvet diamonds. With her was Hazel, George's nineteen-year-
old sister, attractive, even without lipstick, which her father
forbade her to wear.

*I had to do something to get his mind off his grandfather so
I told George he was a damn hypocrite. I succeeded—but I
almost lost him.*

After the funeral, George returned. Florence had hoped the worst was over, but George had a hysterical outburst. He said he could not disappoint his parents.

<div align="center">⌦</div>

I think George has been suspended from college he's in a foolish state.

City College had a reputation for excellence. The dean and the faculty were not convinced George was up to the task. His atrocious grades spoke for themselves. For the week George was suspended, he was always at the Wolfsons' when Florence returned home from school. She was hardly ever out of his sight.

Because of his father's pull George has been reinstated in college. He's learnt his lesson poor boy, and has resolved to study faithfully. He was wonderful today.

George has left home! He's found conditions so intolerable that he's finally had to leave and with the help of my $10, went to Philadelphia.

On a cold Sunday morning in March 1931, George came over, more hotheaded than ever. He was back at City College, but didn't want to be indebted to his father forever.

Mr. Kinzler's abusiveness toward his son was one thing, but George couldn't stand the way he treated his deaf wife. There was no understanding between the parents in either of their

households—nothing like the partnership Florence believed existed between her and George. Kal Kinzler was just as harsh toward his youngest child, Winifred, a skinny freckled redhead who George walked to school every morning and sometimes brought along on dates. Once Kalman cracked Winnie across the face after he learned from a downstairs neighbor that she had been pouring the vitamin-rich Walker-Gordon milk he made her drink out the dining room window. During one fight Mr. Kinzler even threw knives at George, but none found their target. George was riding the rails to Philadelphia. He would cable Florence.

George came back—although I was quite relieved to see him and certainly extremely happy, I was a little disappointed. George's splendid outburst on Sunday all for nothing! I saw him—kissed him—was happy with him—but!—what a comedown!

The day after George left for Philly, Florence glided through Hunter. If things got intolerable at home, she could leave too. Her black patent leather valise, her high school graduation present from Aunty Frances, was under her bed. Maybe she would join George—but when she returned home, she saw a lone figure leaning in a shadow against her red brick building. George had barely made it out of the train station. He certainly hadn't seen the Liberty Bell. A series of tense conversations finally culminated in one big explosion.

Something's the matter with George again. He's decided he's as good as his parents and he annoyed me so, I simply walked out on him. Oh, dear.

She added to the diary's "Memoranda."

March 21, 1931—It's the first day of spring and today finished my love affair. I really feel a little regretful, but my attitude is just this—I'm sorry it ended but I can't dig up sufficient enthusiasm to get hysterical—Adios!

Later that day.

March 21—Wrong again—George came in and looked so appealing that I couldn't refuse him—As long as he loves me, who cares?

Had quite a sweet time with George today. It's getting to be so unusual. Sometimes I wish I could find someone else.

School was almost out for the summer. There were exams, which left George out. Florence got her first taste of Hunter's "purple pride" at Sing, the college's annual spring festival held at the Metropolitan Opera, where eight hundred Hunterites gathered in cheesecloth costumes to dance around the Maypole. Each class devised a "theme," composing original songs to parody life at Hunter. The seniors won the judged contest for their representation of Hades, depicting hell's inmates as students, gigolos, members of the police squad, high public officials, and famous historical figures—Helen of Troy, Nero, Napoleon, Henry VIII and his wives, and Don Juan. Florence

related to the torture chamber, where Hunter poets were cramming for an eternal examination. Momentarily swept up in the school spirit, she realized she had neglected her artistic self all year long. She wrote, *I miss me.*

Tennis this afternoon and had two terrible contacts with George. He said "I did love you"——But I'm alright.

Florence hadn't seen George for weeks because of exams. Finally, she headed for the Central Park courts. George's game was about to start. He saw Florence but didn't acknowledge her. If there was one thing Florence hated, it was a coward.

A boy at the courts got disgustingly fresh with me and George didn't raise a finger!

"Do you love me?" she asked him between sets.
"I did love you," George said, blankly. His eyes looked beady, cruel.

His old flame was also there. She told Florence that George had been seeing another girl steadily for two weeks. Florence wrote in the "Index of Important Dates,"

Absolute End of George, July 1931.
Saw friend George at the courts and snubbed him courageously. He ignored my coldness however, and got quite close. Ugh!

Florence banished her tennis racket to the corner of her room. She set up her easel and a canvas and painted in Central Park. She went up to City College's Lewisohn Stadium, where outdoor concerts were a quarter, and heard Richard Strauss's *Don Juan*. Reminders of George seemed to be everywhere. He was impossible to avoid. She wrote,

Had two dates for today and really enjoyed myself both times. But I am unhappy—I feel so alone and disliked—and—unwanted.

Feel worse today. I thought I'd forget in a month, but the tears are still springing to my eyes and my heart hurts.

Felt so miserable today that I decided to take an extra subject in summer school—so I'd have to work. Saw George in subway—Damn him!

Saw George several times to-day—at the courts. Oh God, how I wish it were all like the first new months—I think—I love him.

Golf today with Dick; and about five boys this evening— I hate them—I despise them all—Don't you see—I want George!

Saw George coming from that new girlfriend of his—I swear—revenge—I'll avenge myself this summer.

Saw George from my window and very much against my will, responded to his efforts at conversation—I'd give anything to know his exact feelings for me.

Met George in the street this morning and incidentally one girl of the new crowd with which he is now associating—He knows what he's going after—wealth—the main point.

Snubbed George rather unconsciously at the tennis courts and am pretty glad of it—how he's tarnished—like faded bronze.

George had chosen status over love.

Had the most satisfactory time contemplating the thrills of a new lover—I'm mad for love—you see what he's done to me.

Nat Howitt was one of the eight beautiful brothers at Spring Lake, a hotel Florence visited in the Catskills. She was thirteen when she first met this dark-haired young man with chiseled features. They later married. (Photo: Courtesy Florence Howitt.)

SPRING LAKE

*To the country today and felt as never before my passion for
the trees & clean air and infinite space.*

Nat and Mac, two young studs with dark hair and chis-
eled features who reminded Florence of cowboys from
The Riders of the Purple Sage, were waiting when her
train arrived in the Catskills. Nat got out of the rusty truck
where he sat shotgun, took Florence's patent leather valise
from her gloved hand, and opened the door for the blonde in
a black beret and shadow plaid dress. Nat was quiet for most
of the ride, cracking a joke only now and then, but his brother
Mackie did not stop entertaining all the way along the bumpy
road to Parksville, in Sullivan County, to the hotel their father
owned.

Florence caused a stir at Spring Lake Hotel, a resort on a ra-
diant lake. It was as if a movie star had arrived. Conversations
stopped. For a long minute, the men at the pinochle table under
a shade tree stopped their battling. A sleeper was elbowed in
the ribs to wake up. The four women playing mah-jongg on
the verandah interrupted the clacking of their ivory and bone
bamboo and character tiles to take a look.

It was quiet, except for the courting song of crickets. The
East Wind, the banker, took the dice, muttering an incantation

in heavily Yiddish-accented Chinese, and cast them on the table, in order to bring the players' attention back to the game of dragons, jokers, flowers, and seasons.

After a summer of watching her daughter moping over George, finally, in mid-August 1931, Mother sent Florence to a mountain hotel. At Spring Lake, there were eight beautiful brothers, Greek gods. The boys watched Florence from their different vantage points—porch, tree, truck, horse. They didn't want to miss anything. One struck a match on his boot. They all had a serious demeanor, except for Mackie.

Spring Lake was a family hotel on a working farm, not one of the grand Catskills resorts. There was a main house known as the Ritz and two dining halls, one for adults and another for kids. The eight brothers were Spring Lake's main attraction. Now, this incredible girl seemed to appear out of nowhere.

The boys were muscular, all good looking, strong from working the farm. Each had been captain of the football team at the local Liberty High School. Their father, Rabbi Kuciel Hurwitz, was a biblical scholar, deeply religious, with a white beard and a twinkle in his eye. Revered by his sons, Kuciel was also respected by his guests, especially the men, who gathered around him because he was "a man of great wisdom." He was from the same village in the old country as Rebecca, which is why Florence was there and not at one of the area's better-known hotels. Florence's friend Janet Racolin, whose father owned 98 Riverside Drive, a big orange-brick apartment house on the West Side, was enjoying a stay at one of the larger hotels.

The rabbi's first wife had died. Hanging on the Ritz wall was her photograph, taken against a silken backdrop embroidered with parrots. After her death, the rabbi moved his family from

A pyramid of boys at Spring Lake, the Catskills hotel Florence visited.
Mackie second row left, and Nat bottom right. (Photo: Courtesy
Florence Howitt.)

the Bronx to Spring Lake, where his sons went to work trans-
forming the plot of land, building the houses from scratch.
The brothers told Florence stories. They walked five miles to
school through storms and blizzards when they were younger.
She heard how each brother grew into the next one's shoes. It
was like an assembly line. They shared pants and shirts, even
socks.

Florence was closest to Nat and Mac, the two middle brothers. There were also Meyer, Joseph, Benjamin, Laurence, Michael, Jerry, and two girls, Bertha and Ann. The oldest sister, Frances, had died at seventeen during the 1918 influenza pandemic. Florence had heard about it as a girl. It was deadlier than the Black Plague. Kids jumped rope to the song, "I had a little bird, its name was Enza. I opened the window, and in-flu-enza."

The rabbi's oldest son, Meyer, the only tall one, became a lawyer. He was the first to set off on his own, undergoing a total transformation. After Frances's death, he adopted his sister's name and changed his last name from Hurwitz to Howitt. Meyer Hurwitz became Francis M. Howitt. This change proved good for business. At a time when New York was still a bigoted place, no one could tell from his name that Francis Howitt was Jewish. Eventually, all of the brothers would become Howitts except for two, who worked for their father until his death.

The newly christened Francis opened up his own Catskill hotel, named South Wind after a line from Coleridge's poem "The Rime of the Ancient Mariner." South Wind was advertised as "In the Catskills but not *of* the Catskills." It became very popular with the young New York intelligentsia because it was liberal, strictly for adults, and nonkosher. Florence, wondering how the old rabbi felt about all of this, found out from the brothers that it was a bitter pill for him to swallow. He considered the bacon and shrimp cocktails served to the children of Orthodox parents a sin. South Wind was also the name Herman Wouk gave to the hotel, nicknamed "Sodom," in his novel *Marjorie Morningstar*.

Florence felt a deep sympathy for the rabbi's second wife. She had never seen such an overworked woman. She spent all her waking hours in an apron, slaving over the wood-burning stove. She would die young.

There were no maids or bellhops at Spring Lake, but it was a full-service resort. The eight brothers—seven, now that Francis was at South Wind—"serviced" the restless wives who were alone during the week with their children while their husbands worked in New York. With their men away, the women were free to take full advantage of the help, slipping the boys their keys. This was the unwritten code of a Catskill vacation. For the summer, these ordinary housewives were undomesticated.

For the brothers, this was the busiest part of their job. The older wives could be very possessive of their young lovers. They expected a lot for their eighteen dollars a week. Florence's favorites, Nat and Mac, were in high demand. Nat was twenty-one, one year older than Mac, who was known as "the more outgoing one." Mac had joie de vivre, making friends easily, especially with the mah-jongg set. "Monogamy is not in my lexicon," went one of Mac's famous lines. Another was, "Take me as I am."

Florence dominated the tennis courts at Spring Lake, and at night, young people gathered around her on the hotel's wraparound porch, by the Ping-Pong table, to have her sketch them in pencil on the back of Spring Lake's stationery. Mac refused to sit for Florence's portraits, saying, "I'm not a potted plant, I'm not going to pose for pictures." During World War II, Mac would be captured by the Japanese. He would survive the Bataan Death March and three years in a POW camp, but his harrowing ordeal would leave him psychologically scarred.

Horseback riding this morning, hunting with Nat, drawing all afternoon, dancing all evening—what more could one want?

Florence had first met Nat three years earlier, when she was thirteen and he was eighteen. Mother had sent Florence and Irving up to Spring Lake with the housekeeper to put roses in their cheeks and meat on their bones, and to give them a sense of what life was like in the old country. Florence gained a reputation as a prima donna. Spring Lake Hotel was a lower middle class resort. Two little rich kids showing up with a black maid was unheard of. It became a running joke and provided material for the amateur comedians. Spring Lake's annual skit showed Garbo-acting Florence and freckle-faced Irving being chased around like two Marx Brothers by their crazed maid, who was after them to drink their daily glass of milk, straight from Daisy's udders.

This year, Nat approached Florence as she sat in an Adirondack chair quietly sketching. He invited her to go for a ride. At Spring Lake, they rode western style. All Florence had to do was sit easy in the saddle—none of that fancy English posting. She followed Nat to the barn and watched him saddle up a working mare, shortening the stirrups for her. Florence grabbed the smooth, worn leather pommel, and Nat boosted her up. Nat was quiet but self-confident. He was more down-to-earth than any of the New York boys she knew. George's knowledge of tacking up stopped at using a shoehorn to pull

on a tasseled loafer. Nat was strong. Handsome. A natural athlete. It was thrilling to be with him.

Nat kept their horses to a brisk, ground-covering walk. It was almost fall, time for haying and spreading lime on the fields. He asked the horses for a slow, relaxed jog. The horses worked up to an easy lope. Florence and Nat didn't return to the barn until early evening. Florence recognized something of hers tacked to the wall in the barn. "My red shorts!"

The first time Nat saw Florence, she was wearing red shorts cut high at the thighs. He took her riding. Somehow, her shorts got torn during the ride. Nat had kept her shorts and hung them up in the barn like a knight displaying his lady's handkerchief. It was a victory flag. Nat smiled, not saying much, but watching for Florence's reaction. She was flattered. As she dismounted, she twisted her foot.

Sprained my ankle again today and friend Nat had to carry me home—He's become so hostile to me can't understand.

After a terrible struggle, I overcame all obstacles and reached 16—Am I happy?—and wiser? For my benefit a lovely birthday party was held this evening. Got all dressed up in a pair of Japanese pajamas and forgot myself so far as to neck with Mackie. That odor of hay—it's got me like the wine.

For Florence's sweet sixteen, she painted pink baby-doll cheeks on with rouge. She fashioned a geisha bun with a pair

of chopsticks found in the kitchen. A silk pair of Japanese pajamas completed the look. Ready, Florence stepped into the barn. Hung with red lanterns, it doubled as the dance hall. Like royal nomads, the brothers reclined against bales of hay, sharing a jug of Chianti. The phonograph played popular music, Bing and Fred Astaire—none of that old-world schmaltz. All eyes were on Florence. Mac, to whom she had always been close, monopolized her. She hardly spoke to Nat, who watched from the sidelines.

> *Either Nat suffers from one rotten inferiority complex—or else—is very egotistical (or am I wrong?)—he certainly disguises himself well!*

She could feel the tension building. So chivalrous earlier, Nat was glaring and even quieter than usual. A muscle twitched at the corner of his mouth. Amid all the excitement, Florence grew dizzy. She had experienced vertigo before and felt herself spinning out of control.

Nat and Mackie carried her outside, where they stayed up with her practically all night. Nat's hand cushioned her head. She could just make out their hushed voices. Mrs. Wolfson had arrived for the weekend.

> *Didn't dare go to Mother's room. You should hear the stories going around because last night I was—Alone with 2 boys—terrible!*
>
> *Had a long talk with Nat down by the lake tonight and learned worlds about boys—he's so shy, Nat—and I couldn't understand.*

The next evening, Florence met Nat. He looked at her with an intensity that frightened her. He promised not to get jealous. They achieved a certain peace, which lasted until the next night.

Had a delightful day with Nat and was gloriously happy until the evening came and he broke his promise to me.

Am through with Nat! He was perfect all afternoon, all evening—but then he, he was awful—oh, what is the matter with boys!

Didn't speak to Nat this morning and later he took me up to the hill and sang love songs to me and astounded me with his explanation of last night.

He had a way of persuading her with just a nod of his head that meant, "Come away with me." They sat together in the dark against a maple tree. Florence looked out over the hills, hearing the coyotes howling in the distance. Nat said there were bears too. He told her how repeated fires had burned deep into the shallow soils, forming mountaintop blueberry meadows. Nat looked up at the starry sky, pointing out the Big and Little Dippers, and the North Star, useful guides, the only works of art he would ever truly accept. He sang love songs to her. He was corny, but so sincere. He actually said she was his lady fair, his sun, moon, and star.

Nat finally kissed me! It was pretty bad, but he was so utterly delightful about it that I didn't care. He's sweet.

Had a funny afternoon with Nat and succeeded in doing a fairly decent portrait of him. Can't understand him.

After a rather hostile day Nat and I concluded by sitting in the car until two and necking. Sounds bad, but it was glorious! His kisses are positively thrilling—some improvement!

⬛

Florence sketched Nat on the porch. He looked nearly perfect with his movie star smile and slicked dark hair. There was more tension between them, but Florence rode it out.

My last day and I'm damned near tears. We rode around all afternoon—it was terrible—and the evening was one mad rush for tears—adieu.

Nat said goodbye so sweetly—I wonder if I'll ever see him again; his shyness might discourage him from visiting me in the city and I do like him loads.

It was almost September and Florence's three weeks in the country were up. Time to go home to New York. It was a sad parting. Florence would miss Spring Lake and all the boys, particularly Mac, but Nat would always be her favorite. Nat wanted to get off the farm. He had won a scholarship to Cornell, where, at five feet eight, he was the captain of the basketball team. In the fall of 1932, he headed to the University of Pennsylvania's dental school on another scholarship. He was the smartest and most ambitious of the brothers—and such a gentleman. Later, Florence would tell her friend, "Nat was like a Greek god, a god among gods."

*Experienced a rather dull, blunt feeling around my heart.
How I miss the country—and Mackie and Nat.*

*Visited Gertie at the beach and we sighed over past days
in the country and Mackie's beautiful skin.*

On her way home, Florence stopped in Edgemere, where
her old friend Gertrude Buckman's family had rented a bun-
galow. As always, Gertie wanted to hear all about Florence's
adventures; she had been up at Spring Lake the summer Flor-
ence first met Nat. Gertie had a thing for Mac.

*Visited Irving in camp today and learned that the boys are
practicing homosexuality. The kid wants to go home.*

Florence also joined her parents on a trip to see Irving at
Boy Scout camp. In his cabin fitted with rows of bunk beds, a
badly sunburned Irving swore Florence to secrecy before con-
fiding that the boys had been practicing homosexuality. When
they got back to New York, Florence and Mother went to the
movies, where Florence tested her out.

*Had a talk with Mother about perverts and received a nasty
shock. Because of her horror of them she blames them for
what they can't help!*

*Started shopping today for new autumn clothes and feel
a little happier—but oh, how I miss Nat's slow smile and
Mackie's mouth!*

Before Hunter started, Florence bought a gray cashmere
sweater set and a hat to wear at the season's new angle. She

saw *Death Takes a Holiday*—"A Comedy About Life"—at the Ethel Barrymore Theatre, in which Death, played by dashing Philip Merivale, comes up to the realm of the living. No one dies while Death is falling in love with a young woman, whom he persuades to return with him to the underworld.

> *George and I found it quite easy to laugh—He said "Can't we be friends?" Is it worth it?*

Florence thought she should have listened to her initial impression of George, recorded in the diary two years earlier, *Insipid and ordinary*. George had gained weight and looked like a stuffed olive.

> *George called last night and I let him know how contemptible I think he is, but today he became wishy-washy—had to slap him.*
>
> *Received a rather beautiful letter from Nat this morning—he's what I thought George was.*
>
> *Another letter from Nat and there's no more avoiding the point—"I surrender, dear" is too irresistible. What can I do?*
>
> *I've discovered Nat in the person of Gabriel Oak ("Far from the Madding Crowd") but I shall wait before letting him know. I still like him.*

In her diary, Florence reflected on all of her relationships with boys, Bernie, George, Manny, and Nat. Her feelings about each one were really a struggle with herself.

I'm conflicted with Nat—we can't think along the same lines—we can't see the same values—the discrepancies are too significant to tolerate. He has a beautiful character—but he needs finish.

I think I respect him more than anyone else in the world—and what does it mean?

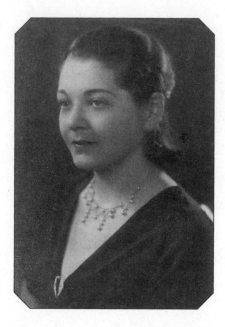

Florence was a sixteen-year-old college sophomore when she met Pearl, a senior. As young literati, they had a natural affinity. Pearl was nineteen in the picture, dated May 1931. (Photo: Courtesy Jeffrey Kehl.)

PEARL

Rode today and let my hair fly in the wind. It was marvel-
ous—I felt so cleansed—so pure—so free—if only I were. I
need another lover—what to do?

Florence created a sensation at Hunter in her riding habit
with fawn-colored breeches and knee-high leather boots.
She wore the costume to school because she knew how
dashing she looked. With her hair cut in a sleek bob, she could
have been a Parisian model. She rode in the park on an im-
petuous chestnut when the day was new. Astride her English
saddle, she surveyed the grounds of her estate, New York.
Florence was an Anglophile, and riding was part of her liter-
ary persona. Riding and writing—she liked the pairing. Riding
calmed her and, at the same time, stirred her thoughts. More
than once, she was tempted to keep riding, out of the park, into
the streets. She could just imagine the looks when she cantered
up to school.

Rode almost two hours when the wind was raw, and the
air chill and black. Rah for the horses—I'd be lost without
them!

Manhattan was kaleidoscopic. Cubist. Just when she was feeling one way, the seasons changed, and so did she. The spell of George was broken. At Hunter, one of the first colleges in America to introduce art into its curriculum, she switched her major from math to art with an English lit. minor. Florence spent her afternoons painting, studying still lifes of apples in one of the college's basement studios. Projected by a beam of dusty light, Botticelli's Venus emerged from the sea, the eternal feminine. She found her course in medieval art fascinating, especially the old illuminated manuscripts and books of hours with extraordinary illustrations by monks in small cells by candlelight.

"Music Does More Than Soothe the Savage Beast—It is the medium through which the ordinary human being can communicate with the heart and mind of a genius," informed the banner decorating the Hunter Concert Bureau at the Student Exchange, where Florence bought a season to the Philharmonic for seven dollars and a dollar ticket to her first opera, *Lucia di Lammermoor*, which she saw at the Met. Lily Pons was the lead, driven mad by an impossible love.

The Civic Repertory Theater's doors were closed until the following fall. Eva Le Gallienne had sailed to Europe for a year of rest after being severely burned in a fire. "Eva Le Gallienne Is Burned in Blast, Actress Seriously Injured" read the *New York Times* headline. During a weekend at her country house in Weston, Connecticut, Eva had casually struck a match on her cellar door to light a cigarette. An explosion of propane had critically burned her face and hands. Her girlfriend, Jo Hutchinson, was injured while trying to beat out the flames

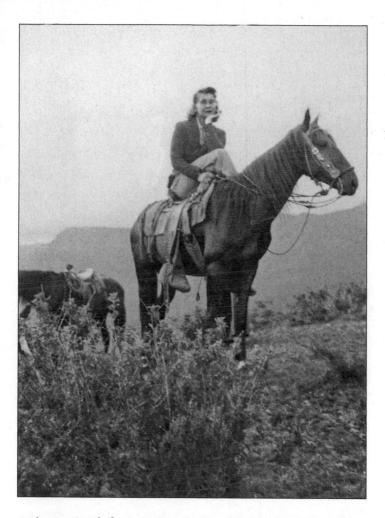

In the morning, before attending classes at Hunter, Florence, an accomplished equestrienne, outfitted in a jaunty riding habit, ventured forth on a fine, sleek horse, taking advantage of the fashionable bridle paths of Central Park. She also rode in the mountains. (Photo: Courtesy Florence Howitt.)

threatening to consume her lover. Le Gallienne's tragedy and sudden absence only reinforced Florence's feeling of how quickly the world changed.

Wasted a whole day and cried in an hour of weakness—but fell in love with Courbet & Vermeer in the museum.

Spent all afternoon in the museum and saw the Chinese snuff bottles of jade & onyx and carnelian—oh, to touch them!

Saw the most superb illuminated manuscripts—exquisitely & perfectly painted—are wonders, of course—our books are so cheap, there ought to be some discrimination.

The Metropolitan Museum of Art became Florence's new sanctuary. Free and almost deserted during the week, it was a temple that she wandered, solitary and content, for hours without encountering a soul. At the foot of the great marble staircase was George Grey Barnard's sculpture *Struggle of the Two Natures of Man*, simultaneously good and evil, spiritual and material, Apollonian and Dionysian. In the Greek and Roman wing, Florence weaved in and out of friezes and kraters depicting scenes from classical mythology and the day-to-day life of the ancients. A Roman colonnade formed a courtyard surrounding a green lawn displaying Greek and Roman sculpture. In the center was a shallow goldfish pond.

Worked all day—wrote, painted, practiced, shopped—I don't need anyone—as long as my mind is kept young & my hands.

Am on the lookout for a really satisfied person—and so far I've discovered that happiness is an alien blessing to those who are true to themselves.

Merrily—merrily—and not much else—everything appears trivial—especially my own creations—what makes me great?

The museum today—more music—poor substitutes perhaps for life and people and I'm under no illusions—Shall I never live heartily?

Like a disciple, Florence stood before contemplative stone Buddhas and felt herself magically transported to the Orient. Blissfully wandering on, she was reminded of the words, "life is but a dream," from the children's song. Her favorite exhibit was the display of snuff bottles of carnelian, aventurine, and lapis lazuli. To feel the cool polished stone would be like touching something precious in her soul. In the Impressionist galleries, Florence circled Degas's *Little Fourteen-Year-Old Dancer*, cast in bronze with a real satin ribbon in her hair. Florence needed to create. She felt it was the only way she would have the life she wanted to live. In her diary, she recorded her struggle with who she was and who she would become.

*I'm reading the most marvelous book—and it makes me feel
so happy—although it's sheer tragedy.*

Hunter girls dressed in flirty floral frocks scented with
jasmine and musk were the fierce daughters of immigrants.
They were ever striving and stalwart in their determination
to do better for themselves. The basement was the artistic
center of the college. Exposed heating pipes, usually at full
blast, lined the ceilings of the art studios, causing the whole
lair to smell of wet clay. The basement housed the students'
lockers as well as the publication offices of *Echo*, the college's
literary journal, the *Bulletin* newspaper, and the *Wistarion*
yearbook. Mice scurrying about for the remainders of brown-
bag lunches made girls shriek. One thing that got under
Florence's skin was any girl who spoke with a distracted, apa-
thetic voice. Hunter was an orchestra pit of these out-of-tune
violins.

In the dim light, Florence's hands selected a volume of
Browning, recognizable by its bulk, and her Virgil by the
smoothness of its cover. A young woman came up behind
her, bending over her locker. Tapping Florence lightly on the
shoulder, the girl handed her *The Well of Loneliness*. She didn't
need to say a word.

The Well, a scandalous book by Radclyffe Hall, caused a
stir in Hunter's halls as it was passed around from student to
student. The book was a loosely based autobiography of its
lesbian author, whose lovers included Parisian salon hostess
Natalie Barney. It told the tragic coming-of-age story of Ste-
phen Gordon, a dapper daughter of English gentry, who grew

up riding horses on her father's estate. It traced her struggle to live a life condemned by "polite" society and to become a writer. *The Well* was Florence's first intimate view of a romance between two women, and it brought her painfully, achingly along with Stephen, whose hopes and dreams slowly withered.

Hunterites were expected to maintain a sense of dignity, act like ladies, and adhere to a strict code of behavior. Dean Egan, a 1908 Wadleigh graduate, who also went to Hunter, ran a tight ship. Diction, dress, and personal conduct were values held in the highest esteem. A girl in Florence's class was expelled for wearing an organdy blouse to school, which Dean Egan said might inflame men, although there were few male teachers. One of Dean Egan's more strictly enforced rules was no hand-holding in the hallways. There were many undercurrents in the all-female student body, deeply formative friendships, whispered "entanglements" and "liaisons," but everything was kept sub rosa.

> *"Wrong" becomes a term laughingly meaningless—and "normal"?*
>
> *Hate to complain in the face of my various activities, it could seem stupidly ungrateful—but matinees & dances leave me cold—Is what I want so impossible?*
>
> *I know it sounds stupid and crude, but I've got to fall in love, and be loved—I miss it so!*

Striding into class, Florence created an impression of glamour tinged with mystery. Somehow she managed to get away

with her riding outfits, which she wore almost daily. If it ever came to arguing with Dean Egan, her ensemble was undeniably the costume of a serious horsewoman. Florence left her riding crop in her locker, although she would have preferred to tuck it under her arm to illustrate a literary point, emphasize something noteworthy in a slide, or prod someone in the right direction.

Hunter was full of exclusive cliques. Invitations poured in from seven sororities, requesting her presence at tea. She attended, but left unimpressed by these silly clans, which perpetuated a feminine world of secrecy. Florence scorned the beauty parlor girls chattering about their manicures and hairdos.

Spent the evening with two girls—"popular" girls, so called and still sick with their callousness & pettiness—but they're pretty well adjusted. I prefer tête à têtes.

Florence knew she was unique. The popular girls were attracted to her. She was invited to go out dancing with a pair at the Hotel Pennsylvania on Seventh Avenue and Thirty-third Street, where the Café Rouge ballroom was home to big bands, the Dorsey Brothers, Count Basie, Duke Ellington, and the Glenn Miller Orchestra. A quick cab ride delivered them to the lavish lobby of the art deco New Yorker Hotel on Eighth Avenue and Thirty-fourth Street, a forty-three-story vertical city, with five restaurants, ten private dining salons, ninety-two telephone operators, forty-two barber chairs, and twenty-two manicurists. Under the gold ceiling of the Grand

Ballroom, enveloped by painted murals, Florence swayed to the syncopated rhythms of the orchestra. The evening was fun, but she found these shallow girls not so different from the arrogant boys she knew. Their trivial interests were appalling.

Painted—played piano—read Baudelaire—and saw Manny.
But I couldn't resist thinking about that girl—!
 Invited that girl—Pearl is her name—to tea next Thursday afternoon—I hope I'm not disappointed—with her voice, I shouldn't be.

According to plan, Florence and Pearl Siegelstein met, one late afternoon in March 1932, at an English tearoom on Lexington Avenue, advertised as "a rendezvous for Hunterites." Italian mosaic tiles fanned out over the floor. Red leather banquettes promised privacy, cordoned off by frosted glass beneath art nouveau chandeliers. It was Prohibition. Even the most innocent teashop had an air of mystery. A violinist played Haydn.

Florence had first been invited to the genteel tearoom by her mathematics professor from last year, also a lover of classical music. Attractive, lonely Dr. Marguerite D. Darkow, much admired by her students, had noticed her young pupil, so worldly and wise for her sixteen years.

Visited a former teacher of mine, Dr. Darkow, and was amazed by her pessimism and dependence. She is brilliant.

Florence began visiting Dr. Darkow at her teacher's small Yorkville apartment, where they drank more tea, smoked cigarettes, and listened to the phonograph play sonatas, partitas, and fugues. Dr. Darkow told about her years at Bryn Mawr and graduate studies at the University of Chicago. Florence revealed how she longed to travel abroad. Dr. Darkow pointed out that Europe was ripping apart at the seams.

> *To Dr. Darkow tonight and talked hours on the economic condition of the world—she expects general massacre within 5 years—it is possible.*

Florence also became friends with her young German instructor, Fraulein Hildegarde Kolbe.

> *Tea with a beautiful and gracious lady and decided to become sweet and charming—It's an easy way to embarrass people.*

Miss Kolbe had come to the States after the war to go to Smith, where Florence had wanted to transfer, but the Wolfsons vetoed her plans to attend the social work program because it began in the summer. "The summer is when you go to the mountains to meet men," said Mother.

> *A more gratifying time than I have experienced in a long while—Pearl fascinates me! We sipped delicious coffee and exquisite apricot brandy.*

Now, Florence shared a booth with Pearl, whose auburn hair was pinned back from her rather pretty face. Pearl looked intently at Florence over her china cup, stirring in a few sugar cubes. She managed to combine feminine charm with strength of character and good nature. Florence was sixteen. Pearl was nineteen, a senior. Both young women wrote for *Echo*, Hunter's literary magazine. Pearl was a playwright with three original plays under her belt and had been one of ten elected to the honorary English society. Her last name, Siegelstein, meant "one who pushes rocks." Florence thought it an apt description for this intelligent brunette with heart-of-stone determination. Her first name was also fitting. Pearl usually had *le mot juste*.

Pearl's parents, immigrants from Eastern Europe, were descended from stonemasons in the Carpathian Mountains. Pearl had grown up in Harlem, and Florence's brownstone memories resonated with her. She had also attended Wadleigh, although the two hadn't known each other there. Her family's relocation to the Bronx was a source of great distress. Pearl felt as if she had been banished to Siberia. Her family thought that her father, a truck mechanic, was crazy to let her go to college. She could have been working, contributing something to the family pot. After all, it was the Depression. But her father said that if Pearl wanted to go to college, she should go. Pearl was tremendously likable, and Florence was strongly attracted to her.

Was rather cold to Pearl in class today and feel like a little beast—I'll ask her to lunch on Thursday—I could almost love her!

Arm-in-arm, the young women walked New York, experiencing the city through each other's eyes, talking over ideas for plays. Florence had just finished reading *The Monk and the Dancer* by Arthur C. Smith, and was looking forward to his second short story collection, *The Turquoise Cup*. They passed the usual corner scene of down-and-out former Wall Street brokers selling apples and pencils from cardboard boxes. Florence was used to looking away as she tossed in a coin, but Pearl opened her eyes. They were just trying to feed their families. She insisted Florence look at them.

Out with Pearl tonight and accidentally came upon a life that was real and beautiful and made me feel loathsome—a blind pianist who is happy—in a small cheap restaurant.

They spent hours in Central Park. They admired Cleopatra's Needle with its twin in London and a similar obelisk at the Place de la Concorde in Paris, uniting them in their love of antiquity and European culture. They lingered at the Shakespeare Garden, planted only with flowers that appeared in the Bard's sonnets and plays. They passed the Hooverville of shacks in the old emptied reservoir north of Belvedere Castle. Slim lines of smoke rose from the fragile makeshift structures and tents.

Pearl now completely dominates my mind—Once I hop over my stone wall, I'm lost—but something about her gets me!

On a park bench, Florence and Pearl discovered they shared a love of *Alice in Wonderland*, reciting in unison, "Jam to-morrow and jam yesterday—but never jam to-day," and John Webster's poem "Nets to Catch the Wind": "Vain the ambition of kings who seek by trophies and dead things to leave a living name behind, and weave but nets to catch the wind." They didn't leave the park until the lamps glowed in orange-pink orbs at twilight. Not long ago these were gas lamps lit by hand. Much had changed since their parents arrived in America. The flappers had shed corsets and the stiff old Victorian designs for free-flowing materials, altering the way they moved through the world. Zippers had replaced troublesome buttons and hooks and eyes. Everything was speeding up. Old rules were there to be broken. The Depression wasn't going to stop them. They were going forward. The hell with men. It gave Florence such a sense of freedom. She also felt that element of tragedy she had read about in *The Well of Loneliness*, dramatic and soul-wrenching.

She is so sympathetically identical—Why are not men like her?

Slept with Pearl tonight—it was beautiful. There is nothing so gratifying as physical intimacy with one you like—talk is simply wasting time.

One evening, three weeks after their first tea, Pearl came home with Florence. Despite Mrs. Wolfson's cool reception of her friend, Florence invited Pearl to spend the night. Since Florence was a little girl, she had innocently shared her bed with friends. Pearl confided in Florence that she never knew for certain who would be beside her in the morning. The practice was not uncommon in the overcrowded tenements of immigrant families, where there was a shortage of beds and the constant need to accommodate a new distant relative who had arrived from the old country. Pearl borrowed a pair of silk pajamas from Florence. The girls slid under the covers of her twin bed. They turned toward each other, whispering, moving closer. Pearl kissed Florence. Slowly, they explored each other's bodies.

> She whispered "Je t'aime" but—what next?
> How exhausted I am!—No sleep twice this week. A stupid, stupid day and an intense hour with Pearl. She is so good—and good for me. I almost love her.

Florence cut classes to have lunch with Pearl, who introduced her to a friend, Polly, another Hunter student. They became a threesome at Schrafft's, where Florence indulged in her favorite hot fudge sundaes. They went to Childs for midnight pancakes, sitting close at one of the gleaming white marble tables under sparkling chandeliers. Pearl slept over nearly every weekend, sometimes on school nights too.

In their slips, in Florence's locked bathroom, Pearl helped Florence dye her hair to keep its startling shade. Florence sat

on the edge of the tub, watching Pearl stir the bleach mixture and hang Florence's wet brassiere up to dry. When Florence dyed her eyebrows and eyelashes and the result was disastrous, Pearl came to the rescue.

Another night with Pearl and nothing remains to be said— except . . . I'm not ashamed— we're both so happy.

Locked up all morning with Pearl and Mother's tactics were quite amusing—She trusts no one—not that it matters!

Morning was as delicious as the night. In the light filtering through her windows, Florence awoke, entwined with Pearl, their naked breasts pressed together. Florence heard the door rattling. It was Mother, asking why she had locked it.

Mother's suspicions made it uncomfortable to have Pearl over. Although Florence still did from time to time, she had grown vaguely dissatisfied.

I love to be very close to Pearl—I love physical intimacy— when I embrace her, I could love her—but distance is depressing.

Pearl called—she stayed the night—but Mother saw that we were separated!

Cut more classes this P.M. and went out with Pearl and Polly—How will it end? And when?

Out with Pearl and two others and almost curled up with boredom—She spent the night with me—& again it was beautiful.

Most of the day with Pearl—She satisfied me only when there is a physical contact—it's so much more tangible!

Had an interesting day with Pearl (does she love me as much as she seems to?)

An amusing letter from Pearl—I've lost all emotion for her—it's horrible—why can't I fall in love again?

Saw Pearl for two hours and am amazed at the extent of physical power I possess over her—I like her arms around me.

Painted and drew and achieved nothing—started to write this evening and have become involved in a stupid plot.

Florence raced to finish her latest—a break-up letter. Florence began, "Dear Pearl." She was getting bored. The physical pleasure was now the only thing that kept the relationship going.

Saw Pearl for one brief moment—and read all afternoon— To live in books is cowardly—but people are not worth investigation.

Wrote all day—wrote all night—and succeeded only in breaking my finger nails.

Am reading the life of Mozart and cannot help thinking that one's capacity for suffering is in direct proportion to one's greatness.

Their affair felt like a cheap little story. How to end it? Florence wondered if society was right after all. Perhaps the more she suffered, the better the artist she would become. The

thought came to her while she was reading the biography of Mozart. She felt it was only a matter of time until others knew who she was.

A queer day of music and pain and wild pride of acknowledged genius—or perhaps it was simply realization—My conceit is outrageous—I realize my limitation—I'm not ordinary—but after all—sympathy & receptiveness are less unique than endurance.

The Wolfsons' telephone rang. It was always Pearl. Florence told Mother to make excuses. Florence stared at herself in the mirror. She felt wretched, but who was she living for anyway? Why was it so difficult to live as she wanted?

Rode this morning and almost fell off the horse—I was so tired—tried to write but words wouldn't come—I'm sick!

The next day, riding through the park, Florence almost tumbled from the saddle. She saw George at the courts and halted her mount to speak with him. He had replaced the Park Avenue blonde he had dropped Florence for with a new girl-friend. Drop one and pick up with the other, with a perfectly blank conscience. How did men do it?

Spoke to George rather lengthily this P.M. and was amazed by his cold-blooded selfishness—yet he seems happy—why?

A letter from Pearl this morning asking me if it is "finale"—what can I say—I don't want to hurt her—I don't want to love her.

Saw Pearl really for the first time in a week and she was hurt by my silence—she phoned one night—I simply ignored it.

Spent several hours with Pearl who finally turned over and kissed me—I had to explain—a miserable failure—still loves me.

Pearl this afternoon and had a peculiar time—I don't understand how she can still want me physically—she kissed me so passionately!

I had to forget myself and make believe she affects me as she always has—I like her & admire her—but impersonally.

Echo's May 1932 issue came out. Florence and Pearl both had stories in Hunter's literary journal. Pearl's "Pink Tea-bowls" was about a young woman poet who marries a sewage construction magnate, settling for a bourgeois life. Her character chose everything Florence and Pearl detested. Florence's story about a friendship between two women, one who quit school and married while the other pursued a career as an artist, won Hunter's prestigious literary prize. She was awarded the grand sum of forty dollars. Afterward, Florence handed Pearl an envelope containing the break-up letter. Later, Florence reflected on a short story that she was writing:

How I love to inflict pain on my characters!

A letter from Pearl that tore my heart (I had written severing our relationship)—but how much more injurious to bring

her peace—better to suffer now than become completely perverted.

Florence didn't reply.

Have Monday, however, to look forward to, another girl— beautiful voice—etc.

ECHO OFFICE

The Echo *office in the Hunter basement was furnished with what were considered luxuries: a couch, Florence's large wooden bureau, a type-writer and teacups for cozy editorial meetings. The students called the little furry creatures with tails that also met in the publication office, "bêtes noires."* (Photo: Hunter College Archives.)

M

Things I can't do fascinate me," Florence told a Hunter reporter who was writing a profile on her published in the *Wistarion* yearbook. Florence was elected editor in chief of *Echo*, Hunter's most prestigious position for a student. To Florence, she might as well have been elected to the masthead of the *New Yorker*. *Echo*'s basement office was furnished with what were considered luxuries at college: a couch, typewriters, and a tea set for cozy editorial meetings. The only outside light came through a yellowed transom over the door, still, several plants clung to life. A foreboding seascape hung on the wall.

Pearl helped Florence paint her office in pearl gray and beige. The effect was subdued, sophisticated. Seated at wooden tables, Florence's *Echo* staff struggled to put fantasies and images into words. Tired fingers struck the keys of iron Underwoods heavy as anchors. A heating pipe in the corner of the room transmitted sound effects from the upper floors. The girls hoped for a juicy morsel of gossip.

A dusty bedspread hung over a messy bookshelf hid the girls' many drafts, all of which Florence scrutinized under the warm bulb of her metal gooseneck desk lamp before releasing anything for publication: well-crafted short stories; a critique of T. S. Eliot; a Rossetti poem; an interview with Amelia Earhart;

and a parody of *Beowulf* as written by Ernest Hemingway, as one of the *Echo* writers put it. Florence worked at the office's only solitary bureau, an unmovable wooden desk filled with locked drawers, which held her contraband copy of *Ulysses*—Joyce's masterpiece was illegal in the States—a bottle of white wine, and a soft pack of Luckies. She didn't usually smoke, but the cigarettes were there in case anyone needed one. There were those who believed in a mystical connection between smoking and the flow of words.

While the young women worked, drifting in and out of abstraction, Florence tackled the unexpected twists and turns of her own story. The wall clock ticked like an agitated heart. Writing made Florence feel powerful. This fall, she had the heady realization that she could drop one girl and pick up with another—like a man, like George. There was the delightful promise of sex to come. Florence laughed to herself.

She stood up, straightening the pencil-silhouette of her charcoal gray suit with the black velvet collar and snapped her pocketbook shut. There was a nice chill in the air. She adjusted her hat and informed the girls when she would return to check proofs. She had a date.

I feel almost vulgar in my desire to write.

Had a pleasant afternoon with Marjorie Failes—she's English—essentially so—and mutual comparisons are interesting.

Marjorie Failes was British, a twenty-one-year-old senior. The blond beauty reminded Florence of the seductive Marlene Dietrich wearing stockings, a corset, and a top hat in *The Blue*

Angel. Florence, imagining herself as Garbo, could see the two of them as the "Botticelli Twins." After all, they really looked the part. M, as Florence called Marjorie in her diary, was tall, slim, and looked very Anglo-Saxon. Her wide, pale face was set with a moist coral mouth. Her eyelids gleamed with petroleum jelly. Florence's sultry, low-timbred voice played against M's upper-class English accent. Florence found M intoxicating. M was like one of Ibsen's modern women—Hedda Gabler came to Florence's mind. She could also see M as one of the characters from *The Well of Loneliness.*

Was highly stimulated—As a type, she's completely unknown to me—but I admire her serenity. I was charmed—but she's afraid of boring me, of being distracted too much by my peculiar experiences & claims.

Sitting beside M at afternoon tea for the first time, Florence was nervous but exhilarated. M was serene. Florence had never been serene. Intense, she thought, was the right word to describe her. Florence hinted to M of her past with Pearl, some girl who had fallen violently in love with her last spring. In her understated tone, crossing her legs close beside Florence's under the table, M asked if she was boring Florence, pointing to Florence's "experiences." Florence said she was eager to have M write for *Echo.* M's style was crisp, subtle, and compact, very different from Pearl's overwritten and emotional prose.

How physical claims can intensify the spiritual!

Florence and M were soon inseparable. College wasn't important to M, who was graduating, and missed far more classes than she attended. Florence began cutting so they could binge on art exhibits and French movies. They made a pact to know each other, as well as to immerse themselves in art.

> *Cut school with Marge this afternoon and took in waffles and 2 art exhibitions.*
>
> *Visited several art exhibitions and worked myself into a state of morbid envy—I am so impatient and so eager—it's unjust.*
>
> *To the Independent Artists show—a dangerous place that made me dizzy—so much painting—so much bad painting! Occasionally a miracle here and there.*
>
> *The gods smiled upon us and gave us something to create—of course, that was the trouble—our perpetual, unworthy laziness.*
>
> *Felt quite awful in school and M took me home—for one bold moment we touched—but fear drove us apart and it's still the same.*

They saw the film version of *Dinner at Eight* with Jean Harlow, and Mae West's *I'm No Angel.* "When I'm good, I'm very good," said the femme fatale, "but when I'm bad, I'm better." One afternoon, they walked all the way downtown from Hunter to the Whitney Museum of American Art on Eighth Street. Later, they went to the Faileses' large apartment on Fort Washington Boulevard in Washington Heights.

Pearl sweetly brought flowers by way of celebration—Dined out with her and passed a miserable evening—it is my fault!

On Florence's seventeenth birthday, she spent the evening with Pearl at their old favorite, a chop suey joint. It was a strange season. The city newspapers had a heyday documenting a storm that swept the Atlantic coast, bringing a swarm of arctic birds called dovekies, puffin relatives that resembled small penguins, and driving them into skyscrapers. Thousands perished. All around the city, their limp bodies draped over telephone wires, in the middle of the streets, and on the ponds and lawns of Central Park. At dinner, Florence watched Pearl slurp egg-drop soup and gulp down glutinous courses, which arrived one after another in colorful little bowls from the bowing waiter in Mandarin pajamas.

Was moved not so much one twinge—how could I have cared for her so! Later with Marjorie I thought I must have been crazy.

At the Faileses' apartment, Florence and M got ready to really celebrate Florence's birthday. Black nail varnish was in style, and they applied purple eye shadow on each other. They were off in a Checker taxi with rattling jump seats to El Morocco, 154 East Fifty-fourth Street.

Under a crescent moon and white papier-mâché palms shading swank zebra-striped banquettes, Florence and M danced

together and with men who tried, hopelessly, to pick them up. In the late 1920s, flappers expressed same-sex affection in dinner clubs, but the Depression had tightened morals along with pocketbooks.

For these two rich city girls, the El Morocco speakeasy, setting the fashion of discretion and exclusiveness, was a haven. Its dark walls twinkled with stars. They acted as if they had just arrived from Paris's avant-garde scene of beautiful women who loved beautiful women. What was so wrong with that? A captain with a red carnation in his lapel barely gave them a glance. They were toasted by revelers who called them the two blonde tigresses, watching as they stalked each other on the dance floor. Florence swayed her hips a little faster while dancing the mambo and the rumba. They joined the conga line.

Out again to a night club that combined the slyer aspects of obscenity with much noise and drinking—beauty can so easily be defiled by exploitation.

Unexpectedly, she bumped into George out with a girl and his new crowd. George was shocked to see Florence with M.

George tonight and know that no matter what I feel—I'd take Marjorie any time to him or people like him—I have ideas.

Outlined the all-woman play with M—the last act—and it seems fairly coherent & significant—it's grand! Started the third act and it moves much smoother, much more intel-

ligently—probably because the situation calls for dramatic treatment. It means so much to me.

In the *Echo* office, Florence and M huddled together on the mossy green moth-eaten sofa, the only comfortable spot, which held three chubby girls during Florence's editorial meetings. It was also where Florence lay down during an occasional bout of writer's block. M listened to Florence describe her vision for their all-woman play. She wanted to express the modern tempo she felt. M got up. Florence watched her lissome figure glide across the room to the door and lock it, without the least bit of concern that the *Echo* girls might need to get in. M snapped off the lights. The Underwoods were quiet, lined up like Mother's Singers, which her young seamstresses pedaled with their tireless legs.

It's happened finally—do you hear? It's happened—She was marvelous—but if she even regrets—or is disgusted!

M came over to Florence and sat at her feet, caressing her body, running her hands over her hips. M hiked Florence's floral dress up. Her fingers walked above her stockings, teasing her. She unbuttoned Florence's dress and pulled off her slip. Nothing like the struggle with George. Florence was stunned by M's boldness. Slowly, M rolled down Florence's hose. Was it M's fingers or tongue? M's lips brushed Florence's inner thigh. Florence had never felt anything like it.

Was touched until I finally screamed with pain.

In the locked *Echo* office, M gave Florence her first orgasm and demanded nothing in return. The scene repeated itself many times.

I suspected her of such abilities.

Florence had been unlocked without the risk of pregnancy, a constant worry since birth control was illegal. Florence was still a virgin. She was a good girl. Old-country remedies like a sponge soaked in vinegar were not foolproof.

Painted M all day and felt powerful—so fine—Amazed once more by her vulnerabilities—it was Pearl, who suddenly stalked in.

After they made love, Florence painted M as she lay on the threadbare couch, like Manet's *Olympia*. Pearl stormed in. Why was she there? Although she had shared a bed with Pearl, the affair was much more innocent. M and Pearl were both in front of her. One was beautiful. The other was merely sweet— ordinary really, nothing special. Florence wondered what had she ever seen in Pearl. M was standing svelte in her black satin bullet bra, taking her time pinning her wool kilt and adjusting the tie of her blouse.

An awful, heart wrenching hour with Pearl—how she tore herself apart before me! It was horrible! But it's pretty distasteful—has she no pride?
Watched M hurl stones into a dark lake and the beauty and freedom of her movements seemed to cut me so—that I

wasn't with her all evening. Cut school all day with M and can recall nothing now but tears and anguish and "eternity in your eyes"—the bitter look some people have.

Florence and M walked around the Central Park Reservoir. The amorous young women drew disapproving looks, passing sallow men under bowlers and women scurrying home, protectively clutching their patent leather purses. M searched for a smooth stone to throw into the water and looked like a Greek goddess. M told Florence she had beautiful eyes. Since Florence was a child, Mother had said, "It's too bad your brother has such big eyes and you have such small ones."

Took a walk around the reservoir with Mother this evening and read the Sunday papers all P.M.—I throw up my hands.

On a rare evening together, Florence and Mother walked around the Reservoir. As the sun went down, a few riders in black velvet caps cantered by. Florence studied Mother closely, petite with square shoulders and hips in a floral dress and the broad-brimmed straw hat she liked. Rebecca knew her daughter was much prettier than she had ever been. "You have a beautiful figure," she told Florence when fitting her. Mother took pride in Florence's beauty as a valuable passport to a good marriage. Florence hoped that she wouldn't be anything like her parents, who seemed too miserable to admit beauty into their lives. Sometimes Florence wondered what it would be like if she could communicate with Mother.

Another quarrel—enormous, this time—with Mother—we're so far apart—I pity her for her wretched life and I shudder when I consider the future—there must be concessions.

Looking forward to the time I leave home. I want to get out into the world—alone.

A marvelous day with M, reaching a point of zero despair—But Mother's spread poison, already, accusing us of a friendship à la Pearl—it's rotten!

Mother knows—God—that look on her face—why—I've never see such heartbroken fear before—and she wept—so quietly—but I don't feel I've done wrong.

One evening, at the Wolfsons' apartment, seeing Florence and M together, Mother said coolly, "A friendship à la Pearl." M left. "I know how you admire her," said Mother. In her effort at reforming Florence, she warned Florence how "dangerous and threatening this thing could be to her whole life."

A bitter evening at home—there will never be peace here—I think all my eccentricities were caused by this tense and wretched atmosphere.

Dear God, I'm sick of this mess! What am I—man or woman? Both? Is it possible—it's all become so hard, so loathsome—the forced decision—the pain.

Florence found Mother's words deeply troubling. Loving M came naturally to her, just like loving men. In her psychology class, the students were taught that Dr. Freud believed bisexual

instincts were shared by all men and women. His findings suggested that the bell curve of human sexuality contained at one end those who abhorred certain practices, at the other, those who reveled in same-sex touching, and a few who engaged in bisexual intercourse. When M's arms were around her, Florence felt there was no problem. M understood her. It was when Florence was alone, facing her family and future, that she felt uncertain.

Florence still dated boys. Mother began taking a more assertive role in Florence's social life.

Out tonight with some horrible boy—a fraternity brother of George's—and forced myself to be charming—it can't always be M—I'm chilled.

December 31, 1932—Out all over town—out all night—and a more insignificant, ill-smelling, sickening time I cannot imagine—the coarseness of boys in their teens! A year unexpected in its endowments—rich in learning—revealing in much—yet—what its fruits?

For New Year's Eve, Nat came to New York from Philadelphia, where he was in his freshman year at the University of Pennsylvania's dental school. Nat had been writing to Florence since their summer together at Spring Lake. Florence and Nat went out on the town. Crowds in glittering top hats were toasting the New Year and tooting toy horns to "Auld Lang

Syne." To Florence, it all seemed childish. She kept her distance from Nat.

A letter from Nat which troubled me all day—as much as I've warned him—tried to dissuade him—and how [I] shall hate to hurt him—you see, he loves me.

In the diary's "Memoranda" section, she wrote,

I'm worried—so worried—it may be that I am no better than a prurient, promiscuous adolescent—why is it that, not really loving Marjorie, I can lie happy in her arms and urge her kisses—I'll do anything to have her alone—yet today when I thought I was never to see her again, I felt no passionate sorrow—Is the other love? I doubt it—but I'll not endure Nat's embraces—oh, I wish I knew—I wish I knew why I valued our relationship when I'm not a lesbian—not even bisexual—at least, I don't think so—she's not—what attracts her to me—in that fashion—will I ever find out—it's so necessary, so necessary.

At long last, the Civic Repertory Theater reopened. For M's birthday, Florence and M went to see *Alice in Wonderland*. Florence had not seen Le Gallienne since the actress had returned from her year of recovery abroad. The house lights dimmed. When the curtain lifted, Alice, played by Josephine Hutchinson in a baby blue dress, sat in an enormous armchair,

which dwarfed her so she looked like a little girl. Her long hair was held by a black silk ribbon. Jo sat with a black cat in her lap, reading a book—so innocent. Alice pursued the White Rabbit, falling down the hole into strange surroundings. Le Gallienne played the Mad Hatter, but seemed wrong for the part. Since being burned in the fire, Eva had insisted on wearing heavy makeup and gloves, onstage and off, to cover her terrible scars.

A touch of reality that still pains—M told me that her brother refuses to see Eva on the stage—because of her private life— he loathes such women—there are many like him.

M's brother's engagement to a Jewish girl, hardly the accepted norm for a young man of his class brought up in the Anglican Church, was about to be announced. He had no idea that M and Florence were more than friends.

On the Civic's stage, the Cheshire Cat was vanishing, beginning with the end of the tail and ending with the grin.

"It doesn't matter which way you go," said the Cat.

"So long as I get somewhere," added Alice.

Florence still saw similarities between herself and Eva, which she tried to figure out in her diary. Eva Le Gallienne, the strongest woman she knew, was faltering.

Saw Eva tonight in "Alice in Wonderland" and was bitterly disappointed—my ambition parallels Eva's—and she's failing—if she fails—what can I do?

Terrible hours of self-reproach—"What will become of

me?" she said—you see, she's 22. Hours tonight in M's embrace and saw at last the hopelessness, the terrorizing frustration of such a relationship as ours—It was never like this with Pearl.

At the Faileses' apartment, Florence and M stayed up all night talking. Parents, friends, even strangers, wanted to know why two beautiful women were not yet engaged. Several of their classmates at Hunter were already wearing rings.

"I love you—I love you so much"—At times we were happy—but physically—and she's marvelous.
 She was almost hysterical—this is all so aimless—so terrifyingly final—if I only had money! If I had money & independence—if we could live together—heaven could be had.

M and Florence discussed living together. Florence pictured the Greenwich Village studio she had once dreamed of for herself, where the two of them could exist happily, writing and painting.

M would be graduating Hunter in a few months, but Florence still had one year left. M loved her and said she would wait for her. M said they were destined for each other.

How wonderful to get away from the bourgeois world of men who expected women to be mothers and housewives. But without money, there could be no independence.

Still tired, weary—but tasted a few moments of fine soft pleasure—some day we shall be free—physically—but the concessions—the betrayals!

—

It was wonderful today—but the moan—"How long we must wait!"—agonized me—The unity, the merging, the clear and fragile beauty—Dear God—!

M said—isn't it vile—Can you imagine killing yourself for the less adequate life of another? I hated her and loved her. We can never strike sameness.

Another unpleasant contact with M—and I am beginning to question my independence—If one only knew what counted ultimately as it is—I think I need her.

A little less rigid today but the anguish until it wiped out all reason—all beauty—She pays a heavy price for individuality.

The end—a few brief words at night—and everything is shattered, everything from existence—It was so wanton, so selfish—& real.

Florence concluded that their love was hopelessly misguided. She couldn't see a way for them to continue without lies and deceit. Even Aunty Frances, who had always accepted Florence for who she was, was too much of a Puritan for Florence to share this part of her self.

It's over both Marjorie & I agree on the inadequacy, the lowness of the whole affair—I shall never, never again seek satisfaction outside myself.

Incredibly lonesome—and still sick with the realization of finality—it is like death—but so ugly, so unlike us—but we don't exist—M is out of my life!

M seems almost unreal now yet existing—like a painting.

M now seems as remote as immortality—there is nothing to hold me—except my will.

Two hours out in the bitter, lashing cold and then driven into a smoky happiness by Beethoven's Third—our finales are never so noble.

Out in the snow and felt unpleasantly rigid—despite a deep desire to fling myself into the soft white mountains—once I was spontaneous.

How well Shakespeare could see the truth! His 36th sonnet—it's the key to everything.

Eyes red from crying, Florence drifted in and out of a restless slumber. She curled up in her armchair in the corner of her room and let Shakespeare's Sonnet 36 console her: "Let me confess that we two must be twain, although our undivided loves are one."

Again the old problem—easy joy is torturous sacrilege—and music and art and literature who knows?

Started a short story finally—about a woman who willed things—and who was at last destroyed because there was no solution to her—will.

Cut school, didn't touch the piano—all to work on a damnable short story I finally destroyed—Lord help me if the writing is all a joke—what to do then?

Florence turned a fresh sheet of paper into her Remington. She was starting a new story. It had been so long since she had written anything worthwhile. Slowly, it came back to her. Black letters grew into words on the blank page.

My story seems good—the possibilities are too vast for my capacities—but I shall try—I shall try!

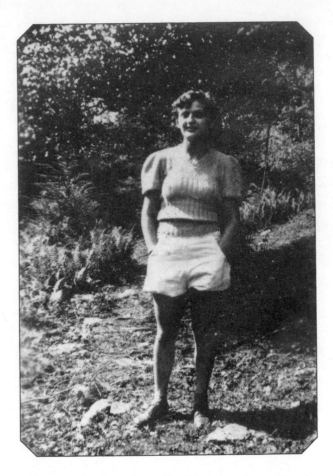

Florence took a picture of her friend, nineteen-year-old Evelyn Pober, born on November 27, 1914, tramping through Central Park. After Evelyn's death, Florence wrote, Looking at her picture chills me—I feel her warmth & sweetness so very much now—and it is no longer—something inconceivable. (Photo: Courtesy Florence Howitt.)

EVELYN

O ut, out, brief candle! Life's but a walking shadow, a poor player, that struts and frets his hour upon the stage, and then is heard no more. It is a tale told by an idiot, full of sound and fury, signifying nothing."

My beautiful youth flitted away in the pursuit of the secret of mechanics & waves & sound. Almost out of my mind with boredom and my superfluity—I fit nowhere—belong no where.

In front of the blackboard riddled with equations for the speed of light and the relativity of time, the girl reciting Shakespeare's soliloquy provided a welcome break in the middle of Florence's physics class, an annoying requirement. The student was a member of Make-up Box and Shakespeare Society, a roving band of performers that went from class to class. Another favorite was Hermia and Helena's scene from *A Midsummer Night's Dream*. "So we grew together, like to a double cherry, seeming parted, but yet a union in partition, two lovely berries moulded on one stem."

Alone really—and waiting for a new companion—I am that unfeeling—I can go straight into another's arms without remorse—I shall probably never see her again.

She no longer exists.

M had graduated and was gone from her life. Her senior year, Florence poured her energy into the hard work of *Echo* editor in chief. The only literary competition challenging *Echo* was the English Club, whose ranks included Belle Kaufman, the granddaughter of the Yiddish humorist Sholom Aleichem. The English Club's president was a young woman from the Bronx, Helen Davidman.

Joy, as Helen preferred to be called, had haunting eyes and wore her dark hair short. Like Florence, she had lofty literary ambitions. Joy's short story, "Apostasy," about a young Jewish girl who converted to Christianity through a sexual experience, won a prize. Joy often talked about going to the burlesque shows on Fifty-third Street and was rumored to be sleeping with a professor. She had run against Florence for the editorship of *Echo*. In a close race, Florence had won. Now Joy was on Florence's staff as an associate editor.

A job today—Saturdays only—and feel rather deflated— but horseback & good books and concerts cost so much—I can use even more than I earn.

Florence joined the sea of gray and black fedoras, the great tide of workers flowing through Pennsylvania Station. Young women smiled down from billboard posters promising "Hours and Hours and Hours of Loveliness—Strenuous hours at office

or country club? No matter, you look cool as exquisite tinted porcelain—fresh and satin-soft and lovely. That is Pinaud's gift to you with this new Powder." Florence emerged from the subway at Macy's, with its red star marking Herald Square at Thirty-fourth Street. Florence got a job, earning three dollars a day, working as a salesgirl in the furniture department on Saturdays. It was demeaning work for a writer.

Many Hunter girls worked at Macy's or at the department store's competitor, Gimbels. Belle Kaufman worked in Macy's basement book department. The two stores were constantly engaged in sales wars. College girls sold on the floors while working girls without degrees or burdened with heavy Brooklyn or Bronx accents toiled behind the scenes in the pneumatic tube rooms, which sucked in customers' money and spat back change, since there were no cash registers on the sales floors. "Be everywhere, do everything, and never forget to astonish the customer," the mantra of Macy's first woman retail executive, Margaret Getchell, still prevailed.

My first taste of work—and I must confess I find it little to my liking—I sold for two hours only—and was exhausted. It's not pleasant.

Work started at eight and ended when the department superintendent, a woman the size of a love seat, dismissed Florence. On her first day, she sold an entire dining room set, but found it draining standing on her feet all day, making small talk with couples who joked about trying out the mattresses.

Discharged—because my attitude while I sold was arro-
gant and abrupt—I felt sick—seeing myself inevitably as a
misfit—what if I am?

Florence lasted only two months at Macy's. She blew her two-dollar severance on a horseback ride through Central Park.

A marvelous ride—it was cold and the horses were fresh and
eager—It's for this I want money—simple and beautiful.

"As editor of *Echo*, Florence has had moments of deep despair," wrote the reporter writing a profile on Florence for the *Wistarion* yearbook.

"There must be a literature peculiar to Hunter," Florence said wistfully, "and it should be rich and colorful literature, arising from such a widely varied group. But Hunter students don't look to *Echo* as the organ of their expression. They don't send us their contributions."

The reporter wrote, "Florence is characterized by a kind of vivid naivete and an eager sincerity. At the outset, she rebelled against the old chauvinist policy of *Echo*, which has built around the magazine a tradition of pseudo-intellectualism. She often declared that if contributions are not satisfactory, she will not allow *Echo* to go to press."

Worked hours at school on that damned magazine and had
a pleasant time—a jolly time—but the minds of those
girls!—cheap.

Third Row: Rosalie Klein, Rita Price, Beatrice Wertheimer.
Second Row: Sonia Feymer, Mildred Nazarec, Estelle Sugarman.
First Row: Emma Bauman, Joy Davidman, Florence Walton, Edith Miller.

As editor in chief of Echo, *Florence roused the college's complacent literary journal into an expression of modern thought. With her sharp, probing mind, she showed her staff she would not tolerate affectations of style. Students either violently disliked or intensely admired her. Florence stands in front, second from right. Joy Davidman, who later married C.S. Lewis, in front, second from left.* (Photo: Tina Feinberg for the *New York Times*/Courtesy Hunter College Archives.)

An interview with Bruno Walter—a vigorous, intense man whose sincerity & love for music are so creative—made me feel degenerate.

More trouble with that damned magazine & M's story— & Pearl's story—It's such a silly, trivial matter.

Absorbed in work and additional manuscripts from M who has finally written a suave, unified story. Our communications are those of strangers.

Florence was an uncompromising taskmaster. *Echo* was important work that she found meaningful, like her interview with Bruno Walter, the conductor of the New York Philharmonic.

None of the mechanics of publishing was easy. The printer tried to cheat her. Florence had to deal with resistance from her staff.

The girls strenuously opposed the publication of M's short story, "The Years Betray," about a lonely woman living in a remote New England farmhouse who commits suicide by driving her horse and sleigh off an icy bridge. The girls found it too depressing. They vetoed Pearl's story as well.

On top of everything else, Florence's all-woman play was censored by Dean Egan. There was nothing she could do about that.

Up against the academic mind and am blazing—my last short story was censored because of implication not even existent—and the fear behind the censorship is significant.

Was accused by the rest of my staff—Echo—of all sorts of things—mainly rudeness & the ability to make them feel like worms—they fear me, they said—How absurd.

Arriving at the *Echo* office, after she was discharged from Macy's, Florence was met with furtive looks and snorted half hellos from the disheveled brunettes. Their Underwoods were silent when she reached her desk. On her blotter were pages of childish charges. Florence was accused of acting superior.

Perhaps I deserve it all—I did something that fills me with disgust, makes me see my shameless and incredible selfishness.

A bitter clash ensued. Florence defended herself. There was no explicit mention of her passionate sessions in the locked *Echo* office with M, but the way the girls looked at her with such malice, Florence couldn't help thinking this was the source of their hatred.

Hear that my hostile and malicious staff have concocted pages of charges against me. Some of them are such obvious lies—it makes me feel quite sick—completely disillusioned.

I know now that obscurity for me is disastrous—Have not the respect for people which flatters them and believe implicitly in the superiority of my taste. Result—conflict.

A long discussion with a teacher who simply oozed wellness and good feeling—she would not see the truth—as I saw it—would not admit that people lied & were mean. She advocated tolerance of all and any human feeling. Condemned me for discriminating—in something she was right— but I cannot love the world.

To resolve things, Florence met with the head of the Hunter English Department, Blanche Colton Williams, the faculty advisor to *Echo* and the English Club, and a biographer of the English Victorian novelist George Eliot. A grande dame who wore a fresh orchid to class every day, Dr. Williams had

a chaise longue in her office, where she pressed on students her "Handbook on Story Writing." She took her department to tea at the Plaza.

> *That I should have become involved in such a mean & trivial mess—it's incredible! I never realized what envy could do to people.*
> *An Echo meeting and loathe them all as things unclean and vicious—I was angry and bored & bitterly disappointed in one.*

The art editor, Estelle Sugarman, a great lump of a girl with coarsely crimped brown hair, was furious with Florence. Beatrice Wertheimer looked like she wanted to eat her. She was cornered by Rosalie Klein, Rita Pierce, Mildred Mesurac, and Emma Bauman, who smelled blood. Florence was steaming, but unafraid. Joy Davidman emerged as the ringleader of the mutiny. Joy demanded a recount! It was a kangaroo court.

> *Busy with foolish little matters—everything little—unimportant—detached—they may be good but they're empty—one must feel—something!*

Florence reminded them to behave like writers, not sorority girls. They had a literary journal to put out. Art to create. A responsibility to maintain the highest possible standards. Florence's sentiment seemed to be lost on her hostile staff, all except for one girl at the back of the room, the quietest *Echo* staffer, who had been carefully observing Florence for months.

*Worked all day on Echo and I am still trembling with anger—
the incredible malice those loathsome girls displayed! I was
grateful for the one that was with me.*

*Another clash—more bitter and more degrading than
yesterday's—Evelyn is a comfort—at least unselfish and
honorable—the others have nothing but their own glory.*

Evelyn Pober was a lovely, sensitive creature, gentle-eyed,
surprisingly gregarious. She wore her hair drawn into a chi-
gnon at the nape of her neck. Evelyn did not look as if she
belonged in New York. Everything about her seemed alien to
the tough, crowded island, where weeds struggled to breathe
and good friends were rare. Evelyn lacked the shellacked hard-
ness common to most Hunter girls. She seemed to come from
some distant isle.

Although she had taken little notice of Evelyn until now, Flor-
ence had liked Evelyn's story, "The Proust Recaptured," which
was being published in *Echo*'s next issue. Evelyn's autobiographi-
cal essay described how every Sunday morning she and her four
brothers and two sisters, part of a big family whose parents were
from the Ukraine, took the El to visit the Bronx Botanical Garden.
Evelyn's observations seemed unusually perceptive. It was appar-
ent through Evelyn's writing that she was sharply aware of life. A
stem, a bud, a woman's delicate neck, the clattering blackened El
tracks, all made an impression on her delicate sensibility.

*Saw Evelyn and was delighted by her eagerness—she is full
of vitality and hopes and her face is constantly changing ex-
pressions—she is very dear.*

Spent all night with Evelyn—talking and refuting those foul charges—without her I could have done nothing—she is levelheaded and tactful—I am fond of her!

Florence spent all night in the *Echo* office with Evelyn. She was eager to clear Florence's name. When she graduated from Morris High School in the Bronx, she was in the *New York Times* for winning an award for "Good Citizenship." At Hunter, she was the vice president of Eta Sigma Phi, the honorary society for students of classical studies. Evelyn reminded Florence that *Echo* was named after the myth of Echo and Narcissus from Ovid's *Metamorphoses*. Echo was the talkative woodland nymph who fell in love with the hunter Narcissus. Rejected, chattering Echo retreated to a cave, where she became a voice heard by all.

Evelyn's calm, uncomplicated perspective helped Florence regain a sense of proportion she hadn't known since M. Evelyn was always smiling. She was enthusiastic about school and her life. She listened intently, poised over her Underwood, ready to peck out Florence's rebuttal. Florence felt her anxieties leaving her—the terrible guilt about Pearl and M, her insecurities about whether she had it in her to be a writer. Despite the task at hand, the girls passed a quiet evening. Evelyn believed Florence had been treated unjustly and helped her work on a defense that was hung in the office for her staff to read.

Out with Evelyn tonight and we talked far into the morning—It seems inevitable—but it was so different—God! It mustn't be! What am I thinking!

Those charges have been destroyed—obviously because they were groundless—but those people until today actually believed in their justification!

Florence's editorship of *Echo* stood. Peace was restored, as was Florence's besieged dignity.

Letter from Evelyn this morning that carried echoes of M— almost identical phrases—and completely similar conceptions of me—I suppose it will be.

Before Florence had a chance to respond to Evelyn, M showed up at the *Echo* office. Florence was surprised to see her. She hadn't returned any of M's calls or letters for months. M looked tired, and her usually impeccable hair needed a washing. This woman was not the M Florence remembered.

M this morning—she told me she is pregnant—and considering an abortion—It was as if a stranger spoke—abortion— M—incredible—and heartbreakingly revolting.

Thought all day of M and the physical aspect of it—he is married, has a son her age—I cannot grasp it—she was so fastidious—but she was this person in a struggle.

"I'm pregnant," said M, her wide gray eyes void of emotion. She was not in love with the married man, who had a twenty-two-year-old son. Girls from wealthy families who

found themselves pregnant were taken by their mothers on "European excursions," while others mounted dirty gurneys in dark rooms—horror stories of wire coat hangers and knitting needles. Florence had overheard her father discussing situations with her mother. Florence sensed that M, like the suicidal woman in her short story, "The Years Betray," was bent on self-destruction. Florence had escaped. M had not.

Evelyn tonight—and the same words—I love you—but with a different meaning—and again—I shuttered [sic]—for I could not respond—in any way. One day I shall blow up with my emotions.

A few nights later, Florence listened in a daze as Evelyn spoke the same words Florence had heard from Pearl and M, "I love you." Evelyn was so pure, innocent. Florence remained expressionless as Evelyn's fragile expectant look turned into one of dejection and hurt. Florence resolved not to harm Evelyn.

Realized—with bitterness because of my abandon—how truly tired I was of the delicate love-making of girls. In a boy's arms tonight—it was glorious.

Over spring vacation, Florence took the train to visit Frances in Little Nahant, which provided the necessary distance

from Evelyn. When she arrived, she went out with Manny. During her affair with Pearl, Florence had told Manny they were through, but now she was not so sure.

He was still living at home, but he seemed to have matured. Before, he had frustrated her with his lack of ambition, despite his Harvard degree, but now he provided a delicious distraction.

Manny this afternoon—I wonder if I shall marry him after all—his love is so tender, so complete—I feel mature with him.

Back in New York, phone messages from Evelyn lay scattered on Florence's bed. All of them were ignored. One chilly late March afternoon, the phone rang, and Florence picked up. It was Evelyn. In a weak voice, she informed Florence she had been in the hospital for the past three weeks. Florence waited several days before going to see her so as not to seem too available.

Park East Hospital was a private infirmary on the corner of East Eighty-third Street and Park Avenue. Florence showed up for evening visiting hours. The air in the ward smelled like her father's office. Everything was white. Florence clutched a small bouquet of lilacs in brown paper. The hospital room was long, with narrow white beds, feet facing, arranged in two perfect rows. Evelyn's bed was near the end, next to a window. Her face lit up when she saw her friend. Florence

had no excuse for not coming earlier. She felt like running away.

Visited Evelyn at the hospital—she had been ill six weeks and I was first moved to see her—a terrible shock—she is shrunken & white—but still so dear & sweet.

Florence tried to keep her shock from showing. Evelyn was as pale as her smooth pillow. She looked as if she were made of paper. She tried to raise herself. Florence sat down on the metal chair by the bed, which Evelyn's mother left to give the two friends privacy, going off to find a vase or milk bottle for the lilacs. Evelyn was so happy to see Florence. She did not blame her for the unanswered calls and letters. Florence was unsure of what to say. She felt Evelyn could read her guilt. Evelyn wanted to hear all about Florence's latest play, *Heard Flowers*, the story of a brother and sister who keep their blind younger sister from having an operation to cure her eyesight in order to shield her from her physical ugliness. The next day, Florence went back.

Saw Evelyn again in daylight she looked worse—her arms are thin and her eyes are big and dark—I felt strange—yet I wanted to give her pleasure.

Four days later. March 31, 1934.

Evelyn died today.
 Today was the funeral—and anguish, remorse and guilt—

later Marjorie for safety, but she was foul—Evelyn is dead—
the sweet, the pure, the noble—Evelyn is dead.

The *New York Times* obituary notice made Evelyn's death a reality. Her name stood out printed under "Deaths." "POBER—Evelyn, on March 31, 1934, beloved daughter of Mr. and Mrs. Louis Chanko, beloved sister of Joseph, Peter, Marussia, Mortimer, Herbert and Isabelle. Funeral services at Riverside Memorial Chapel, 76th St. and Amsterdam Av., Sunday afternoon, April 1, at 2 o'clock. Interment Cypress Hills Cemetery, Brooklyn." The New York City certificate of death listed the cause as "acute bleeding ulcerative colitis." She was only nineteen.

Florence bobby-pinned her black velvet pillbox to her head and secured her veil. After the funeral, Florence visited Evelyn's family in the Bronx. She followed Evelyn's mother into her friend's bedroom.

Visited her family—and there saw a poem, the very last thing
she had written—it was to me—she loved me sweetly—and
I withheld—wantonly, deliberately.

Walked all day and night—think constantly of what I
withheld from her—cruelly and perversely—and suffer the
damnedest torture—God knows I loved her.

Tried to escape from my thoughts with movies & ban-
quet—but it is impossible—always the poem—always my
selfishness—always her love.

New York was quiet, frozen, a place of ghosts. That week, Florence went to the opera. She saw *Il Trovatore* and *Faust*. The

operas were colorful and intense, but they didn't help. She was tired. She couldn't sleep. She tried playing tennis. Even Irving expressed sadness over Evelyn's death.

Thought of Evelyn today—cannot shake off the conviction that she has completely vanished—nothing left anywhere—her beautiful spirit gone.

Nothing—it seems such a waste—this ordinary going to school and being involved in trivial school affairs—a waste that shames me—sometimes I fear it will always be like this.

Graduation was approaching. Going to classes seemed more pointless than ever. She knew she would pass. Florence was determined to put out a great *Echo*. She proofread for hours on end. She tried to make each word speak with beauty and power. Out of thousands of words, only a few survived. Florence made peace with the *Echo* girls, who now worked diligently.

A busy, hectic day at school—with Echo due at the printers and no manuscripts in and some having to be rewritten all having to be read—it was silly.

Echo has finally been delivered—One bolder [sic] *lifted off my weary shoulders—I think it will be a very poor Echo.*

Echo arrived on the last day in April 1934, exactly one month after Evelyn died. The office looked as if a hurricane had hit. Florence opened the elegant gray cover with white art deco lettering. The *New York Times* announced *Echo*'s publication as

well as its dedication "to Evelyn Pober, a member of the literary staff who died recently." Florence had included an original poem in Evelyn's honor.

> *Echo out today—and it's quite beautiful—far, far superior to my last attempt. Evelyn would have been so delighted!*

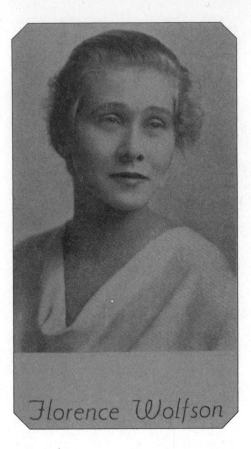

Florence Wolfson

Judging by the words beneath her portrait in the Wistarion, *her 1934 college yearbook, Florence Wolfson, who majored in painting, seemed headed for a career in the arts: "Undecided as to whether she should devote her life to painting or to writing, Florence will doubtless continue successfully to use both as media of expression."* (Photo: Tina Feinberg for the *New York Times*/Courtesy Hunter College Archives.)

THE CIRCUS

I t was late spring. Central Park once again looked like the Forest of Arden. The city's stony squares sprouted patches of green. Sketch artists, laborers, and students shared the shade of pin oaks, oriental planes, yellow locusts, and American elms in Washington Square. Boys dodged traffic as they reclaimed streets for their true purpose, stickball. Brides and grooms posed outdoors for photographers. On muggy days, from the security of their stoops, the shirt-sleeved chorus commented on the sad state of the world, offering remedies for all to hear.

"Fame throughout the wide world is the wish of every Hunter daughter," sang the purple-robed graduates of Hunter's Sixty-Fifth Commencement at Carnegie Hall on June 13, 1934. "Character and Culture" was the crowd-pleasing baccalaureate address. The processional music was the march from Wagner's *Tannhäuser*, a curious choice given the situation in Germany.

Judging by the words beneath Florence Wolfson's portrait in her *Wistarion* yearbook, she seemed destined for a career in the arts, "Undecided as to whether she should devote her life to painting or to writing, Florence will doubtless continue successfully to use both as media of expression." Her yearbook

was dressed up in a silk moiré cover stamped in gold: *Mihi Cura Futuri*, "The care of the future is mine." It closed with a poem.

Reach, skyscraper,
With your pointed spire.
Pierce a cloud;
Paint it gold—
Then what?

The Wolfsons had big plans for their daughter. Now that she had graduated, they expected Florence to find a good job and a rich husband. It was almost summer. There was no time to waste. Mother took Florence to a fashion show, outfitting her in a new wardrobe in hopes of furthering her chances of meeting "a nice man" on a stroll down Fifth Avenue. The silky brown mink coat and matching hat would have to wait in the cedar closet until fall. Engraved invitations began to arrive, addressed in calligraphy, requesting the presence of "Miss Florence Wolfson" at friends' engagement parties. It seemed as if everyone was getting married. Florence often came away from the celebrations feeling depressed. The whole atmosphere bordered on hysterical, and the brides were all the more so, dieting until weak and buying complete model house furniture sets from Sloane's to fill up their new suburban homes in Westchester and New Rochelle.

Saw "The Barretts of Wimpole Street" and from that exquisite love of Elizabeth & Browning went up to Florence's engagement party. I was chilled!

Florence went to the theater alone now. One night, she saw the play about the poets Elizabeth Barrett and Robert Browning. Robert helped Elizabeth, an invalid, played by the elegant Kit Cornell, to escape her father, who decreed that none of his twelve children marry or leave home. Robert spirited his beloved away to Italy, where the two started a new life, combining marriage and art. Florence was spellbound during the performance, but as the curtain dropped, she realized this sort of life was pure illusion. Afterward, she went to the engagement party of her older cousin, also named Florence, who was marrying a dentist.

A date & bored & almost revolted: Something about silly stuffy unimaginative men makes me sick and angry.

That summer, Florence met many eligible young doctors and lawyers. Some were charming and intelligent, but most were crushing bores. Florence found one in particular, Charles, a doctor, completely self-centered. He behaved like a child when Florence spurned his advances.

⬛

Saw Pearl at twilight—she was very glib and told what I think countless lies—It was very pleasant.

She went out with Pearl a couple of times. She enjoyed seeing her again, but there was no hint of romance.

Pearl tonight—she seems to be getting along very well and very confident of herself—there can be no doubt of her success—she'll write successfully.

There were some good times with Caryl, her old friend from Wadleigh days, the pretty blonde with the alabaster white skin who was Florence's first artist's model. It was just as well that their relationship stayed platonic.

Florence invited Caryl up to Little Nahant to visit Frances. When Caryl met Arnold, the mustached twenty-two-year-old son of Frances's sister Ray, it was love at first sight. Caryl and Arnold, his stepsister and her beau, and Florence all went out one evening. Florence felt like the fifth wheel. They drove up to a lovers' lane at the top of a cliff, where the couples speculated, "What do you think we should do with Florence?" Seventy years later, Florence still remembered Arnold's suggestion: "Throw her over the cliff?"

I prefer now to be alone and think and watch people. To the theatre—a play on the Brontës—fascinating material—but how much more so is Wordsworth! I must start.

It was a frustrating time for Florence. She felt an overwhelming emptiness. She did not think she was making progress in either her writing or painting, but after seeing a play on the Brontës, she was determined to write a play on Wordsworth. She had written her senior thesis on the poet, working on it until she felt his words as if they were her own.

*Walked miles today—swiftly and alone—to sustain soli-
tude for so long with complete satisfaction—is encouraging.*

Walking through Central Park, she thought of Wordsworth
tramping through the Lake District. The tall buildings came into
relief against the early evening sky. The fading sun discarded

Florence had an adventure with two wealthy men at the Pierre Hotel.

pink-orange shadows, which slid across the huge gray buildings on Fifth.

Planning a play on Wordsworth—possibilities are infinite.

■

One hot July night, as she walked up Madison Avenue, a shiny black chauffeur-driven Packard limousine pulled alongside her. Two men were seated deep in the back. From the tailoring and fabric of their suits and silk ties, and from their gold watches, Florence could tell they were wealthy. They complimented her, inviting her to join them for a glass of champagne at the Pierre. Against her better judgment, Florence folded herself into the automobile. The car slowly turned down Fifth.

They offered her a drink from the bar. She didn't have time to take a sip before they pulled up at the canopy of the forty-one-story white granite Hotel Pierre looking down on the Plaza. Next door was the Metropolitan Club, the robber-baron men's society formed by J. P. Morgan and the Vanderbilt brothers, William and Cornelius. Griffins holding lanterns adorned the Sherry Netherland, with its intimate lobby modeled on the Vatican library.

A white-gloved attendant opened Florence's door. She stepped out. Hand-painted French murals reflected in the lobby's gilt mirrors. The street seemed far away. This was the world Mother wanted for her. Engraved within an alcove was the Pierre's motto, "From this place hope beams." Florence followed the two

men into the mahogany-paneled elevator. "Penthouse," directed the taller of the pair.

Double doors opened to a suite—flowers everywhere. French doors led onto a terrace with the most magnificent view. The skyline encircled Central Park like a jeweled choker. The shorter man gave her the tour. There was a bar and safe, a black marble bathroom with lotions and bubble bath on the edge of the tub, stacks of towels embroidered with the Pierre's monogram. Dominating the master suite was an almost too big, satiny bed. Champagne cooled in a silver bucket on a stand next to several long-stemmed flutes.

"A glass of champagne?" The taller man joined them, popping the bottle, letting the cork fly. Florence felt them watching her, waiting for her reaction. She took a sip of champagne. "Have you ever seen a circus?" asked the tall one, refilling her glass. "We're going to have one here."

"A circus?" After what she had seen in the penthouse and the flowing champagne, a private circus did not seem that far-fetched. Florence imagined lions and tigers lounging in the opulence. She had gone to the Madison Square Garden Circus many times. She loved the tightrope walker and the lions jumping through blazing hoops of fire. "This kind of circus is different," continued the man, eyeing her. "It's a woman and an animal having sex. We're importing this circus from New Jersey."

Sophisticated eighteen-year-old Florence was stunned, frightened. Although she had gotten into their car, didn't they realize she was not that kind of girl? "More champagne?" They talked for a while, trying to convince her. Florence wanted no part. They offered to have the chauffeur drive her home. In the lobby,

Florence passed a woman walking a brindled greyhound wearing a rhinestone collar.

A sordid adventure in fashionable enough surroundings—I think I am too frozen to be further disillusioned—but those men! Powerful, mature—my God!

Trying to convince a cheap tabloid that an art column written down to the public would be a good thing—a chance of success. Brought a few samples of a possible column to the "News"—the reaction was not encouraging—but no definite answer given—of course, it was such an absurd thing to expect.

"Make us proud," was her parents' powerful refrain. Florence didn't want to disappoint. She visited the city desk of the *Daily News*, with a large globe rotating in its lobby on East Forty-second Street. In the city room, telephones ringing off the hook competed with the spurt of ticker tape. Copy boys raced between the newsroom and the basement ruled by pressmen. Young reporters loosened their ties, stubbed out cigarettes, calling out, "Cop-y!" She proposed to start an art column, bringing a few samples of her writing. One of the editors asked her out for a drink.

Decided to go into business with Mother—as hostess-secretary-business manager—I will be useful—and inject life into the whole business—it sounds interesting.

Mother suggested Florence come work with her. Rebecca Wolfson Gowns could use her talents to bring a fresh, youthful look to the business. Florence could design her own line and bring in younger clients. Florence agreed to give it a chance, but soon changed her mind. Mother's way was not hers. Although she always dressed beautifully, clothes weren't important to her. Many girls she knew from Hunter were trying to land jobs as lingerie buyers at Macy's. This was not Florence's idea of putting a mind to good use.

＿■＿

Saw Janet—she is going to England—with a definite idea—a love for something real and substantial—and with ability to work it out— certain strength.

At night, Florence rushed into a taxi and directed the driver to hurry. The cab pulled up at the gateway to the Cunard White Star Line pier. It was just before midnight, sailing time. "Flowers for your sweetheart," cried out a boy. "How about a postcard?" Vendors hawked "Ocean liners in a box" wrapped in cotton tufts of steam.

The red, black, and white *Majestic*, the largest steamship in the world, loomed before Florence against the backdrop of indigo sky. Florence was seeing off her friend Janet Racolin. Florence studied the passengers' trunks, plastered with pictures of faraway hotels—Excelsior, Grand, Imperial, Metropol, Continental, and Hotel Mediodía in Madrid. On one of the trunks the Orient Express rounded a bend through a romantic gateway. Florence watched *Majestic* glide away from the pier, as easily

as the model boats in Central Park. *Majestic* grew smaller and smaller. The crowd thinned out.

Waiting on the subway platform, Florence glanced over the subway map, wishing it was a plan of Paris. "Obey the law, do not smoke, or carry a lighted cigarette, pipe or cigar on any station, train, trolley or bus," read the sign above her head, "Offenders will be prosecuted." Inside the green subway car hung with straps and metal fans, all she could think about was sailing away.

Exhausted—in pain—& thirsty for real beauty—thirsty? Dying for it. A party—and so bored that I quit and went home—reading Gertrude Stein—her egotism is delightful—and she knew everyone—Picasso, Matisse, Gris.

Curled up in her armchair, she read Gertrude Stein's *Autobiography of Alice B. Toklas.* Florence imagined visiting 27 rue du Fleurus, Stein's home and her private salon, which attracted many artists and writers. Picassos and Matisses hung on the walls. Primitive sculpture cluttered the giant mantel. It was she who named Ernest Hemingway, F. Scott Fitzgerald, Ezra Pound, John Dos Passos, and other writers who abandoned America to write in Paris after the Great War, the Lost Generation.

Under Florence's bed, ready for Europe, if she could only convince her parents, was her black patent leather luggage set, three matching pieces: the big valise from Frances for her high school graduation, a vanity case that opened to a mirror, and

a circle case. Florence's diary ended on August 10, 1934, the day before her nineteenth birthday. In one of her last entries, Florence wrote,

Janet sailed—to be gone 16 months—! The most marvelous thing that could happen to anyone—Am considering the same if possible. I want so much to leap from myself to an outward reality and if I cannot do it—I am no poet!

ABOVE LEFT: *The poet Delmore Schwartz, pictured as a young man, was a member of the literary salon Florence hosted in her family's apartment. "All of us consume each other, and life without such friends as we are to each other would be unbearable," Delmore wrote in his story, "The World Is a Wedding," about a young literary circle he was a part of. He died at fifty-two in a seedy Midtown hotel.* (Photo: the *New York Times*.)

ABOVE RIGHT: *Eliot, Joyce, Yeats, and Auden were the heroes of Florence and her salon, which included the young poet John Berryman, pictured here in 1937, who went on to win the Pulitzer Prize for* Dream Songs. *He ended his life by jumping off a bridge when he was fifty-seven.* (Photo: the *New York Times*.)

THE SALON OF
FLORENCE WOLFSON

When she was younger, writing and drawing and music all seemed inaccessible to her, yet now she is adept at all of these arts. That her writing is propaganda, she confesses with a readiness rarely encountered in young artists. For Florence feels that her life will remain apart from the turmoil of modern economic struggles," wrote the Hunter reporter who profiled Florence in her 1934 *Wistarion* yearbook. "After all," Florence said, "isn't everything that is written propaganda? Not necessarily political, of course," she hastened to add. "I read about strikes and revolutions, but when I walk out into the night and see the sky above, I think: after all, are these things important to me? And I find they are not."

In the fall of 1934, Florence, just nineteen, enrolled in the graduate English program at Columbia University, the Acropolis of New York, across the street from Barnard, where she had shown up for her interview in a jacket and tie. Entering through the gates on Broadway and 116th Street, Florence was now one of a select group of female graduate students. She studied van Gogh's agitated canvases and Cézanne's apples with the art historian Meyer Schapiro. She attended parties with the illustrious Lionel Trilling. She found a mentor in the poet and critic Mark Van Doren.

In his three-piece suit, smoking a pipe, Professor Van Doren inspired Florence to be politically active for the first time in her life. Together, they organized a peace rally protesting America's plans to send troops to Europe, where three dictators—Mussolini, Hitler, and Stalin—were poised to dominate the world's stage. "No second front," shouted Florence from the steps of Low Memorial Library. Hundreds of students in tweed and camel's-hair coats echoed her protest. In front of the names of the immortals engraved above the colonnaded facade of the university's newly erected Harkness Library, later renamed Butler, she shouted, "We won't go to war!"

There were thrilling discoveries to be made all over Columbia's campus. Athena's white marble bust greeted her at the entrance of Low Library, which was modeled on the Parthenon. She walked across the twelve signs of the zodiac embedded in the floor. There was a cast of Rodin's *Thinker* beside St. Paul's Chapel, with its medieval stained-glass windows. A short walk away, St. John the Divine was on its way to becoming the largest Gothic cathedral in the world.

At times it seemed Columbia required the impossible. Florence and her fellow M.A. candidates were assigned a full biographical exegesis on an obscure literary figure for their theses. The task was to resurrect one individual's story, like a needle lost in time's haystack. Florence's needle was John Hughes, an English poet and critic of Edmund Spenser, author of *Faerie Queene*. Hughes lived from 1677 to 1720, little known to anyone outside of Queen Anne scholars. Florence had to produce thousands of words on a figure who failed to warrant more than an inch of space in the pages of hefty encyclopedias.

Her research led her into the darkest recesses of the library's stacks, where she was witness to some very nonintellectual pursuits. It was a favorite necking place for master's and doctoral candidates. She spent hours in the Beaux-Arts New York Public Library on Fifth Avenue and Forty-second Street, its millions of books guarded by two proud lions carved in pink marble. Mayor Fiorello LaGuardia named the lions Patience and Fortitude, the attributes he thought every New Yorker should possess.

"Beauty old yet ever new eternal voice and inward word," Florence found carved above a female nude in a fountain niche of the library's edifice. Inside, she submitted call slips for her books, brought up from the stacks on a book lift and delivered to her numbered seat by a librarian. She worked at one of the wooden tables in the reading room, Room 315, lit by arched windows and chandeliers. Besides other students, the reading room was a refuge for out-of-work businessmen who treated the library as their office.

"A good Booke is the pretious life-blood of a mafter fpirit, imbalm'd and treafur'd up on purpofe to a life beyond life," read John Milton's words above the door. Under a brass lamp, hair in a messy bun, Florence read through piles of books, her mind revolving around one thought: What makes a person great? What makes a life significant?

"I had often thought wrapping gowns and dirty linen—the bane of conjugal love," read Hughes's pathetic correspondence. She could take it no longer! Dr. Johnson had included Hughes in his *Lives of the Poets*, but Jonathan Swift and Alexander Pope had thought his verse and prose mediocre. Florence concluded

that Hughes was hopelessly second-rate. On her faithful Remington, Florence finished her heavily footnoted, one-hundred-page master's thesis, "The Life and Work of John Hughes," with her first, forceful interjection of the first person—which students were discouraged from using. Florence typed with passion, "The great tragedy of most lives as I can see it is that the mind and spirit are rarely equipped with sufficient power to realize an endowment. There are the geniuses and there are the feeble ones. John Hughes was not a genius."

Florence had another realization while conducting her research. It was that life was out there for her to experience, not merely to contemplate, cooped up in a room. She joined the Columbia Drama Club. Invited to a Valentine's Day formal, she had to go to rehearsal first. Mother made her a drop-dead gold lamé backless evening gown, which fastened around her neck with a jeweled clasp, like a starburst. She stepped onstage in the gown, which she wore without a bra or stockings. The fabric flowed down her half-naked body like liquid gold, spilling at the hem, barely showing the tips of her sandals. She created a sensation.

Florence's escort to the faculty dance was Dr. Brown, a mathematician in his mid-thirties. His name was Arthur, but he preferred her to call him "Doctor." That evening, she found him to be a ridiculous figure. He was academically brilliant, but socially inept. He introduced Florence to Bernard Koopman, a thirty-five-year-old professor known for his work in dynamics, probability, and "ergodic theory," later called chaos theory, and central to pure mathematics. Professor Koopman asked Florence to call him Bernard.

Unlike Dr. Brown, he didn't try to overwhelm her with

his knowledge. Bernard was a good dancer. As they traveled around the room decorated with doilies and red hearts, she learned that he had lived in France and Italy with his family before attending Harvard and earning his Ph.D. at Columbia. In Paris, he had known Eva Le Gallienne, when they were both teenagers, around the time Eva made her stage début at fifteen. Bernard and Eva used to play football in the Luxembourg Gardens. Looking from Dr. Brown to Bernard, Florence understood how essential a full life was.

As Florence bent to light the fire in the fireplace, she unpinned her long hair and let it cascade seductively onto her shoulders as her guests pondered Aristotle's *Art of Poetry* and the life of Saint Thomas Aquinas. These were their heroes. Her first year at Columbia, Florence began a salon in the Wolfsons' living room, assembling an avant-garde group hungry for ideas and as passionate about words as she was. Ideas were their aphrodisiacs, the intellectual lifeblood of their being. Each member's day-to-day existence was driven by discussions of Socrates and Plato, relating lofty truths to daily acts like riding the subway. The circle was their real life. They were bohemians, wandering along Riverside Park on a Sunday afternoon, stopping for a thirty-five-cent Chinese banquet or rounds of beers. "Eccentric" or "unusual personality" described just about everyone in the circle.

The salon members were flamboyant, shrewd, artistic exiles from immigrant families. The American dream, for their parents, had been to get rich at whatever cost, no matter what

labor was involved. Their parents were craftsmen, trades-men, and merchants. Their life's work was work. Florence and her friends wanted to be recognized for their artistic genius. They read the *New Yorker*, *Harper's*, and the *Atlantic*. They despised the bourgeois ethics perpetrated by magazines like *Collier's* and the *Saturday Evening Post*. They read aloud from *Hound & Horn*, a literary quarterly founded by Harvard undergrads Lincoln Kirstein and Varian Fry in 1927, devoted to writers they idolized, T. S. Eliot, Ezra Pound, and Ger-trude Stein.

Florence served white wine on a silver tray at the group's midnight sessions. Her friends stayed until early morning, talking philosophy, getting drunk, having little orgies in Florence's bedroom, seeking physical as well as intellectual pleasure, all in pursuit of "the Socratic quest." "Know thy-self—*gnothi seauton*," reminded their hostess. They medi-tated on Socrates's famous line, "The unexamined life is not worth living."

Many of the private thoughts Florence had only shared with her diary until now were revealed to the group gathered around the Wolfsons' fireplace. As they debated the ethics of Aristotle, they tried to demystify the values of their own homes. Someone suggested that perhaps the problem with their parents was that they didn't make enough love, and that these repressed feelings of sexuality had forced them into shriveled lives.

Florence had never seen any warm connection between her parents. Yet she remembered once, when she was little, going to Mother and saying, "I'm tired of sharing a room with Irving.

As a nineteen-year-old graduate student at Columbia, Florence hosted a salon in her parents' apartment. (Photo: Courtesy Florence Howitt.)

Why can't I sleep with you, let Daddy sleep with Irving?" Her parents laughed, speaking to each other in Yiddish. Florence didn't know what they were saying, but understood that married men and women slept in the same bed. Another time, searching for change at the bottom of Mother's underwear drawer, Florence felt something beneath the big underpants and girdles. The small flesh-colored rubber dome was a total

mystery. She had difficulty imagining her parents making love more than twice, once for her and once for her brother.

<center>▬</center>

The twenty-one-year-old poet Delmore Schwartz was the golden boy of the circle. Gesturing wildly in front of the fireplace, his dark blond hair damp with perspiration, Delmore preached the relevance of the classical philosophers to their own lives. Equally at home with baseball stats and the canon, he was the group's orator. Florence leaned against the mantel, mesmerized by his torrent of words. Looking around the room, sketching her friends in her mind, Florence wondered about each one's fate.

<center>▬</center>

In 1932, after coming such a long way together from playing duets on the piano as little girls to telling delicious stories about Bernie at Far Rockaway and sighing over Nat, Florence and her old friend Gertrude Buckman had a falling out. It wasn't an argument, but a difference in how they saw each other. It happened just before Florence met Pearl. All grown up, Gertie no longer wore her chestnut ringlets long. Her pale complexion was as refined as any on the Sunday society pages, and she had legs a Ziegfeld Follies girl would envy.

Before they parted ways, the two friends would go down to Greenwich Village together, where they spent hours searching the shops along Booksellers' Row on Fourth Avenue. They had luncheon at an Italian café, where Florence took a photograph

Florence took a photo of her friend, Gertrude Buckman, who had aspirations as a painter and sculptor. In 1938, Gertrude and Delmore Schwartz married. Their marriage ended in divorce six years later. (Photo: Courtesy Florence Howitt.)

of Gertie, laughing over the red-checked table. At night, the young women saw Le Gallienne's *Camille* at the Civic Repertory Theater. Both came from overbearing families, but had found an escape in writing. Florence painted. Gertie had aspirations as a painter and a sculptor. Not so much had changed since they were fourteen. Gertie still loved hearing Florence's adventures, begging for ever more details. Back then, Florence wrote in her diary,

*Received a beautiful letter from Gertrude today—she writes
well—and sensitively—how I wish she were a man!*

Florence was attracted to Gertie, to her mind and way of
seeing things. But ultimately Florence felt that Gertie was
exploiting her experiences for her own writing. Florence
wrote,

*Out with Gertrude for luncheon—a delicious meal. But more
than once I felt like screaming. I was stifled.*

*Our relationship is merely a clearing house for my experi-
ences—it can't last that way.*

⌨

*To Gertrude's tonight and met boys who shocked me into
respect—brilliant, thoughtful, gentle and mentally fastidi-
ous—the conversation sometimes oppressed me—it was too
logical.*

In March 1934, Gertie and Florence started seeing each
other again. Time had managed to erase their misunder-
standings. Gertie introduced Florence to her boyfriend, Del-
more, whom she had met while studying literature at New
York University. Delmore's name meant nothing to Florence
at the time. She just thought of him as Gertie's beau. The
three formed a loose comradeship with Delmore's friend
Julian Sawyer, who, like Delmore and Gertie, had grown up
in Washington Heights.

Heard Bach's Matthew Passion—some of it glorious—and stayed up again till early morning talking & talking with Gertrude & those 2 boys.

Florence's salon grew out of this group. Julian was openly homosexual and did a good impersonation of Greta Garbo. He greeted Gertrude Stein when she arrived in New York, falling to his knees on the pier. In 1941 Julian published a book, *Gertrude Stein: A Bibliography*.

In the summer of 1934, after Delmore's junior year at NYU, he moved to a room in Greenwich Village and vowed to become a great poet.

All of the members of Florence's salon were writing—plays, short stories and novels. All were gifted, but unrecognized. Among those taken with the brainy and beautiful graduate student was the poet John Berryman, who went on to win the Pulitzer Prize in poetry for his *Dream Songs*. There was a young Greek named Hippocrates Apostle, born in Tyrnavos, who came to New York as a child. Hippocrates was crazy about Florence. He would become a leading translator of Aristotle.

Florence invited William Barrett, a Ph.D. student, who later described himself at that time as a "lugubrious bookworm," to her salon. He went on to become a professor of philosophy at NYU, and one of the foremost interpreters of existentialism with his book *Irrational Man*. He wrote about Florence in his memoir, *The Truants: Adventures Among the Intellectuals*. "There was a young lady who was going around trying to do what seemed a very unlikely thing at the time—to assemble a salon," wrote Barrett. "It seems there was a man coming up from downtown and he and I were simply made to know each other."

The young man was Delmore Schwartz. Barrett was skeptical at first, but Florence's instinct proved right. Will became a regular at her salon, and he and Delmore soon became the closest of friends. In the 1940s, they began working together as editors at the *Partisan Review*.

Some of Florence's friends were of the opinion that homosexuality, as practiced by the Greeks, was noble. John Latouche, a poet and librettist whose ancestry was French Huguenot and Irish on his father's side and Jewish on his mother's, grew up in Richmond, Virginia. His mother and father were divorced when he and his younger brother were small children, and they were raised alone by their mother, Effie Latouche, a seamstress, in circumstances of genteel poverty.

His love of men inspired the book and lyrics he wrote for Columbia's 1935 varsity show, *Flair-Flair: The Idol of Paree*, performed in the grand ballroom of the Hotel Astor for an audience of students and their parents as well as serious theatergoers and critics. *Flair-Flair*'s setting was Paris in 1912 with scenes at a Montmartre café and at the Folies-Bergère. One of John's hottest lines was, "Oh give me a man who with one word'll make me jump right out of my girdle!"

Latouche, then a sophomore, was expelled for the lewdness of his lyrics. "Touché" was his signature line. He continued attending the salon. Later in his career, he wrote the lyrics for Broadway shows, including *Cabin in the Sky* and *The Golden Apple*, a retelling of Homer's *Iliad* and *Odyssey*. In the 1950s he held his own salon on the Upper East Side, entertaining Ten-

nessee Williams, Carson McCullers, and Truman Capote. He introduced Jane and Paul Bowles to each other.

Most members of Florence's salon had experienced difficult childhoods. John Berryman's banker father shot himself when his son was twelve. Afterward, the young poet moved from Florida to Astoria, Queens, with his overbearing mother and his younger brother. When Delmore Schwartz was sixteen, his father died, leaving his family virtually penniless. Delmore would spend his life writing about the last time he saw his father. He was with his brother in Times Square. It was raining. Delmore brushed against their father's sandpaper cheek in a good-bye kiss through the window of the cab, which took off into the night.

In 1938, Delmore was finally recognized for writing a masterpiece, a short story called "In Dreams Begin Responsibilities," in which his narrator sits in a movie theater watching his mother and father on a date on the Coney Island boardwalk in 1909. At the moment his father proposes to his mother, horrified, Delmore's character jumps up from his seat and shouts, "Don't do it. It's not too late to change your minds, both of you. Nothing good will come of it. Only remorse, hatred, scandal and two children whose characters are monstrous."

Another quarrel with the family—over a trip abroad—everything I suggest is condemned—there is nothing beyond the conventional rightness of what they think.

In May 1936, Florence received her master's degree in English literature from Columbia. Europe was an artist's paradise with its art and literature, philosophers and playwrights. It was a beacon, a life destination. Everyone in Florence's circle was in a race to get there. She had been working on her parents since Janet had sailed in 1934. Her diary entries from two years earlier still echoed her feelings.

In a blind and utter stupor—all day—home is wretched—to pity my parents is futile and destructive—and unless I fly from here—I think I have been cheated of rich beauty.

"Why shouldn't I go to Europe?" Florence asked her parents. Magazine articles described American exiles as escapists seeking inspiration in sex and alcohol. *Lose Your Innocence Abroad* was a popular guidebook. Mother felt Florence's chances of meeting a successful doctor from a good family were better in New York than aboard a lurching ship or running around in uncertain Europe. Rebecca's offer to Florence was another summer in the Catskills, where she would meet "a nice Jewish man." To Mother and Father, Europe was still the old world of oppression, which they had fled, and where they would never return. There were other considerations. Once again, the world was spinning out of control. "Who knows what to expect?" said Mother. "This is no time for a young woman to travel to the Continent alone."

Just shy of her twenty-first birthday, Florence went to the Cunard White Star office and bought a ticket to Europe. She used part of the four hundred dollars she still had from winning the Regents, New York State's college scholarship, at

fifteen. She hadn't spent the money because she had gone to Hunter, as her parents had insisted. There was not a lot the Wolfsons could do, beyond making Florence promise to return after her tour, which would last three months: Memorial Day until Labor Day. The long battle with her parents was over. To the members of her salon, her ticket was as good as a letter of introduction to James Joyce. Florence had won.

A photograph postcard of Filippo, an Italian count and poeta-aviatore, Florence fell for in Rome. In a white aviator's jacket, flying out of Italy's first airport. Filippo inscribed the photo, "Florence! Ti voglio bene . . . Filippo 2 luglio 1937. R. Aeroporto Centocelle Nord." (Photo: Courtesy Florence Howitt.)

THE ITALIAN COUNT

At midnight, surrounded by shouts, echoing laughter, and blue-gray clouds of steam, the ocean liner glided out of New York Harbor. Florence was sailing on her own maiden voyage. "All ashore that's going ashore!" It was the final call. Gongs sounded. Uniformed sailors in caps and licorice-thin black ties raised the gangplanks with tall canes. "Where are the trunks? Don't forget to write! I love you! Bon voyage!" The voices trailed off. With an enormous blast, the ship's horn announced the start of the ten-day, three-thousand-mile voyage. Florence offered one final wave to Irving and Mother, who had reluctantly come to see her off. The Wolfsons watched Florence dissolve into a blurry doll.

The crowd flung kisses and confetti at the departing ship. They waved good-bye, mouthing unheard words. Florence felt as if the eyes of the whole world were upon her. Manhattan's skyline and the tall columns of the Palisades receded, and the lights of Coney Island grew fainter until there was not even a speck of light. Standing together on deck, students let out shouts of freedom. It was like a scene out of the Astaire and Rogers movie *Follow the Fleet*, which was playing at the RKO Palace, its mini-drama dances romantically set against a moon-lit deck, Ginger wearing a satiny sailor suit singing Irving Berlin's "Let Yourself Go."

Unlocking steamer trunks, opening drawers to release pajamas, slippers, and robes, Florence became acquainted with Natalie. Their parents had arranged for the two to travel together, sharing a bunk in their small cabin on the lower level of the ship, which also accommodated two other young women. Florence laid out her pot of cold cream next to Natalie's pink boar-bristle toothbrush. She was going to Europe to get away from girls like Natalie. Her eyes traveled down the brunette's brown turtleneck and formless beige skirt, which looked like a Girl Guide uniform, to her thick brown stockings disappearing into sensible wedged heels.

Natalie made Florence feel as if she was headed for Camp Louise, where she had worked the previous summer—until a typhoid epidemic broke out—instead of embarking on her long-awaited artistic escape. That night on the pier, before departing, Mother had given Florence a sharp look amid the chaos of fond farewells and hoisted trunks. Mother reiterated the plan for the girls to stay together the entire time they were abroad. European universities provided inexpensive board for student travelers. Florence and Natalie were to divide their stay between University College London and the American House of the Cité Universitaire in Paris. Passengers received baskets of fruit, lollipops, and bon voyage letters like nautical valentines. One card pictured a cute wet puppy, like Nipper, the RCA dog, peering out of a life preserver.

Florence spent the first six days of the journey feeling dizzy and nauseated. Shaken like a martini, she thought she was going to die in her rocking cabin. Natalie, who was as hardy as she looked, brought crackers and apple slices back to the cabin, the only treatment offered seasick passengers. Alone in her

Florence sailed to Europe on the Georgic *in May 1936. Florence took this picture from the deck of her brother and mother, center, who came to see her off.* (Photo: Courtesy Florence Howitt.)

bunk, Florence thought of all the fun she was missing. But as the distance between Florence and home increased, she started feeling better. By the sixth day, the queasiness and vertigo were gone.

Florence rented a wooden chair on deck for sixty-five cents and wrote her name and cabin number on the small plaque nailed to it. She came out from under her parasol to meet handsome Peter Anderton, a young doctor from Australia with dark pomaded hair and a book tucked under his arm. Conversation between two strangers was eased with an amber nip of cognac. Peter smoked a pipe. They waved as the impressive *Queen*

Florence had a shipboard romance with Peter Anderton, a young doctor from Australia. They also spent time together in London. (Photo: Courtesy Florence Howitt.)

Mary passed their ship. They dined together. Florence also met another Australian, dapper blond Tom Lowe, and an artist, Adolf Dehn, who was a friend of e. e. cummings.

Peter rolled a cigarette for Florence, brushing a loose strand from her forehead. Natalie strolled by on deck, eyeing them. Florence figured they'd be together long enough in Europe. She was going to enjoy this leg of the journey on her own. The quality of the light, the color of the sky, the air, all seemed better, different, as if she were experiencing them for the first time. On the tenth morning, Florence made out a lighthouse.

Foghorns sounded. Tugs guided *Georgic* into port at South-ampton, where Florence walked down the gangplank carrying her patent leather circle case.

Home at last on the soil trod by her beloved Wordsworth, Coleridge, Shelley, and Keats. The British official smiled at Florence's photo, welcoming her on behalf of His Majesty, and stamped down hard in her passport. Once she and Natalie dropped off their bags at the dormitory, Florence was ready to go exploring, but Natalie wanted to attend the afternoon tea for American students. Florence already knew people in London. Janet Racolin had given her several letters of introduction to men she had met while in England two years earlier.

Waiting for the double-decker bus under her crimson hat, Florence was thrilled at the mere sight of the king's coins on her outstretched palm encased in her soft brown kid glove. She loved the English accent and the sound of heels walking over cobblestones. At the British Museum, she studied the three god-desses of the Elgin Marbles, marveling at the way the forms flowed into each other.

Tom Lowe took her to Ascot. They motored to Hampton Court, meandering through state rooms and sipping wine by the palace fountain. They tasted the fruit of the Great Vine, the oldest grape vine in existence, growing vigorously in its hot-house. He also invited her to see the Aldershot Tattoo, a Brit-ish military drum performance dating back to the seventeenth century, which alerted soldiers it was time to return to their

barracks. Guns went off, leaving the acrid odor of gunpowder in the air. Other than London's newspaper stands, there were not many places Florence sensed war anxiety.

Florence had a letter of introduction to a young Indian studying at the London School of Economics, who invited her to a ball. Mother would have disapproved, but Florence was thrilled. She had packed a gown for such an occasion. The ballroom was like something out of F. Scott Fitzgerald. A ten-piece orchestra played for the room filled with men in crisp dinner jackets and young women, who reminded her of M. Her tight blue-silk halter dress matched her eyes. A group of

Florence also met dapper blond Tom Lowe on board the Georgic. (Photo: Courtesy Florence Howitt.)

Lily Koppel

admirers gathered around her table, cigarettes poised, as Florence recited poetry, in French, from Baudelaire's *Les Fleurs du mal*. Glasses clinked late into the night.

Another letter introduced Florence to a member of Parliament who asked her to tea. On the House's terrace above the debates and judicial hearings, she ate wild strawberries with clotted cream before she was off to Covent Garden to see *Swan Lake*. It was only Florence's first week in London, and Natalie was very angry. "I'm leaving you," she stormed at Florence. "All you do is run around on dates. I met some girls and I'm going to travel with them."

Florence tried to convince Natalie to stay. She invited her out with Peter Anderton and his friend Bill, who Florence said wanted to meet Natalie. It was a beautiful day. They all motored to Windsor Castle and picnicked at Runnymede, where the Magna Carta was signed. Natalie sulkily smoked her cigarettes and posed indifferently for group photos. When they returned to the dormitory in London, Florence was delighted that Peter had fallen for her. Natalie packed in a hurry and left. Florence was stunned. Abandoned in London! But she realized it was the best thing that could have happened. Getting rid of Natalie was like losing a piece of cumbersome luggage. Florence had no stomach for watered-down personalities. She was ready for a solo adventure.

The first thing she did was visit Oxford, which Matthew Arnold called "the city of dreaming spires." Students rode to lectures on bicycles through the town, black gowns flying behind them. Florence wandered through Christ Church Meadow and Magdalen College, where she had tea with a student. She was invited to another ball. She also visited Cambridge, where

Florence arrived in London in June 1936. (Photo: Courtesy Florence Howitt.)

Samuel Pepys's seventeenth-century London diaries were on display. She had given a copy to her brother as a present before sailing, inscribed, "For Irving—with the deepest affection—Florence."

Florence saw Shakespeare country and the Bard's modest home in Stratford. An oak staircase led to the Birth Room, its walls covered with signatures of visitors—Thackeray, Dickens, and Browning. She found the names of Walter Scott and

Lily Koppel

Florence on the terrace of Parliament, where she was invited to have tea by one of its members, pictured here. (Photo: Courtesy Florence Howitt.)

Carlyle. She didn't skip the half-timbered Elizabethan farmhouse of Anne Hathaway, where two young women gave a talk about the woman who had married Shakespeare in 1582 while pregnant with his child. Hathaway was twenty-six and Shakespeare was eighteen. Florence loved the thought of an older woman with a younger man.

She visited imposing York Cathedral. The names of England's inns, the Unicorn, Swan, and Mermaid, made her feel

as if she had entered Le Gallienne's production of *Alice in Wonderland*. Florence hiked the Lake District, walking from the village of Windermere to Grasmere, visiting Dove Cottage, the home of Wordsworth. She ran her hands over a cool slab of unadorned slate, the poet's grave, without so much as an epitaph, next to a murmuring brook. She saw the daffodils. Her path led her through fields, over hills, past the Mortal Man Inn and the summit of the Old Man. She felt like a child again. Inhaling deeply, she soaked in the view, the stone walls, valleys, and lakes. She stopped to rest in a tea garden. Water lilies floated on their pads. She stayed the night at the Temperance Hotel in Grasmere.

In the morning she climbed the loftiest summit, looking

Florence's travel companion, Natalie, pictured here with Peter Anderton and his friend Bill, on a double date, just before Natalie left Florence. (Photo: Courtesy Florence Howitt.)

over the Lake District. She thought, This is where he wrote "I Wandered Lonely as a Cloud"! She recited her favorite lines from Wordsworth to the landscape: "In which the burthen of the mystery, in which the heavy and the weary weight of this unintelligible world, is lightened." Just three years before, when she was eighteen, Florence had written in her diary,

How I love it—writing, acting, breathing the atmosphere— and one day I'll have it. If I cannot write, I shall die.

Florence continued by rail to Scotland, where she climbed the hill to Edinburgh Castle, which she had practically to herself, looking over the misty city. She walked the Royal Mile to the remains of Holyrood Palace, where she saw the dingy room where Mary Queen of Scots had spent her last days before she lost her head. In one of the shops on Princess Street, Florence modeled a Harris tweed coat. The boiled wool bore traces of seaweed from being spread on the beach to dry. She treated herself, as well as to a case of Scotch, which she sent ahead to the ship. She started back to London, where she picked up her luggage, posted a farewell letter to Peter, and continued by rail to Dover, where she caught a steamer to Calais. It was already mid-July. Time was flying.

Crossing the English Channel to France, Florence met two tall, bespectacled young Germans. Gerhardt and his awkward friend rattled on about their studies at Heidelberg and Munich. Florence had taken German at Hunter, but they were eager to

impress her with their stilted English. Gerhardt insisted Florence come back with them to Bavaria.

"We want to show you off," said Gerhardt.

"You are the perfect Aryan girl," agreed his friend.

While she was on the ship, they were impossible to escape. Florence's parents had forbidden her to go to Germany. Usually one to speak her mind, Florence was reluctant to tell them that she was Jewish. Political unrest was growing. Since she had arrived in Europe, civil war between the Republicans and the Nationalists lead by General Franco was raging in Spain. El Greco's paintings of the ecstasies and torments of the soul would have to wait.

Florence arrived in Paris, happy to be alone. The Cité Universitaire provided quarters for university students from all over the world. She registered with the old concierge at the American House. There was no sign of Natalie. Florence wandered through the Tuileries of the Louvre, racing up the great staircase to the *Winged Victory*, the ancient Greek goddess. Now Florence had one to celebrate too.

She found her way around Paris without a map, browsing the bookstalls along the Seine. Notre Dame towered above. She bought a beautiful book of geological maps of the Seine, dissecting the sedimentary layers of rock and silt on which the City of Lights rested like an artist's model on her divan of pillows and shawls.

Florence sat at an outdoor table at the watering hole of many artists and writers, Café de Paris. She settled herself with a pack of Gauloises and a glass of red wine, resting her Leica on the marble tabletop. She felt as if she were watching the street from an opera box. She took a photo of the café

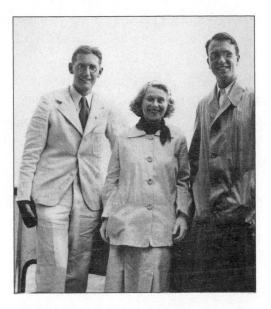

Crossing the English Channel to France, Florence met two young Germans. Gerhardt and his friend, who wanted Florence to come back with them to Bavaria. "You are the perfect Aryan girl," they told her. (Photo: Courtesy Florence Howitt.)

scene. Waiters brought carafes of wine to wash down new tastes.

She took another photo of a Parisian at a neighboring table reading his *Le Monde*. Florence returned the smile of a young man with mournful eyes. He joined her.

Mornings, after *café au lait et croissant*, she explored the streets and boulevards. Florence shopped along rue du Faubourg Saint-Honoré and the place Vendôme. At Schiaparelli's salon, a scarf, a purse, a pair of gloves acquired the status of objets d'art. She stopped inside a wine and perfume shop, a

Florence took a picture of Café de Paris. (Photo: Courtesy Florence Howitt.)

divine combination for the senses, smelling the different flasks displayed on the carved fireplace mantel, dabbing on various scents. She bought a bottle of Vouvray. She picked up her mail at the American Express at 11 rue Scribe. Not a word to her parents about Natalie's departure.

Florence crossed over the Pont au Change to the Ile de la Cité, where she visited the flower market. On Sundays, it was a bird market. She went to the Sainte-Chapelle. Up a worn stone staircase, she emerged into its stained-glass sanctuary—a jewel box. Before dinner, she took photos of the view from her window. A photo of her hand laundry, she titled, "My Sink (also panties)."

Florence visited Chartres Cathedral. The faces of the prophets and saints carved into the facade seemed to study her. Saint Michael, the protector. The Kings of Judah held their Bibles close, like sacred diaries.

Back in Paris, Florence took one of her long walks, past the Théâtre Sarah Bernhardt, ending at the Jardin du Luxembourg. A balloon escaped from a seller's bouquet. A little girl struggled to sail her toy boat in the fountain before her mother herded her away from an impending rainstorm. Florence walked along the gravel paths, thinking about Mother's determined desire for her to marry. That's what awaited her in New York. "You are very smart, very pretty," Mother's voice echoed in her mind. "You don't deserve all that we do for you. You have no love for your mother."

Nearby was 27 rue de Fleurus, where Gertrude Stein lived and held her salon. Florence had hoped to find another *Waste Land* or *Ulysses* or Paris school of painting, but the Lost Generation had left Paris. Fitzgerald had returned to the States. Pound was in Fascist Italy. Hemingway was off to Spain to write about the civil war. Florence found a round trip to Rome for twenty-five dollars, third class, passing through Switzerland, Milan, and Florence. The only catch was that she had to go to the Vatican and kiss the ring of a cardinal. She packed and left in the morning.

Her train passed through the Alps. Compartments were marked FUMEURS, NON-FUMEURS, and DAMES SEULES. In Lausanne, she found a pension, where four American students were staying while earning their medical degrees. Florence enjoyed leisurely afternoon teas in the garden, served by Madame, who ran the hotel with her daughter Berte, who was Florence's age.

Every night Florence dined with the boys. Afterward, they sat around smoking their pipes and offering their opinions about Europe's deteriorating political situation. When Florence grew restless of the Alpine tranquillity, she departed for Milan.

"In vettura!" called the conductor. She snatched her ticket and ran for her train to Florence. She was leaving from Milan, where she had seen Leonardo's *Last Supper* and lunched with a rich old Italian in a garden restaurant shaded by palms. Outside her window was a sea of clouds, which she watched like a film. The sun came out and then disappeared. "Cloud scenes from the train to Milan," Florence titled one photograph in her scrapbook. Under another, "& still more clouds."

At Bologna, a man got on and sat beside her, although there were plenty of empty compartments. His rough voice interrupted her reverie. He invited signorina to join him in the dining car. Florence's first instinct was to refuse, but she recalled the optimistic voice of her guidebook: "Travel is resisting the fear of the unknown." He was a businessman, amused that Florence was going to her namesake city. He spoke of Florence's frescoes and nudes. Did she know where she was going to sleep? He recommended a *"piccolo paradiso."*

With a cloud of steam, she stepped into Santa Maria Novella station in Florence. Her train companion handed her an address written on a scrap of paper. He said he would meet her at the pension in a few days to show her around. He kissed her on both cheeks, lit a cigarette, before disappearing into the crowd. Florence was tired. She didn't speak Italian and had a hard time

Florence met a member of one of Mussolini's elite troops, Walter, a Bersaglieri, wearing the corps' distinctive wide-brimmed hat with capercaillie feathers. Florence pasted his portrait into her European trip scrapbook. Underneath it, she wrote, "Walter, the Fascist who wanted to marry me." (Photo: Courtesy Florence Howitt.)

finding a porter for her luggage. Florence climbed into a taxi and handed the driver the address. The taxi didn't budge. The driver looked at her through his rearview mirror.

"*No, signorina. Non vada.*"

"*Si,*" she insisted. She had read about swindling foreign taxi drivers, bad as gypsies. The driver swore in Italian and threw his cigarette out the window. "Brothel!" said the driver. "It's a bordello!" He offered to take her to a friend's pension. Speeding through Florence's narrow streets, she felt lost in a maze.

The small cab cut sharply around corners. She glimpsed the aged green-and-pink marble Duomo. Clothes strung between buildings reminded her of the Bronx. Her parents had no idea she was in Fascist Italy. No one did. The son of a bitch! How could she have been so naive? Florence felt lucky to be alive.

A fat wrinkled woman wearing layers of black welcomed her to the pension. In the courtyard, over a bottle of wine, Florence was introduced to Walter, a Fascist soldier, who lived there. White satin sashes crossed his green military coat fringed with epaulettes. Little golden stars pierced each lapel, which Florence fingered questioningly. Walter explained he was a member of one of Mussolini's elite corps, a Bersaglieri, meaning "sharpshooter."

Florence saw the Ghiberti doors of the Baptistry. While she was in the middle of focusing her camera on Michelangelo's *David*, before his big moment with Goliath, a line of Fascist soldiers marched across the Palazzo Vecchio. Distracted, Florence's frame cut off *David*'s head, capturing the sculpture between his thighs. Florence was overrun with Blackshirts. Kiosks and stone walls were plastered with posters depicting Italy's men of action. In the Uffizi Gallery, Florence saw Botticelli's *Birth of Venus*.

Over a romantic dinner, Florence told Walter about her close escape from the man from Bologna. They moved on to politics. Ignoring her surroundings, Florence declared, "Hitler is a monster." Walter's face became serious. He didn't care for Hitler either. "You're the perfect woman," Walter said. "Will you marry me?" "It's impossible," said Florence. "Walter, the Fascist who wanted to marry me," Florence wrote beneath her photo of Walter, which she added to her scrapbook.

Looking like actors in a Fellini film, Florence and Walter pictured together. (Photo: Courtesy Florence Howitt.)

In Perugia, she stayed at the Hotel Giotto and saw the frescoes. In Assisi, she viewed the crypt of Saint Francis through its iron gate and the old Temple of Minerva. She advanced on Rome, where she found a beautiful pension in a medieval palazzo with arcaded, harlequin-patterned ceilings for 125 lire a night, the equivalent of one dollar. Florence awoke in her vaulted room with an iron chandelier and a desk chair like a throne. She dressed for her meeting with the cardinal. Her white silk dress hugged her body. She tied a red scarf around her neck.

"Bella," a young man called to her on the street. She stopped to ask the handsome Italian for directions.

A street scene in Perugia, where Florence saw Giotto's frescoes. (Photo: Courtesy Florence Howitt.)

"Filippo Canaletti Gaudenti da Sirolo," he said, introducing himself, flashing a perfect smile. Filippo spoke English. "Canaletti" was his old noble family's name, meaning "little canals." "Da Sirolo" meant "of Sirolo," their seaside town on the Adriatic, in his region of Ancona—the jutting calf muscle of Italy's boot. Filippo's olive skin glowed against his white silk suit. He looked like a movie star. In reality, he was a count, a *poeta-aviatore*, a poet-pilot, who was studying medicine at the Universitadá di Roma. Florence told him about the kiss she needed to bestow on the cardinal. Filippo offered Florence his arm, which she took.

Along the Via Veneto, Filippo bought a red carnation from a flower seller, tucking it behind her ear. They passed shops,

The pension where Florence stayed while in Rome for 125 lire a night, the equivalent of one dollar. (Photo: Courtesy Florence Howitt.)

churches, and cafés. The two were reflected in the windows of Fratelli Prada, displaying the house's shoes, handbags, and signature walrus skin suitcases. Florence and Filippo flirted their way into the walls of Vatican City. Florence started up the steps. Filippo leaned against a wall, lighting a cigarette, shaking out his match. Florence made her way through the Vatican's corridors hung with maps. The old cardinal stared at Florence. He crossed her and summoned the stamper of passports.

She emerged into the bright square. The count, even more gorgeous, was still waiting. Under the ceiling of the Sistine Chapel, Florence and Filippo found the Creation, Adam and Eve in the Garden of Eden, and the Great Flood.

Florence and Filippo found they both relished the decadent

poets. One of Filippo's heros was Gabriele d'Annunzio, an Italian poet from his family's region, a womanizer, daredevil, and mentor to Benito Mussolini, and author of *The Pleasure Child* and *The Triumph of Death*. D'Annunzio had a love affair with Eva Le Gallienne's idol, Eleanora Duse.

Filippo, with whom Florence had a romance in Rome, was a painter, pilot, poet, and medical student, one of Rome's circle of beautiful people, later immortalized in Fellini's La Dolce Vita. *(Photo: Courtesy Florence Howitt.)*

In his private propeller plane, Florence's modern Mercury swept her off her feet. He wore a bright white aviator's jacket, helmet, and goggles, flying out of Aeroporto Centocelle Nord, the first airport in Italy, established by the local aviators' club in 1908 on the occasion of Wilbur Wright's visit. Filippo took the plane into some thick clouds, ripping them open.

At night, Filippo took Florence dancing in Rome's grand hotels, where she celebrated her twenty-first birthday. Filippo spent his nights among celebrities and the rich of the Via Veneto, seeking excitement in art and sex. One of Rome's circle of beautiful people, immortalized in Fellini's *La Dolce Vita*, he was her perfect match, a young playboy surrounded by princes, princesses, marquises, counts, countesses, and artists. Filippo considered himself a hedonist. He was totally amoral; he slept with men from the Diplomatic Corps in the afternoons for money to take her out at night, he told her. Florence mused about him in her scrapbook, "An exquisito personality." Just feel, his eyes winked, don't think.

They visited the Roman baths, where they easily conjured up cavorting nymphs and satyrs, and lingered on the steps in Piazza di Spagna. They walked among the ruins of the Roman Forum and Colosseum for hours. Filippo studied her in front of an archaic female nude, molding her into the pose. Up a staircase, his little studio, which Filippo described as his "fin de siècle type salon," filled with piles of books of poetry and paintings. There were photos of seductive women and four portraits of youths (the bold sons of his landlady). They made love on his bearskin rug in front of a gilt-framed mirror, but there was the inevitable parting the next day at Stazione Termini. He called after her, "Florence, don't forget!"

Florence spent several days in Cannes and Monte Carlo with two Princeton boys. Here, in Cannes. (Photo: Courtesy Florence Howitt.)

Florence had one more week before she had to return home. Along the Italian Riviera, on her way up north, she met two Princeton boys who invited her to spend a few days on the Côte d'Azur, where they burned through the rest of their trav-

eler's checks in Cannes and Monte Carlo. There were beaches, fleets of white yachts, regattas, and fêtes at palatial resorts with tennis courts and polo grounds. Her hair bleached white blond by the sun, Florence lay next to the Monte Carlo pool and at the Casino in Cannes as the boys dove from the high board. In the third-class carriage back to Paris, they propositioned Florence outright for sex. "We'll have a ball," they said. "We can just put up some sheets." Angry, she refused. As the train hurtled ahead and the great playground of the French Riviera disappeared, all she could think about was her dreamlike time with Filippo.

In Paris, fall had arrived. The rows of chestnut trees in the Luxembourg Gardens were changing color. At the American Express, worried letters from the Wolfsons were waiting. The threat of war was mounting. The world was about to turn into an inferno. Florence spent her final afternoon under an awning in a café along the Seine, enjoying the view of Notre Dame in the rain.

Reluctantly, she traveled back to Southampton, where she boarded the *Mauretania*, a floating Waldorf-Astoria, where her case of Dewar's Scotch, bottle of Vouvray, and tweed coat she had sent ahead were waiting. Florence felt as if she were leaving part of herself behind. She thought of her arrival in Europe only three months earlier. It seemed a lifetime ago. Now that she had tasted freedom, she wanted more. Florence met two girls on board, Anne Baker and bookish, brilliant Isabelle Kelly. The three of them dined together. Menus were decorated with an Impressionistic painting of a boat on rough waters. They went to the ship's final formal dance.

On her last night at sea, Florence snuck up alone on deck at

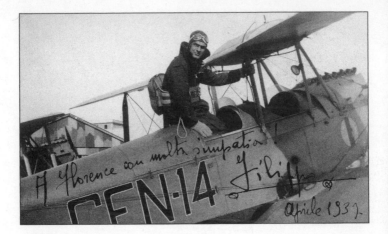

Another photo Filippo sent Florence. He wrote, "A Florence con molta simpatia! Filippo aprile 1937." (Photo: Courtesy Florence Howitt.)

four a.m., holding on to the rail, staring out at the inky waves. Although uncertain about her future, she was a world away from her parents' steerage crossing, unsure of what the new world held in store for them. New York's skyscrapers emerged like dark crystals. Steam blowing, flags flapping, Florence was home.

"Have you anything to declare? Silk stockings? Seditious literature?" *Mauretania*'s crew prepared passengers for customs inspection at Pier 54.

Back in New York, letters and photographs from Filippo followed. In one, Filippo looked like the silver-screen idol Tyrone Power, climbing into the cockpit of his plane. In another, he wore a bullet belt and held a rifle, leading an Arabian horse along the shore of the Adriatic. In 1940 Filippo published a book

of love poems, *Il poeta e l'amore*, which he sent Florence. He drew a red star next to "Ho abbandonato l'appartamentino"— "I've Abandoned the Little Apartment"—about the memories encapsulated in his old student quarters, making him feel "the melancholy of a Don Juan."

Florence, blonde American love,
came to this ridiculous little room.
I, pilot-in-training, wept for her.
How distant from me this memory is!

*Investigator Charles Eric Gordon's magnifying glass illuminates a
private eye advertisement in an old phone book. Mr. Gordon used old
phone books to find Florence. (Photo: Joyce Dopkeen/New York
Times.)*

PRIVATE EYE

I walked the streets of New York wrapped in my tangerine Bergdorf's coat with the iridescent lining and single Bakelite button, which only needed a trip from the trunks to my local Aphrodite French Dry Cleaners on Columbus Avenue. My feelings of uncertainty about whether I had it in me to become a writer, my striving for recognition and search for love, connected me to the young woman of the diary. Again, I felt as I had when I first arrived in New York from Chicago. Hurtling over the Queensboro Bridge in a cab, I was struck with Manhattan's thousands of windows glowing at night, each a hidden story and life. Florence wrote on July 14, 1932,

How the days slip by—this is tomorrow night & it seems— still—like yesterday.

Time was running out. If Florence was still alive, she would be a very old woman by now. My first step was to Google her. I came up with a NASA Web site listing a Florence Wolfson as one of over a million names engraved on two fingernail-sized microchips, taken up with the *Stardust* spacecraft on its five-year trip from Earth, past the moon, to rendezvous with the comet Wild 2. After the spacecraft collected interstellar dust

samples, providing cosmic windows into the distant past, the names were left to drift in space.

A diary is about change, and Florence's New York and mine couldn't have been more night and day. Florence's metropolis was a vast theater, like one of the lost wonders of the world. It was alive with writers, painters, playwrights, and jazz. Ideas and art mattered. People rushed to the city because the mere thought of it burned a hole in their souls. My New York seemed out of tune, on its way to becoming a strip mall filled with Paris Hilton look-alikes.

The island of Manhattan sinks a foot every thousand years. We are sinking now. Who will one day swim through the Washington Square Arch and around the silver pen of the Chrysler Building? What will they think as they circle the Empire State Building, that once fearful mass of steel and hard-edged stone weathered to blond? Our colossal spires are no longer seen as great lighthouses for the triumph of the human spirit but as dusty old stage sets, the backdrop of chain stores.

Florence's words floated down through the city's canyons, and into my mind. Only a few favorite places survived from her New York. One was the Metropolitan Museum of Art, where I often sought rest in the Chinese Garden Court. From the rooftop sculpture garden, I stared at the dreamlike citadel of Manhattan's rooftops. New York is the place of stories, allegory, and metaphor. Like Alice in Wonderland and Dorothy on the road to Oz, Florence was determined to make her way. I discovered the diary, a real-life time machine, which transported me back into Florence's world. Florence once wrote, *Oh, for dear old New York!*

The *Times* was an unexpectedly old-fashioned environment when I started working there in 2003, the same year I found the diary. Nicknamed the "Gray Lady" for its staid appearance and style, the paper was still operating out of its hundred-year-old French château home on Forty-third Street in Times Square. The newspaper business was now an e-mail and computer experience, a far cry from the city rooms Florence visited when she proposed an art column in 1934. No clattering typewriters, no smoking. Not a single shout of "Copy."

Before the *Times* was transplanted into its new glass and steel headquarters on Eighth Avenue and Fortieth Street, I spent hours in its antiquated, rarely used library, reading everything I could get my hands on about historic New York—*Here Is New York*, *New York Is Like This*, *Incredible New York*, and the city's oldest guidebook, the red leather-bound *Valentine's Manual of Old New York*. I imagined a city of farms and meadows. Its little streets still carried names from the early Dutch days—Coenties Slip, Pearl Street for the pearly shells once found there, and Maiden Lane—originally Maiden Path—a favorite meeting place for lovesick maidens and their swains.

Florence's diary slept in a Chanel shoe bag in my bedside table. I continued to report for the *Times* celebrity column, experiencing a different nightlife from Florence's toasting the night at El Morocco. One night I received an invitation to an unusual event. A car would pick me up and drive me to a "secret location," which I was "forbidden to disclose." I slipped into the pink flapper dress that I had found in a trunk.

My carriage whisked me through West Side streets, pulling up at what looked like a concrete loading dock near the Hudson River. It turned out to be an offsite facility of the Guggenheim Museum.

The party was in honor of Vik Muniz, a contemporary artist known for, among other works, reproducing Leonardo da Vinci's *Last Supper* in chocolate syrup. Inside, the model-thin, designer-clad guests were sipping Dom Perignon and watching *The Cremaster Cycle*, films by Matthew Barney, an artist who has used Vaseline as a medium. Barney's film played on a flat-screen television inside a $385,000 Mercedes Benz Maybach 62, courtesy of the party's sponsor.

While half the crowd orbited the car, an industrial elevator brought the rest of us up to a laboratory. A black curtain opened to a small viewing room, where the lady of the evening, *Woman Ironing*, which Picasso painted during his Blue Period, was on display. A Guggenheim conservator explained that it was not simply a painting of a woman at work. Appearance was misleading. An infrared camera revealed a second image on a computer screen, the upside down figure of a man. The painted-over portrait was discovered when the canvas was undergoing a routine cleaning at the museum's conservation lab. The man in the painting was probably a leather worker friend of the young, struggling Picasso, who didn't have money to buy a new canvas.

When the guests tired of Picasso, we were driven to Ian Schrager's Hudson Hotel, where there were oysters, Cuban cigars, and more champagne up in the penthouse. On my way home in the early morning, after the after-party at the nightclub Bungalow 8, I realized that I was beginning to relate to

Florence better than I did to many of my contemporaries. I yearned to feel life as intensely as Florence had. What she once wrote about M now captured my feelings about her,

She substantiates—she strengthens—how I need her!

In front of my closet mirror, I let the flapper dress gently slide to the floor. It felt as if we were one person, this young woman from the 1930s and I. Could she possibly still be alive? It seemed unlikely. In one of the photos I had found in the trunks, which now sat on my desk, I was met by the stares of the black-tie diners in paper-cone hats and bibs at a beefsteak dinner in the grand ballroom at the Hotel Astor in 1922. "Well, you're going to find her, aren't you?" I imagined a short, muscular man in a bow tie, chomping on his cigar, saying to me. "Come on, live a little." Under a feathered hat, I could almost hear his wife adding between bites, "If I was the girl, I wouldn't expect anything less."

New York City was changing fast. My time to find Florence was fleeting. Eva Le Gallienne's Civic Repertory Theater had fallen to the wrecking ball to make room for a parking lot. The Roxy "Cathedral of the Motion Picture" was only a memory. One of Florence's favorite silent film stars, Gloria Swanson, wearing a red feather boa, took a photograph in its rubble after the carillon came crashing down. A T.G.I. Friday's opened in its place. The Wolfsons' brownstone and its surrounding blocks were razed to make room for public housing. Spring

Lake was reincarnated as a yoga retreat. Far Rockaway hit rock bottom, no longer the home of Playland. Wadleigh, coed now, still stood on West 114th, where I climbed the tower rumored by students, mostly African American, and to be haunted by a teenage girl drowned in a pool by her jealous boyfriend.

The Hunter building where Florence attended classes on Park Avenue was destroyed in a fire on the night of Valentine's Day 1936, the sixty-sixth anniversary of its founding. I visited today's Hunter, a modern complex built in the 1980s with glassed-in bridges suspended over Lexington and Sixty-eighth, where the archivist, Professor Julio L. Hernandez-Delgado, patiently assisted me with a metal cart loaded with acid-free boxes containing Florence's 1934 *Wistarion* yearbook and the *Echo* issues she had edited.

I opened her yearbook, affectionately nicknamed the "old Wisty" by students, searching for her picture. I had only seen her in the old newspaper clipping. Excitedly, I flipped the yearbook's pages, scanning row after row of determined-looking young women in matching white V-necks, many Florences, Evelyns, Lillians, Shirleys, Miriams, Zeldas, Beatrices, Roses, Pearls, and Marjories. What had happened to all of them? Turning a faded page, I was met by a knowing smile, one of the few students who merited a full-page profile: Florence Wolfson. I recognized her immediately. It was as if she had been waiting for me. But Hunter turned out to be a dead end for finding where she was now.

―

Florence's New York became my self-assigned beat. On a snowy December day, I was wandering SoHo when I stumbled

upon a dusty window display of Japanese brush paintings of cherry blossoms at the Koho School of Sumi-E on MacDougal Street, an artistic oasis nestled among the neighborhood's designer boutiques. Gently clanging bells welcomed me into the studio of the school's eighty-three-year-old sensei, Koho Yamamoto.

Koho, eyes outlined in ink, was a small, strong woman, reaching just to my shoulder. She invited me to have green tea with her, which she made on a hot plate while smoking a short cigarette, constantly misplaced under the piles of artwork. Still lifes adorned every surface. Strewn about were philosopher stones, old seashells, and newspaper blotted with midnight-blue blotches of ink for practice. "Since the students have not experienced the Asian world, bamboo flute music is played to create a quiet and calm atmosphere in the class." Koho pressed play on an old tape deck, transporting me. She translated the Japanese lyrics: "This is a very beautiful song about a young woman whose lover dies."

I followed Koho's geisha bun to the back of her cramped storefront, where she showed me her life's work, abstract paintings of bamboo, pine, plum blossoms, and orchids. She had learned the ancient art form as a teenager while imprisoned in an internment camp during World War II. Later, she studied at the Art Students League, where Florence took life drawing. On the photocopied sheet Koho handed me, she instructed, "Destroy many paintings"; "Meditation is through Sumi-E therefore long conversation is not allowed in class"; "No smoking during class hours."

"A Philosophy Runs Through Each Brushstroke" was my *Times* article on Koho. I also began to study with her. As her

steady, ancient hand guided mine across the rice paper, I thought about Florence. Did she end up in her studio? As Koho pulled open a wide metal drawer to hand me supplies, a brush and ink, a pot of magenta impatiens fell to the ground. "It didn't break," said Koho. "That's good luck."

I discovered more survivors from Florence's time, who became part of my life and "All the News That's Fit to Print," forever preserved in the historical record of the *New York Times*. I enjoyed writing about New York's literary life for the *Times*, visiting the Proust Society. Florence read all seven volumes of *In Search of Lost Time* in a two-week stretch when she was ill and restricted to bed. I wrote about the C. S. Lewis Society. I rang the doorbell of a SoHo loft labeled "James Joyce," to visit the Finnegans Wake Society. I profiled a dream group in Ozone Park, Queens, and a gathering of hypnotists who tried, unsuccessfully, to put me under. "You are standing at the top of a beautiful staircase with red velvet carpeting," said the hypnotist in gold slippers. "A beautiful orange golden light is peeking around the doorway. You are going deeper and deeper."

Three years after I found the diary, and a hundred *New York Times* stories later, I had covered Hurricane Katrina from New Orleans, rummaged through the Bouvier Beales' attic at Grey Gardens, and flown to the Netherlands to interview Maharishi Mahesh Yogi, the guru to the Beatles in the 1960s, in his secluded woodland retreat.

One Sunday in February 2006, a little lonely, I was wandering through the recently renovated Museum of Modern Art on

West Fifty-third Street. I stopped in front of a red Olivetti Valentine typewriter. It would look nice next to the baby Hermes typewriter I had retrieved from the Dumpster. In the yellow pages, I found the last remaining typewriter store in Manhattan.

The next day, I entered the Flatiron Building, where I opened a frosted glass door, boldly stenciled ROOM 807. Blackened machines filled Gramercy Typewriter, like miniature trains waiting in a rail yard. "Welcome to the heart of Manhattan," said Paul Schweitzer, the business's sixty-seven-year-old owner, looking up from an old adding machine he was tending. "I would shake your hand, but—" He smiled, holding up his inky fingers. He affectionately referred to the typewriters surrounding him as "dinosaurs." He pointed out an iron Underwood dozing on a low shelf like an anchor at the bottom of a lake. I gathered that there were still a few people around who, like Florence and me, wanted to hear their words smack the page.

"You want to feel that you are writing." Mr. Schweitzer grinned. "Not being a writer, it's hard for me to put it into words." He lifted up a black Smith & Corona, which looked like a small piano, even to the gold-inscribed names. His desk was scattered with toothpicks, rubber bands, ribbons, and invasive green computer chips (he also repairs laser printers).

"I can find anything in this place," Mr. Schweitzer assured me. He told of desperate writers calling to say, "My M is not working!" He makes house calls with a black leather kit, which looks like a medical bag. Here, in Room 807, in the Flatiron, I felt myself being transported back to Florence's time. A blackened hammer, screwdriver, pliers, and wrench hung on

the wall. There was an ancient Webster's dictionary, a Brillo box for scrubbing keys that called to mind Andy Warhol, and an inky bar of green soap resting on the sink in the corner. Paul Schweitzer's father, Abraham Schweitzer, had opened the business in 1932.

"A Valentine or a lavender Remington, whatever you want." Mr. Schweitzer assured me they were all obtainable. As I was leaving, he offered to take me out for an egg cream. We made a beeline across Fifth Avenue to Eisenberg's Sandwich Shop, "Established 1929." Mr. Schweitzer had eaten a tuna fish sandwich every day for the last forty years, seated on one of the stools at its marble lunch counter. A thickly frosted devil's food cake incubated under a protective dome.

"Helping the Words Sing, with a Clickety-Clack" was my *Times* article about Mr. Schweitzer and his typewriters. The day it ran, I received a curious voice mail. "Hello, Charles Eric Gordon here, I read your story about Paul Schweitzer. I could see that green ink-stained bar of soap. It brought a tear to my eye. I'm an attorney, investigative counsel—I work like a private investigator, finding missing people. If you'd ever like to talk or meet for lunch, call me." Beep.

"Charles Eric Gordon, not G. Gordon Liddy," he said arriving in a trench coat. His license plate read "Sleuth3." We sat out a March snowstorm at Keens Steak House in Midtown Manhattan, in business since 1885 under its ceiling lined with old clay pipes that bring to mind Sherlock Holmes. "I'm too old

to run up fire escapes with a gun. The only thing I'm packing is a magnifying glass," said Mr. Gordon, pulling one out of an inside pocket. "But this is more for middle-aged investigative attorneys than for show. Unfortunately, I don't have the Sam Spade bottle of rye in the pocket."

I could only read many of Florence's entries with the help of a glass. For a long time, I couldn't decipher M, a letter Florence wrote stylishly like a triple pi symbol.

Mr. Gordon was fifty-three, with a shock of gray hair and a mustache. Clutching a vintage phone book like a rare first edition, he explained how he uses old telephone books to track down witnesses, heirs, debt skippers, bail jumpers, fugitives, and missing spouses—essentially, the lost—including the dead, and those who never existed. Long before Brooklyn Law School, as a boy from Long Island, he read the white pages during Passover seders at his grandmother's house, memorizing the old telephone exchanges. "Zzyzzy Ztamp Ztudioz Co.," Mr. Gordon pointed out to me in the old Manhattan phone book he had brought along. "I used to think it was an underground investigation agency."

Mr. Gordon was fixated on the 1920s and '30s. "When I was growing up, my brother used to say, 'Look, you've got to come watch this *Star Trek* episode, they found this planet where an astronaut left a book behind about Al Capone's Chicago and the planet's set up like the Roaring Twenties.'" Mr. Gordon also loved the *Twilight Zone*, one episode in particular, in which a man went into a woman's apartment, where he spied an old telephone and started noticing all sorts of objects from the past. It turned out there was a parallel universe and the

woman was living in the 1920s—and he had somehow entered it. Finding Florence's diary, I felt like I had traveled through a time warp.

"Investigation by an Attorney Not by Computer" read Mr. Gordon's law journal advertisement. "Human intelligence is very important," he added. He explained that he worked about six cases at a time. Often the trail grew cold and the search stretched on for years. There are people who remain hidden, but most leave paper trails—leases, phone listings, voter registration, and burial records. Once he had to convince a bag lady living in an SRO hotel on the Upper West Side that she was an heiress. They all asked the same question: "How did you find me?"

"Tracking Heirs and Deadbeats, Starting with 10 (Often Dusty) Digits," was my *Times* article about Mr. Gordon and his trove of close to one thousand telephone books, dating from 1914 through the 1980s, from around the world, including the Czech Republic, Lithuania, Russia, and Aruba. He asked me, if I traveled somewhere exotic, to remember to pick one up for him. "It's very, very confidential," he said, when I asked him his source for his latest 350 books. "I don't want to cause ripples in the investigative community."

We talked over a glass of red wine. I ordered a steak sandwich. He had a green salad. His teenage daughter had convinced him to become a vegetarian, asking that he not eat things with eyes, but he still loved the smell of a good steak.

"Charlie." By now he was no longer Mr. Gordon. I spread a cloth napkin out on the table, carefully placing the diary in front of him.

"So, what do you think?" I asked, after telling him what I knew about Florence Wolfson, which, at this point, was not a lot. "This is a person," said Charlie, choking up. "She was nineteen in 1934, the year the diary ended. From what you have shown me, this was a woman who would be at home with us today." He shook his head with a smile, examining the diary. "She could be a twenty-something like you. This is an amazing woman, Lily. Wouldn't it be something if we could find her?"

Charlie's Midtown office was decorated with pulp detective magazines from the 1930s picturing scantily clad women sent into offices as decoys to root through files. A plastic Sherlock Holmes action figure rested on top of the law books on his desk. From my own sleuthing I knew that Basil Rathbone, the actor who originally played Holmes, was the only man Eva Le Gallienne had ever had a serious relationship with. Rachmaninoff played on a CD player. A plaque from the Society of Professional Investigators (SPI), of which Charlie is a vice president, hung on the wall.

Through the window was a clear shot of the pyramidal art deco buildings of the fur district north of the garment district, where Charlie's grandfather had been a partner in a children's underwear business. I could see the New Yorker Hotel, where Florence danced to big bands. It later became the headquarters of the Moonies.

"It's half past twelve—would you like a shot?" Charlie

pulled a bottle of Pinch Scotch from his drawer. "Is it too early?"

"I'll have one, if you do," I said. Charlie also loved 1980s rock. He selected Hall & Oates's "Private Eyes."

"To finding Florence." We toasted with our Dixie cups.

"Na zdorovje!"

Behind Charlie was a framed picture of the Russian mystic Rasputin with dark piercing eyes and a coarse beard, lifting one bear-claw hand in front of his forehead as if casting a spell. Looking at me with a serious expression, Charlie said, "What if you could cross Arthur Conan Doyle, who wrote Sherlock Holmes—his cold, factual deductive reasoning—with the intuition of Grigori Rasputin? What if you could combine them into one person?"

His face was rosy. He looked wild-eyed.

"That's not me," Charlie laughed, "I wish to God it was, but I do draw on that sixth sense and I try to use it. I've had this in cases before with dreams, where dead people have been telling me where to look—it's an intuition, like 'check here.' It's sort of like Florence is saying, 'Find me, find me.' "

I finished my shot. "She is telling you that."

Charlie confided, "My part is nothing compared to yours, Lily."

Charlie thought he could locate Florence's heirs. He is not a licensed private investigator, but as an officer of the court, he was privy to restricted records and could conduct investigations that served a legal purpose, like returning the lost property of the diary.

We had a few things going for us. Her name was a big one.

Charles Eric Gordon used a magnifying glass and old phone books to find Florence. (Photo: Joyce Dopkeen/*New York Times*.)

"We're lucky it's not Cohen or Jones, but a less common name," Charlie pointed out. His first step was to consult the New York City Birth Index for people born with the last name of Wolfson. He found three Florence Wolfsons. Using their dates of birth, he ran checks with confidential, proprietary databases. Two of the Florences were deceased.

Charlie launched an offensive on several fronts. Using a telephone book from 1934, he looked up Wolfsons at different addresses and found a listing for a Dr. Daniel Wolfson who lived at 1391 Madison Avenue, the same address written in the

newspaper clipping with Florence's photograph. I knew from reading Florence's diary that her father was a doctor, but since she called him Dad, the name Daniel didn't ring any bells. Charlie and I analyzed each new development.

One night, Charlie called me.

"Lily, she's alive."

From the birth certificate of the only surviving Florence, born on August 11, 1915, Charlie learned that her father was listed as Dr. Daniel Wolfson and that her mother's name was Rebecca. Charlie was also able to confirm that this Florence Wolfson was now known by a different name. Charlie said, "If her name had been Susan, or Rose or Mary, it would have been a lot harder."

Digging further, he learned that Florence's married name was Howitt and she wintered in Pompano Beach, Florida, and summered in Westport, Connecticut. "Florence lives in one of New York's sixth, seventh, and eighth boroughs, Dade, Broward, and Palm Beach," said Charlie. "Usually, at this point I can call up my Aunt Gertie, who may know her from the beauty salon, but I have a feeling they run in different circles."

"Charlie, what if she doesn't want to speak to me?"

One afternoon in April 2006, eager and a bit nervous, I dialed Florence's Florida number on my cell. After two rings, a refined voice with the command of a stage actress answered.

"Hell-o?"

"Florence?"

Holding the red leather diary in my hands, I began to tell Florence the amazing chain of events that had led me to her. "Oh, yes, the diary is mine," Florence said. "I want to meet you."

"Lily and her new grandmother," said Florence. *Lily Koppel and Florence Howitt, at ninety, in the Pompano Beach, Florida, condo she shared with Dr. Nathan Howitt, her husband of sixty-seven years until his death at ninety-six in 2006. On the wall is the oil portrait of Florence done by her friend Eda Mann, the mother of Erica Jong, the feminist author of* Fear of Flying. (Photo: Colby Katz.)

SPEAK, MEMORY

On a Sunday morning in May 2006, I made my way through the marble concourse of Grand Central Terminal. Standing above the entrance was Mercury. I searched the zodiac in the aquamarine ceiling. There was Pegasus flying across the sky and Orion the hunter, whose sight was lost and later restored. I passed the gold station clock atop the information booth, perhaps the most romantic meeting place remaining of old New York. The Metro-North train to Westport raced through Harlem and the South Bronx up along the industrial corridor on the east flank of the Hudson. My fellow travelers, their feet resting in flip-flops, were listening to iPods and scanning newspapers and celebrity magazines, *Us Weekly*, *People*, and *In Touch*.

"Westport," announced the automated conductor. I got out at the white clapboard station house with a preppy crowd, squinting across the sunny parking lot for "the blonde in the champagne-colored Honda Accord," as Florence's sixty-four-year-old daughter had described herself over the phone. Valerie Fischel greeted me warmly. Driving along a winding road, past an old graveyard and the high manicured hedges of the suburban estates in Martha Stewart's old neighborhood, I found out she was a Juilliard-trained modern dancer and retired divorce attorney. Over a one-lane wooden bridge overlooking Long

Island Sound, where sailboats bobbed at their anchors, we entered a private community near the Cedar Point Yacht Club. We pulled up at a gray cottage, the home of Florence and her husband, Nathan Howitt, a retired oral surgeon.

Florence held her arms out to me, smiling, in red lipstick, wearing tortoiseshell-framed glasses. We hugged. "She's beautiful, this girl," Florence announced. Her walls were hung with modern canvases, some her own. She still had her mother's flecked Venetian mirror and black-marble-topped serving table, part of the dining room set where Florence once wrote on her lavender Remington. On her ottoman was the *New York Times* crossword she was working on.

I handed Florence her diary. She leaned back in a leather Eames lounge chair. The airy room flooded with light from floor-to-ceiling glass doors that opened onto a garden. She journeyed back seventy-six years. I sat beside her, watching closely for glimpses of the young woman I felt I knew so well.

"Oh, this is unbelievable." Florence caressed the book's worn cover and fumbled with its lock. "How can we open this?" Her fingers released the diary's rusted brass latch, as she had so many times before. She paged through the faded days, dense with her blue and black cursive handwriting.

Florence peered into the diary as if it were a crystal ball. "*Have stuffed myself with Mozart and Beethoven—I feel like a ripe apricot—I'm dizzy with the exotic,*" Florence read. "*Like an old maid I'm yearning for love—love!* This is from a fifteen-year-old girl!" Mesmerized, Florence read on, "*Time merges with eternity and I am left behind—Perhaps this is the planting time—does harvest always come?* I was seventeen." She went

on, "*Had a miserable argument with Mother this evening—I hate home—Whenever I voice the lightest complaint, the heavens over my head are crushed.*" On another page, she found, "*I never fully realized what a tragedy my parents' lives are.*" Florence looked up, "I never remember Mother or Father kissing me."

"Who was M?" I was curious. "Oh, Marjorie was one of my admirers," said Florence, very matter-of-factly. "In those days, it was fashionable for girls to have relationships. Like Virginia Woolf and Vita Sackville-West." Florence's two daughters, who are both divorced, had heard it all before. Karen, sixty-one, a psychotherapist, earned her master's in social work at Columbia, and also graduated from Hunter. She remembered Florence telling her and Val, when they were in their teens, about *The Well of Loneliness*.

"What I loved was I didn't have to worry about dates," explained Florence. "The hell with men. It gave me such a sense of freedom. There was a little sex, I have to tell you." She laughed. "There was a lot of sex, as a matter of fact. I had the breathless experience of acting like a male in the sense that I could dump one and pick up with another." She was back in the present. Florence questioningly searched my eyes. "What did you think when you read this?"

As she paged through the diary, tiny pieces of red leather fell into her hands. "Wouldn't you think I would have had a literary career?"

"You were planning a play about Wordsworth," I said.

"Oh, my God, really?"

"You wrote—" I reached for the diary, reading, "*Planning a play on Wordsworth—possibilities are infinite.*" I glimpsed another entry, "*Am on the lookout for a really satisfied person.*"

How, I asked, did the diary end up in the Dumpster? "It was just something that did not exist for me after I wrote it," said Florence, who suspected that the book was inadvertently abandoned in 1989 when she and her husband left 98 Riverside Drive, where they had raised their two daughters in 9F. In 2003, I moved into 2E. Florence's departure from New York City to an affluent Connecticut suburb seemed to write a final chapter in the chronicle of the eager, searching girl she had once been. "Where did all of that creativity go?" she wondered aloud as she pondered the newly rediscovered story of her youth. "If I was true to myself, would I have ended up living this ordinary life?"

In 2001, two years before I found the diary, Florence and her husband Nat were driving home at night from a wedding in Boston, when they swerved off the highway and headlong into a tree. "Nat kind of conked out," said Florence. Nat had experienced a sudden fluctuation in his heartbeat, subsequently corrected by a pacemaker. When Nat came to, smoke was coming out from under the hood. He got out, but Florence was unconscious. Her door was jammed closed. Alone, on the side of the road, Nat was helpless. A volunteer firefighter happened to be driving by and was able to pull Florence to safety before the car burst into flames.

"Would you believe I used to ski?" said Florence carefully descending the spiral staircase from an upstairs loft she built as an artist's studio. "Did you see my tennis trophies?" Like Greek goddesses playing doubles, little golden figures

stood ready with their tennis racquets on pedestals engraved, "Champion Florence Howitt."

Her leg still bothered her from the car accident. That same year, her body was ravaged by *E. coli* bacteria. "You can't imagine how annoying this is to me," said Florence, kicking her cane. "I'm very embarrassed to have to use this in front of you."

Valerie brought down a shoebox of photos from an upstairs closet. "The hole," as it was called, was a repository of Florence's old sketchpads, charcoal nudes, colorful still lifes, and writings.

"Me on a horse . . ." Florence studied a scalloped-edged black-and-white photograph of herself in riding breeches in the 1930s. Of New York's hundreds of earlier stables, only Claremont Riding Academy remained operational for years. It was a sad day when it closed in 2007.

"Oh, that was a gorgeous coat." Florence gazed at a portrait of her glamour girl days, enveloped in a black velvet coat with a silver fox collar. "Would you believe I was once slender? I don't have clothes like that now. I don't—" her voice broke off. One of Florence's persistent regrets was the loss of her snakeskin coat. "Time is the school in which we learn, time is the fire in which we burn," quoted Florence. "Socrates."

For a long time, Florence kept one of her mother's creations, but she finally gave it away. "It wouldn't fit anyone anyway," said Florence, "except you or one of my granddaughters." Florence has three granddaughters. Deanna taught Spanish and is now busy raising Florence's three great-granddaughters, Ava, Emma, and Celia. Lauren, an actress and modern dancer,

teaches yoga, and is the mother of Florence's two great-grandsons, Dylan and Jesse. Riva, Florence's youngest grand-daughter, a graphic designer, lives in Manhattan in the West Village.

Out came the stern portraits of the Wolfsons—Irving riding his rocking horse against a canvas backdrop painted with a stormy sea. Her kid brother was now eighty-eight years old, a retired cardiologist and a leader in the Unitarian Church in Worcester, Massachusetts. He was disowned by his parents when he married the love of his life, Annabel, a Lutheran and a nurse he met during his residency at Mount Sinai Hospital. "Annabel made me human," Irving told me over the phone. He remembered all the way back to being bathed in the sink. In a flash, he recalled the name of the Wolfsons' dog, Prince, pointing out that there is still a lot of research to be done on how memory works. Florence and Irving have remained close.

"Look, I was a photographer too. Here's a picture I took, it won a prize," said Florence, handing me a photo of the no-longer-standing Murray Hill Hotel's curved tier of balconies on Park Avenue and Fortieth Street. The same shot was taken by Berenice Abbott, the photographer known for her images of the 1930s, published in her WPA book *Changing New York*. "I forgot I was interested in photography. I did everything!"

Florence showed me a photo she took of her mother under her wide-brimmed straw hat against the blossoming cherry trees in Central Park.

"My mother was a very bitter woman," reflected Florence. "But I have been thinking of her recently, I really have.

I wonder if we could have communicated." Rebecca retired from her business when she was in her sixties. A few years later, even though she had looked forward to this time her entire life, she admitted to Florence, "The worst thing I ever did was stop working."

"If only I had my mother's drive," said Florence. "I think about my parents a lot these days. You being here, I can feel them now. I realize their worth. My mother was such an achiever." In 1969, eighty-two-year-old Rebecca died from heart disease. Florence felt it was a mistake to sell the family's Steinway grand piano, which she kept for years. Music had been her mother's refuge. The year before, Florence's eighty-three-year-old father ended his life with an overdose of morphine. Convinced that he had cancer, he didn't want to be a burden. It turned out that he did not have the illness.

Florence remained close to Frances, who gave her the diary. Florence remembered telephoning her in 1970. Her old friend was tired and said she was going upstairs to lie down. Frances died that day, in 1970, from cardiovascular causes. She was seventy-two.

"From the diary, I could tell you had a rich internal life," I told Florence. "Also an external life," added Florence. "You want to see me in mink? How do you like that? My mother gave me the coat."

There were the usual snapshots—Florence with her daughters, granddaughters, and great-grandchildren. In one shot, Florence wore a dress someone had made her as a gag out of the *Wall Street Journal* for her eightieth birthday party. There were pictures of her and Nat at black-tie events at the Rolling

Hills Country Club in Wilton, Connecticut. These were all images of a full life, but not the one Florence had dreamed of.

Florence found the scrapbook of her 1936 European trip; its cover was missing, but it was full of carefully marked photos. Her Italian count fell out: Filippo, hands on his hips, posing in front of his propeller airplane. "Filippo Canaletti Gaudenti da Sirolo." Florence rolled all of his names off her tongue. "A movie star. We were two ships that pass in the night. It was one girl's triumphant march through Europe."

At the bottom of the shoebox of photos was one of flapper

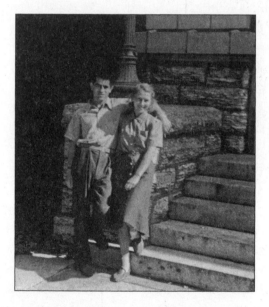

In 1939, at twenty-four, Florence married Nat Howitt, who was just out of dental school at the University of Pennsylvania. (Photo: Courtesy Florence Howitt.)

Lily Koppel

Florence, a sophisticated young Manhattanite, outside of her family's apartment building on Ninety-sixth Street and Madison Avenue. "Life offered me opportunities that I don't think a lot of girls get. I think about it—" She took a deep breath. "It was quite a life."

"You know, you're a very unusual person," I said, squeezing her hand.

"Thank you, I'm not," said Florence. "I was."

"You are."

"I'm less unusual now than I was," she said. "I've given in to a lot that I objected to. From being the kind of person you found in the diary, how did I become a tennis player, a party-goer, and a party giver?"

The ship Florence sailed to Europe on, the *Georgic*, was repainted battleship gray and employed as a troop carrier during World War II. Docked in Egypt, the vessel was attacked by German bombers and burned in the Suez Canal. Later, she was salvaged from her half-submerged state.

When twenty-one-year-old Florence returned home from Europe, her parents pressured her more than ever to find a job and a husband. She worked at an advertising agency, earning twelve dollars a week, where a married executive, Adolf Marshuetz, noticed her. Addy watched Florence figure-skating at Rockefeller Center. They went out for hot cocoa and drinks at Rumplemayer's in the St. Moritz Hotel on Central Park South. He took her to dinner dances at his country club. They would meet on Grey Advertising's back stairs to kiss. Mother

liked Addy, but Florence never wanted anything more than an affair. She had no intention of marrying him.

Florence also dated a millionaire who lived in eleven rooms in the art deco Century apartment towers on Central Park West, built in 1931 on the site of the demolished Century Theater. Mother was invited along with Florence to dinner, where a manservant presented sweetbreads prepared by the cook. Florence had never heard of the delicacy, made from the thymus gland or pancreas of a baby lamb. Mother was thrilled.

In those days, sex was the most important thing in the world for Florence. "Sex was art," Florence said. Only a beautiful man would do. "You can see I always depended on relationships," said Florence, paging through her diary. "Here"—she stopped at an entry—"*I'm so exquisitely, gloriously happy. Why? It's George! There was no sex. We spent hours, all night, in each other's arms, caressing each other.*"

I learned that "making love" meant something different back then.

"It's called heavy petting," said Florence.

In 1939 Nat Howitt, one of the eight beautiful brothers from Spring Lake, proposed to Florence by mail. I reminded Florence of the letter Nat had sent after their summer when she was sixteen, in which he wrote, "I surrender, dear." At sixteen, Florence recorded, *There's no more avoiding the point—"I surrender, dear" is too irresistible. What can I do?* Also, *I think I respect him more than anyone else in the world—and what does it mean?*

Florence's husband Nat Howitt leaning against their car, which they drove to Mexico on their honeymoon, dated 1939. (Photo: Courtesy Florence Howitt.)

On a Friday night in August 1939, Florence, who had just turned twenty-four, eloped with Nat, fresh out of dental school at the University of Pennsylvania. Her parents' wedding present was a Buick Roadmaster convertible, which the newlyweds drove to Mexico on their honeymoon. Florence recalled wearing a black silk mask to the bullfights in Mexico City. Back in New York, Nat wasn't making any money yet, so they moved into an apartment connected to her parents' apartment on West End Avenue and Ninety-second Street.

Ninety-five-year-old Nat quietly entered the room. He wore violet-tinted aviator sunglasses, a patterned silk robe hung on his thin frame. Nat sat down on a leather Barcelona chair across

from his wife of sixty-seven-years. "Dad," said Karen. "Put on your hearing aid, you're in Mom's diary." I handed Nat the Western Union telegram, which I had found in one of the trunks, addressed to "Miss Florence Wolfson." He was quiet and stared for a long time at the words on the faded paper—"I love you, Nat."

Florence worked for a time at the Audubon Society, where, fearing prejudice, she was known as "Florence Wilson," until she got a job with Miss Virginia Rice, a literary agent. Miss Rice, a good friend of George Kaufman, was an old maid and very repressed; Florence saw her get violent about writing, but she was a good person. Miss Rice helped Florence get published for the first time. A stint of writing feminist-tinged advice articles for women's magazines followed—*Cosmopolitan*, *Good Housekeeping*, and *Ladies' Home Journal*, which at the time published serious writers such as Upton Sinclair and Sinclair Lewis. Florence wrote dozens of articles—"What Does One Do with the Unmarried Daughter?" "How to Behave in Public Without an Escort," "A Place for the Extra Woman," "Do You Know Everything in Your Daughter's Head?" "The Case for Privacy," "Women Don't Give Women a Chance," "How to Quarrel with Your Husband," and "Don't Apologize So Much!"

Still working on her trusty Remington, twenty-six-year-old Florence wrote a book called *Are Husbands Necessary?* It was addressed to the young woman caught between a sensible marriage and following her heart. Publishers told her she was "too ahead of her time."

By Florence Howitt

Don't Apologize so much!

In her twenties, during the 1940s, Florence wrote feminist-tinged advice articles for women's magazines, such as "What Does One Do With the Unmarried Daughter?" "How to Behave in Public Without an Escort," "How to Quarrel With Your Husband" and "Don't Apologize So Much!"

Before Florence and me was a peacock-colored array of vintage magazines, which displayed her byline across gelatin recipes for casseroles and advertisements—"She's engaged! She's lovely! She uses Pond's." Florence turned to me with a shrug. "The obvious culmination would have been for me to become a Nora Ephron."

After Pearl Harbor, Nat joined the army and was stationed in Lakeland, Florida. The officers' wives all read *Good Housekeeping* and couldn't wait to meet Florence, whose advice they avidly followed. When she arrived, they were taken aback by the twenty-six-year-old's independent manner. Florence never felt completely at home on the 352nd Army Air Field Base. During an officers' banquet, she felt stifled and announced that she was going out for some air. One of the officer's wives followed her outside, inviting her to sit in her car. "It was like a scene from a play," recalled Florence. Mary, tall and dark, leaned over and kissed her.

Taking on a Le Gallienne–like role, Florence taught drama at Florida Southern College, a Methodist school in Lakeland, designed by Frank Lloyd Wright, situated in an orange grove. Florence picked fruit off the trees while rehearsing her all-female troupe, the Vagabonds. "Here On Campus Director-Writer . . . in their midst a very interesting woman," reported the local paper. "Mrs. Florence Howitt is always looking for new ideas that will inspire her to write."

Back in New York, the family moved to 98 Riverside Drive, where, fifty years later, I found the trunks. While living there, Florence's focus shifted from pursuing a career in writing to playing tennis, bridge, and the stock market. She entered Wall Street in 1950 with five hundred dollars, and hit it big. The

same year Florence and Nat, along with Nat's brother Larry and his wife, Sophie, bought a hotel in the Berkshires, in western Massachusetts, Seven Hills, a Gilded Age mansion with ten fireplaces. Edith Wharton's estate was next door. Florence was happy playing the grand piano every night in the music room. Leonard Bernstein, a regular, was credited with naming the hotel, but actually, it was Florence who came up with Seven Hills, after the Seven Hills of Rome.

When Florence was forty-five, she told Nat that she was going to Europe alone. She assumed that in their marriage she was free to act independently, and she did. She finally made it to Spain. In Vienna, she saw Freud's couch. In Italy, she went to Capri, climbing the steep steps of the island, looking out at the Mediterranean. It was the height of the season, and all of the hotels were booked. Florence walked and walked until she finally came to a villa, where a man, like someone out of a fairy tale, told her where the last room on the island was waiting, he said, "just for you." At the Grand Hotel Quisisana, whose past guests included Claudette Colbert, Ernest Hemingway, and Jean-Paul Sartre, her room on the ocean was "right at the edge," remembered Florence, where she loved to be.

In Venice, she sat in the Piazza San Marco on a sunny October afternoon, sipping coffee and listening to *The Blue Danube*, marveling at the total unreality of the scene, which became "Schmaltz Italian Style," an unpublished short story. Florence wrote, "I am in a picture by Fellini, part of the background. Only a cunning director could have placed that artist where he stands before his easel, surrounded by an emotional crowd of Venetians who exclaim over every brushstroke. And those two

young lovers walking hand in hand surely are extras . . . Nothing in the surroundings dispels the fantasy. The soaring Campanile, the tender lion watching over the Piazza, the Byzantine domes of the Cathedral—all, all part of a vast stage set. The band plays on and I half imagine Katharine Hepburn, hurrying across the old stones on her way to a rendezvous. Katharine doesn't appear, but the sense of some great wild emotion overwhelms me . . . My throat aches with the piled-up sentiment, the release of emotions I never experience on Fifth Avenue. I must get relief. I am full of love, sadness, nostalgia, yearning, and the beauty is too much to bear. I plunge into the nearest bar."

When she returned home, Florence went to a psychoanalyst, who told her sternly, "Your goal in life should be to be a wife and mother," remembered Florence. "And I was weak enough to believe him." For decades she kept on searching, feeling there was something missing in her life.

Around this time, a friend had a dinner party in her Park Avenue apartment, to which she invited a balding George Kinzler. "He was overweight, typical bourgeois. Nothing like Nat," recalled Florence. "I was relieved."

After graduating from City College, George enrolled in the executive training program at Macy's, the same year twenty-year-old Florence sailed to Europe. George spent forty-two years at Macy's as the store's principal gourmet food buyer. The French government awarded him its Ordre du Mérite Agricole. His 1995 obituary in the *New York Times* read, "George

Kinzler, 81, a Consultant on the Selling of Specialty Foods." George was married to a woman from a society family until he left her for a younger blonde whom he met at the bus stop when he was in his mid-sixties.

Despite his Harvard degree, Manny Lipman stayed in Lynn, where he worked a union job as a jig borer at General Electric, making templates for machines. He worked fast to leave himself time to read—Ayn Rand, Karl Marx, Zane Grey, and Shakespeare. He raised his daughter Sydney by himself. Florence wrote in her diary when she was eighteen, *Manny tonight and was convinced of his inadequacy—yet he is superior—& believes in himself—perhaps if I loved him.*

"Manny was a great underachiever," said his niece, author Elinor Lipman, the daughter of Manny's brother Louis. In his sixties, Manny taught high school English in Nantucket. He remained tanned and fit and had a young girlfriend. He died at eighty-two in 1990.

After graduating from Hunter, Pearl taught high school English in the New York City schools. In a short-lived career as a playwright, represented by the famous theatrical agent Audrey Wood, she had a couple of Broadway near successes. The *New York Post* described her *Lady on a Porcupine* in 1945 as "a comedy about a woman who sits uncomfortably astride an existence that fulfills only half a life for her." Pearl was married, for over fifty years, to the sheriff of New York. Before her death in 2005 at ninety-three, she discarded all of the manuscripts of her stories and plays.

Florence's colleague on *Echo*, Joy Davidman, went on to marry C. S. Lewis after a troubled first marriage to William Lindsay Gresham, author of the noir *Nightmare Alley*. Joy's

marriage to Lewis, shortly before her death, was the basis of the film *Shadowlands*.

Another classmate, Belle Kaufman, who later changed her name to Bel for an *Esquire* byline, gained fame as the author of the best-selling book *Up the Down Staircase*. She remembered Florence in the *Hunter Magazine* in 1984: "I admired and envied the leaders of the Student Council, the editors of the school publications, the class beauties, the mavericks, and the few who brought a whiff of glamour to school, like a young woman who used to appear in class in fawn-colored riding breeches, presumably after a canter in the Park. I don't think she was ever reprimanded by the Dean for being inflammatory, since she wore them almost daily. How I envied those riding breeches and the exotic life I imagined she lived outside of Hunter!"

When Florence was in her eighties, she visited the Jewish Museum on Fifth Avenue with a friend. Looking up from a bench, she saw her old friend Gertrude Buckman. Florence walked up to the old woman coming through the door. "Are you Gertrude?" Gertrude uttered, "My God."

Florence and Gertie embraced. The two old friends hadn't seen each other for over fifty years. Gertrude was poor and lived in a basement apartment on the periphery of London. They talked. Florence promised to visit her, but never did get to London in time. "It was very sad knowing that somebody I had so much in common with was so alone and had such a miserable life," admitted Florence. "I remember writing in the

diary, *How I wish she were a man!* Because we had so much in common, Gertrude was artistic, creative, and pure. She was purer than I was in terms of material possessions. I think I liked material possessions, even in those days."

In 1938, Gertrude Buckman and Delmore Schwartz married. With the publication of his book *In Dreams Begin Responsibilities*, Delmore was recognized as one of America's preeminent writers, winning the praise of T. S. Eliot, Ezra Pound, and Vladimir Nabokov. Delmore's mood swings were unpredictable, and Gertrude couldn't tolerate his cheating. They divorced six years later. It was a hard time for Gertrude, who continued to write for the *New York Times Book Review* and published a book, *Compliments: A Treasury of Tributes to Friends and Lovers, Relatives and Rivals*. Delmore went on to teach and write, inspiring many, including Lou Reed, who dedicated the song "European Son," on the Velvet Underground's banana album, to Delmore.

"The people, the culture, the brains," said Florence. "It's terrible today. Does anybody think and live philosophy? I can't imagine my grandchild or my great-grandchild or anyone writing this," she said, tapping the diary.

Florence admitted that there is a cost to an artistic life. Many of the members of her salon died tragically. On a hot July night in 1966 Delmore Schwartz, fifty-two, dependent on alcohol, barbiturates, and amphetamines, died from a heart attack in the seedy Columbia Hotel on West Forty-sixth Street. Saul Bellow's novel *Humboldt's Gift* is a fictional portrait of the fallen poet. In 1972 the poet John Berryman, fifty-seven, who had been awarded the Pulitzer Prize for his *Dream Songs*, flung himself from the Washington Avenue Bridge in Minneapolis,

missing the water and hitting the embankment of the Mississippi, where he died of suffocation.

Looking into her diary, Florence said, "They are all gone." She had outlived all her friends and lovers from its pages. Florence's first artist's model, Caryl Weissman, whose dazzling white limbs she used to sketch, died at sixty-two from lung cancer. Sylvia Livingston, at whose apartment thirteen-year-old Florence attended her first dinner party, married a vice president of Macy's and moved to Westchester, where she died from heart disease at forty-six. M remained a mystery. Florence said to me, "Here I am."

Florence didn't know what happened to Filippo, whom she thought about often after she returned from Europe. He reminded her of Antoine de Saint-Exupéry, also a flying poet, who wrote *Le Petit Prince*. One of Frances's sons, Arthur Boruchoff, was staying in Florence's bedroom in her parents' house as a teenager when he came across one of her later journals, which included passages about her Italian count. "That was pretty hot stuff," recalled Arthur at eighty-two.

Searching the Internet, I found a book of Filippo's paintings. There were only three for sale online, two overseas and one at a rare book dealer in New York. I immediately went to the Old Print Shop on Lexington Avenue and bought his monograph. The cover was one of Filippo's abstract red-and-black canvases titled *La Foresta in Fiamme*, or "The Forest in Flames." It had colored plates and a photograph of Filippo at his easel, paintbrush and cigarette in hand, the dome of St.

Peter's in the background. Something fell out from inside—Filippo's calling card, stamped with a gold crown, the sign of nobility, but no address. Filippo's paintings were collected by the aristocracy of Rome, princes and princesses, as well as a former Metropolitan Opera prima ballerina who also danced with the Ballet Russe de Monte Carlo.

I got in touch with Aurelio Tommaso Giovanni Erasmo Leone Prete, an art critic who wrote the monograph, and whose gallery in Rome represented Filippo's work in the 1960s. He said that he had lost touch with Filippo, but related a story about his upstairs neighbor, an American girl, who had a brief affair with Filippo. When Filippo broke it off, she drove her car over a cliff. As for Filippo's ranking as count, according to Aurelio, who comes from a long line of Italian nobility, he fell into the *conte finto* category, the rank of "faux count," adopted by many young provincials who took advantage of the anonymity of the big city to reinvent themselves. He came from Sirolo. A Roman detective, Colonel Armando Stavole, helping to find Filippo, said it was "like to be in a black hole." Finally, it was confirmed that Florence's *poeta-aviatore* was dead.

For Florence's ninety-first birthday on August 11, 2006, I gave her a red leather-bound *Hedda Gabler*, embossed in gold, translated by Eva Le Gallienne, which I happened upon while searching the dusty stacks of the Strand Bookstore on Broadway. In 1935, at the height of the Depression, the Civic Repertory Theater lost its private endowment and closed. Eva and Jo had a falling-out. Jo left for Hollywood. At eighty-one, Le Gallienne made her final appearance, once again flying onto the stage as the White Queen in *Alice in Wonderland*. Le Gallienne died at ninety-two in 1991 at her home, which she had turned

into a sanctuary for animals, welcoming possums, skunks, raccoons, and bluebirds. She lived in Weston, one town over from Florence in Westport. The two women never met after their scene in Eva's dressing room.

On Sundays, I took the train to visit Florence in Westport. The train departed from Grand Central at seven minutes past the hour and arrived at eleven past the next. We ate mini-bagels with whipped cream cheese and lox, and frozen yogurt, chocolate-covered orange sticks, and almonds chilled in the fridge for dessert. I traveled with Florence back to the time she kept her diary.

"I was so full of the love of life," Florence said to me. "It was my world, a whole different world. You know, you're reconstructing that life for me."

"Is that okay?" I asked.

"Yes," she exclaimed, her graying strawberry blond pixie hair framing still luminous blue eyes, which didn't seem to have aged.

"But it was so long ago!"

Florence stared into the garden. Birds chirped over chamber music playing on the stereo. "Show me a sunset or a tree silhouetted against the sky, and I can still work up enthusiasm over it," she said quietly. "Look at the long shadows. They're rare for this time of year." The old oaks and maples stood like ladies waiting to dance.

"Now it's beginning to look familiar," said Florence examining her diary closely. "I can see myself writing in it. It

couldn't have come back at a better time. I really needed it. This is a hard time in my life." She held my gaze. "You don't want to hear about it."

We swung back and forth between the present and the past. At sixty-two, Florence went back to school and earned a degree in geriatric counseling. "So I could live with my old age," she told me. "I don't know how well I'm dealing with it."

Nat, very frail, was dozing in the garden on a deck chair. "I'm taking very good care of my husband, who is not in a good place now. I feel very tenderly toward him. Nat could be unemotional, unable to express himself, and abrasive," Florence explained. "He doesn't say much, but there's an intimacy we have now that's unlike anything we ever had before. It's satisfying to me and very moving for my daughters. I kiss him a million times a day. I get tears in my eye just talking to you."

Since Nat's deterioration, Florence had not visited New York in three years. She said, "I'm perfectly happy just being with him and making him aware of our relationship."

One morning in early April 2007, when Florence was back in Florida, I received an e-mail.

Nat died yesterday afternoon—a relief to him—both a relief and a heartbreak for me.

Lv, F

In May 2007, one year after we first met, I flew down to Pompano Beach to visit Florence. It was a season of uncontrollable fires and love bugs. The bottom of Lake Okeechobee

was burning. "To Fla with Flo," said Valerie. Florence lives in Palm-Aire, a sprawling condominium complex set on four golf courses, full of fellow snowbirds. Florence arranged for her next-door neighbor, Matt, to pick me up at the Fort Lauderdale airport. "He'll be wearing a red hat and will probably have a sign with your name on it," she informed me on the phone. "What will you do at night?" I told Florence I wasn't coming down to pick up men in South Beach.

Her Florida living room, decorated in tones of gray and silver, which opens onto a patio overlooking the swaying palms of a golf course, was filled with a lifetime of collecting art. A bronze cast of Nat's face by an artist friend rested on the black Yamaha console piano. Hanging on the wall was a gold-framed portrait of Florence done by one of her good friends, Eda Mann, the mother of Erica Jong, the author of *Fear of Flying*. Eda and her husband lived next door to Florence and Nat in Westport. Under a red fedora, an intense, sexy Florence looked out from the canvas with inquisitive eyes. "It doesn't look like me," Florence told Eda. "It will," said Eda, quoting Picasso's famous line to Gertrude Stein.

In Florida, Florence and I dipped shrimp in cocktail sauce. We took a Polaroid together. "Lily and her new grandmother," Florence said, smiling. She turned to me. "You've got gorgeous legs."

"So do you," I said. Slender, tanned, not a vein in sight—from all that tennis. We sipped iced tea and cranberry juice mixed with orange.

"You seem so young to me, Florence."

"It's true. I have never felt old," she said. "I always felt like

a neophyte. Isn't that interesting? I always felt like the young one."

Florence fingered through the red diary. "I love that young girl," Florence told me. "I wish my Florence, when she was young, could have known somebody like me today." She paused. "I hope I haven't been a disappointment to you."

"Florence, finding your diary, and then you, it's like I found the young girl and she's ninety."

"But ninety is formidable. You had to wonder what I was like when you picked up the diary!" Florence squealed with delight. "What made you do this, Lily? What did you think I looked like? Am I anything like what you expected?"

That's Florence, a timeless teenager. "I had seen your picture in the newspaper clipping," I said. "So I knew you were gorgeous."

"Not gorgeous, not gorgeous," denied Florence, visibly glowing, her lips with their dab of red lipstick spreading into an uncontrollable smile. Her small gold hoop earrings shook as she laughed.

"You know, you are the heroine of this story," I said.

"Well, I'm happy to hear you say that, because I don't feel like a heroine in my own life," confessed Florence, clasping her diary. "But I have to tell you, I've come to terms with myself, and I'm much happier now than I was a few years ago when I wasn't very true to myself. I had a country-club mentality, I really did, and I'm through with that now. I am what I am, who I am, what I was when I wrote this."

The red leather diary was a gift. It was a gift to Florence when she turned fourteen and needed to express her deepest

longings. It was a gift to me when I found it at twenty-two, struggling with what I wanted to do with my life. Like Florence, I was searching. The diary found me. Again, the red leather diary was a gift to Florence at ninety.

I paused over "Valentine," a poem written by her mentor Mark Van Doren. "To the other side of the farther star, to the outermost dark, then on and on and on to where pure nothing is—If that can be, if that can be—I send your name with a heart around it to hang on the wall of the world."

Florence wrote her last diary entry on August 10, 1934, *Pleasant day anticipating my nineteenth birthday—which brings this to a close—all pretty trivial—but I have grown.*

If Florence kept a diary today, she might write, *August 11, 2007, My ninety-second birthday. Small family party. Studying Buddhism—taking a life drawing class.*

I opened up a new document on my laptop. Staring at the blank page, I thought of Florence making her first entry. I began to write.

Once upon a time the diary had a tiny key. Little red flakes now crumble off the worn cover.

ACKNOWLEDGMENTS

'm still amazed at how Florence and I found each other. If I had never met this extraordinary woman, there would be no book. My deepest gratitude goes to Valerie Fischel and Karen Howitt, Florence's daughters, who trusted me, letting me into their lives. I'm indebted to Dr. Irving Wolfson, for his stellar memory, and to his daughter-in-law and son, Artley and Richard, for sharing their genealogical research on the Wolfsons.

Thanks to Sydney Lipman, Manny's daughter, and his niece, Elinor Lipman. I'm grateful to the Kinzler family: Winifred Breuning; George's children, Peter Kinzler and Ellen Schlossberg; and Hazel's daughter, Lynn Goddess. Thank you to Jeffrey Kehl for his memories of his mother, Pearl. Grazie Alta Price for Italian translations and help in Rome. Thanks Erik Haagensen. Thank you to Bel Kaufman for remembering those Hunter days, and for her kindness.

It's been a privilege to work with my editor, Claire Wachtel. Jane Friedman, Jonathan Burnham, Brenda Segel, Gilda Squire, Julia Novitch, and the many others at HarperCollins, thank you. Thanks to my fabulous agent, Kate Lee. I feel fortunate to have worked with Connie Rosenblum, Wendell Jamieson, and my friends at the *New York Times*, who showed an early interest in the diary. Tom Folsom, my parents, Bob and Mara, and my brother Niko, I couldn't have done it without you.